W9-BZX-703

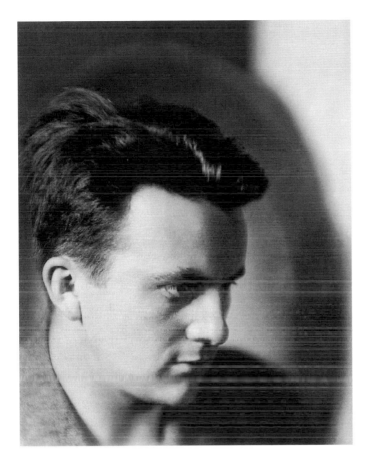

**VLADIMÍR BIRGUS**
**JAN MLČOCH**
editors

Texts by
VLADIMÍR BIRGUS
JAN MLČOCH
ROBERT SILVERIO
KAREL SRP
MATTHEW S. WITKOVSKY

# **Jaroslav Rössler**

## Czech

## Avant-Garde

## Photographer

The MIT Press
Cambridge, Massachusetts
London, England

*Extraordinary help in the preparation of this book was provided by Sylva and Jaroslav Vít, the daughter and son-in-law of Jaroslav Rössler. This publication has come about thanks also to the Museum of Decorative Arts in Prague, the Moravian Gallery in Brno, the J. Paul Getty Museum in Los Angeles, Anna Fárová, Helena Koenigsmarková, Eva Matyášová, Suzanne Pastor, Dorothy Prakapas, Hana Štěchová, Jitka Štětková, Dana Tausková, Milena Tučná, Alena Zapletalová, Jaroslav Anděl, Antonín Dufek, Howard Greenberg, Manfred Heiting, Jiří Jaskmanický, Otakar Karlas, Karel Kerlický, Rudolf Kicken, Robert Koch, Michael P. Mattis, Weston J. Naef, Alex Novak, Eugene J. Prakapas, Martin Stein, and František Štěch. The English-language edition is inconceivable without the intensive interest that Roger Conover, Executive Editor of the MIT Press, has in the art of central and eastern Europe, the precise translation and valuable comments of Derek Paton, and the careful editing of Michael Sims. To all these people we express our sincere gratitude.*

*The authors*

© 2004 Massachusetts Institute of Technology
Photographs © Sylva Vítová
Text: © Vladimír Birgus, Jan Mlčoch, Robert Silverio, Karel Srp, Matthew S. Witkovsky
Concept and selection of photographs: Vladimír Birgus, Jan Mlčoch
Graphic design: Otakar Karlas
Translation: Derek Paton
Editing of English version: Michael Sims
This book originally appeard in the Czech Republic under the title Jaroslav Rössler-fotografie, koláže, kresby
© 2003 Nakladatelství KANT, Karel Kerlický, Kladenská 29, CZ-160 00 Praha 6, kant@znet.cz.

All rights reserved. No part of this book may be reproduced in any form by any electronic
or mechanic means (including photocopying, recording, or information storage and retrieval)
without permission in writing from the publisher.

This book was set in Prague by FPS repro and was printed in the Czech Republic
by PROTISK České Budějovice.

Library of Congress Control Number 2003113824
ISBN: 0-262-02557-4

# Contents

**Rössler's Art Photography, 1919–35** (Vladimír Birgus)    /**7**

**Photographs for Advertisements** (Jan Mlčoch)    /**25**

**Zones of Visuality: Rössler's Drawings, Photomontages, and Radio** (Karel Srp)    /**29**

**Works after World War II** (Robert Silverio)    /**36**

**Experiment in Progress** (Matthew S. Witkovsky)    /**40**

**Jaroslav Rössler – Life in Dates** (Vladimír Birgus)    /**153**

**Exhibitions** (Vladimír Birgus)    /**157**

**Literature** (Vladimír Birgus)    /**159**

# Rössler's Art Photography, 1919–35
VLADIMÍR BIRGUS

Although Jaroslav Rössler was involved in photography for almost seventy years, the most important part of his work, the part for which he is ranked among the leading figures of avant-garde photography between the two world wars, comes from a period of roughly fifteen years. His essential photographs, photomontages, and photograms, which absorbed the impact of Futurism, Constructivism, and Abstract Art and developed them in an original way, were made between 1919, the date of *Opus I*, Rössler's first important photograph, and 1935, when, after being deported from France, private work became something he would devote himself to only sporadically for many years to come. Although they are indisputably among the most important Czech contributions to the development of photography internationally, until recently only a small circle of experts was familiar with them. It was not until the first substantial Rössler retrospective, organized at the Museum of Decorative Arts, Prague, in 2001, and then at the "Foto España" festival, Madrid, and at the Atlantic Center of Photography, Brest, as well as the first, modest book about him and his work (published by TORST, Prague, 2001), that the work of this reclusive artist was introduced to a wider audience. The next contribution to our knowledge of the unjustly overlooked work of Jaroslav Rössler is the present book, the first to focus not only on his art photography and photomontages but also on his drawings.

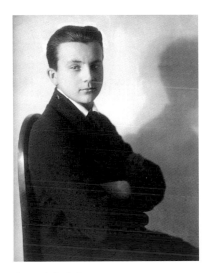

František Drtikol:
Portrait of Jaroslav Rössler, 1922

Rössler's teacher František Drtikol left behind thousands of photographs (there are more than five thousand in the collection of the Museum of Decorative Arts in Prague alone), hundreds of drawings, paintings, diaries, notebooks, published views on photography, and a vast correspondence. The written recollections of his friends and pupils also exist. Rössler, however, left behind far fewer photographs and written documents. Unlike Drtikol, Rössler took part in exhibitions infrequently; consequently, no more than one or two original exhibition prints of even his best-known works from the 1920s and 1930s exist, and many works have been preserved only as prints made from the 1960s to the 1980s, when curators of museums and galleries in both Czechoslovakia and abroad, as well as private gallery owners and collectors, slowly began to show an interest in Rössler's work. In these works one sometimes comes across erroneous dates, which differ by a year or two from those of the original prints or sketches for photographs in his notebooks. Some of Rössler's photographs exist only as negatives or as prints made after his death, carefully catalogued in his estate by his daughter Sylva Vítová and her husband Jaroslav Vít. Today, Rössler's works are dispersed throughout a number of collections. Some unique works, moreover, are not present even in the three largest publicly accessible collections of his work (the Museum of Decorative Art, Prague, the Moravian Gallery, Brno, and the J. Paul Getty Museum, Los Angeles), but are in various private collections in the Czech Republic, the United States, Germany, the Netherlands, and France.[1] Rössler's diffidence and mistrust of people outside his immediate family meant also that the extant correspondence is scanty, making it impossible to gain deeper insight into the artist's thinking or to define more precisely the contours of his personality. Nor do the few notes he made in Czech and French help us, tending to be concerned with the technical side of the photographs rather than with personal experiences, artistic opinions, or reflections on his own work. Possibly, other important works by Rössler will be found, concealed for the time being in lesser known private collections or the archives of the Parisian companies for which he worked. Rössler's biography also continues to suffer from a number of blank spots, obscurities, and incongruities.

One runs into these problems as soon as one tries to ascertain his family background. According to Martin Stein (who wrote his dissertation on Rössler in the Department of Photography at the Academy of Performing Arts, in 1984, while Rössler was still alive), the artist's father, Eduard Rössler, was of German ethnicity but Czech speaking.[2] The maiden name of Eduard Rössler's mother, Hoblíková, does not, however, support the view that Eduard Rössler was in strict terms German; the artist's daughter Sylva knows nothing of her grandfather's alleged German origin. Further doubts about this stem from the fact that Jaroslav Rössler did not speak German. On the other hand, Stein claims to have this information directly from

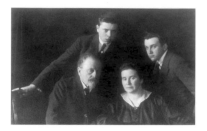

František Drtikol:
Portrait of Jaroslav Rössler (right)
with parents and brother, 1922

František Drtikol: Study, 1922

Rössler, though the artist was 82 years old at the time and could, owing to illness, communicate only in writing.

Jaroslav Rössler was born in Smilov, on 25 May 1902, near the town of Německý Brod, today Havlíčkův Brod. His father first managed a distillery, then, at the time of Jaroslav's birth, was a clerk on the estate of Count Thun-Hohenstein, and in 1905 became the tenant of a farm in Smilov. His wife Adéla, née Nollová, twenty years his junior, came from a cooper's family in Německý Brod. (From his mother's side, Jaroslav was related to Miloš Noll, a well-known artist and illustrator of children's books.) Apart from Jaroslav, they had a younger son named Zdeněk; Eduard Rössler had, in addition, a much older son from his first marriage.

His parents wanted Jaroslav to study, and sent him to secondary school in Německý Brod right after the fourth grade of primary school. The grandfather with whom he lived in Německý Brod was not particularly interested in Jaroslav's education, and Jaroslav ended up getting poor marks and had to repeat his first year. When he showed no sign of improving, his parents sent him to the council school. Since a later attempt at studying at a commercial academy in the town of Kolín did not work out either, the Rösslers decided in 1917 to send their son to train as a photographer. A family friend had a son, after all, who was prospering in the profession. After being declined by the Prague photographer Kaplan, Rössler's parents, on the recommendation of an acquaintance, turned to the best photo studio that ever existed in Prague, Drtikol & Co.

Its principal owner, František Drtikol (1883–1961),[3] was the most important Czech photographer of the period, who, even before World War I, had made a number of outstanding formal portraits, Art Nouveau and Symbolist nudes, Impressionist landscapes, genre scenes, documentary photographs of miners at work, and the album *Z dvorů a dvorečků staré Prahy* (From Large and Little Courtyards of Old Prague), coauthored by his business partner Augustin Škarda.[4] Drtikol had graduated in the early twentieth century from a modernly run photography school in Munich, and, together with Vladimír Jindřich Bufka, it was he who most contributed to the gradual elevation of Czech photography from provincialism, though it still remained behind the more rapidly developing visual arts and architecture in the Czech Lands: in those disciplines, forward-looking Czech painters and sculptors such as Bohumil Kubišta, Emil Filla, Josef Čapek, Antonín Procházka, and Otto Gutfreund had, even before the outbreak of World War I, responded in an original way to the inspirations of Cubism, Fauvism, and Expressionism, and together with the architects Josef Gočár, Pavel Janák, and Josef Chochol, deserve the credit for making Prague a leading center of the avant-garde.[5] The more ambitiously oriented Czech photographers of the period, including not only the professionals Drtikol and Bufka, but also the amateurs Josef Binko, Otto Šetele, Ludvík Komrs, Karel Špillar, Jaroslav Petrák, Adolf Vyšata, and Alois Zych, were for the most part under the sway of Impressionist and Art Nouveau Pictorialism. Romantic landscape photographs, lyrical portraits and nudes, genre scenes, and panoramic views of towns were usually done as gum prints, oil prints, carbon prints, and other pigment processes, which allowed the artist expressive intervention in the final form of the photograph and accented the uniqueness of the original. Czech photographers at the time were still ignorant of the revolutionary works of Alfred Stieglitz, Alvin Langdon Coburn, Paul Strand, and other pioneers of modern photography, not becoming familiar with them until the twenties.

On 1 September 1917, when the fifteen-year-old Jaroslav Rössler began his apprenticeship in the studio, Drtikol and Škarda were serving in the Austro-Hungarian army. The studio was being run by Škarda's brother-in-law, a man named Šourek. The decline in the quality of the apprentices' photos was recalled by Rössler in his interview with Stein: after his return from the war in August 1918, Drtikol apparently wanted all negatives originating from the period of his absence to be destroyed.[6] On the fourth floor and in the attic of the building on the corner of Vodičkova and Jungmannova streets in the centre of Prague (built in 1912 on the site of the house of the leading Baroque sculptor Matthias Bernard Braun) was an entrance hall, a reception office, a large photo studio, a darkroom, a room for retouching negatives, a negatives archive, and a printing room, where the light coming through a glass wall was used during the printing of negatives. Although one could work in the studio in good weather using light coming in through the corner windows, Drtikol usually used lamps with 2000-watt bulbs,

later arc-lamps. First, Rössler learnt to develop and retouch, but did not get a chance to photograph at all; even later Drtikol did not really initiate his young apprentice into the mysteries of making the formal portraits his studio specialized in. The vast majority of the portraits of leading artists, politicians, industrialists, and sportsmen, as well as those of ordinary customers, were staged, lit, and photographed by Drtikol alone; only rarely did Škarda or some other experienced employee stand behind the camera. That, together with his innate shyness, probably also contributed to the fact that Rössler, even later in his career in Paris, was not particularly concerned with the portrait, preferring to photograph static objects.

His years as Drtikol's apprentice and then as his assistant had a profound influence on him. It was not only because of his daily contact with Drtikol's photographs but also because of Drtikol's interest in Symbolism and mysticism, his mastery of the technology of pigment processes, his attempts to achieve perfect craftsmanship, and his profound interest in painting, sculpture, and photography, an interest that was, in comparison with most other professional photographers in the new republic of Czechoslovakia, extraordinary. Working with Drtikol, Rössler also acquired an overview of contemporary trends in photography, because there he had an opportunity to look through foreign photography magazines and books. Thanks to Drtikol's magnanimity Rössler was also able, free of charge, to use cameras, photographic materials, and chemicals from Drtikol's studio for his own photography, which he would otherwise have lacked the means for. Drtikol helped him also to solve problems with accommodations, by allowing him to sleep in the printing room, in which Rössler made a number of his early works. Although most of his photographs from the period before his departure for Paris were made in Drtikol's studio, that does not mean Rössler worked there without interruption from the time he completed his apprenticeship in September 1920 to the end of 1925. Indeed, he left Drtikol several times, but always returned – and was always accepted back without a word. His longest absence was from August 1921 to the spring of the following year. He had apparently let himself be lured away by a Serbian student who offered him a job working with his sister in the Rosandić studio, Belgrade. Rössler was so eager to set out on his first trip abroad that he arrived in the Serbian metropolis too early, before the promised position was available. He therefore began work at the Savić studio, where for about a month he retouched negatives. He then returned home ingloriously, but probably did not show up at Drtikol's until spring 1922. After several deferments he was eventually called up for military service in autumn 1924, and was assigned as a photographer to an airborne regiment in the town of Hradec Králové; instead, however, he was, for some unknown reason, discharged ten days later. He was soon back in Drtikol's studio.

Rössler must surely have been at least superficially familiar with Drtikol's Symbolist drawings from the war years, as is evident from his own drawings with similar motifs and solitary female figures in imaginary landscapes, which he made in 1923. Whereas in Drtikol's work, however, they are allegories of Mother Earth and woman's confrontation with threatening natural or mythical forces in the milieux of realistically depicted mysterious cliffs, Rössler stylized his natural scenery on the background of women with arms outstretched into geometrical forms, which reveal the inspiration of Futurism, Cubism, and also Expressionism (figs. 11 and 12). Drtikol's influence on Rössler's photographic work does not appear in the earliest extant photo, Opus I, from 1919 (fig. 1), which, in an original way, anticipates his avant-garde work (Rössler allegedly destroyed his other work from this period), but it is evident in portraits of his colleague from the studio, his future wife, Gertruda Fischerová (1894–1976), which were made about four or five years earlier, while still fully under the sway of the Art Nouveau style (figs. 4, 5, 6, 7, and 8). They are mostly photos with melancholy moods, in which the artistic backgrounds play an important role – sometimes made with columns (in 1923, Drtikol also began to use columns and other geometric decorations in his nudes), at other times painted directly onto the negative. A special place is held by a photo in which we see mainly Fischerová's hair and the nape of her neck as she turns her ahead away from the lens; the square composition is offset by the cut-off corners (fig. 4).

An important role in some of these portraits is played by the pigment processes, which had been so popular among representatives of Impressionist and Art Nouveau Pictorialism. Rössler shared Drtikol's interest in these complicated techniques, and often used some of them,

particularly the bromoil print. Probably in no other avant-garde photographer is there such a marked contrast between the modernity of the ends and the archaicism of the means used to achieve them. Soon after Drahomír Josef Růžička, a Czech-born American, pupil of Clarence Hudson White, and proponent of Stieglitz's demands for "straight" photography, presented his works in Prague in 1921, most forward-looking Czech photographers of the young generation abandoned pigment processes. Even Drtikol was enthusiastic about photos in the style of purist Pictorialism, as is evident from words he wrote in 1923: "The winners: perfection of technique and inward development. Růžička from America is the best. A zest for life!"[7] At the time, Drtikol himself began to abandon pigment processes, with the exception of the pigment print, and in the late twenties even wrote: "Simple, ordinary glossy photography is the best. …Even though I tell myself that sometimes gum or oil would help me to achieve a certain effect, I avoid them. I maintain: the negative must be a finished article."[8] Although we cannot take Drtikol's statement literally – he used the pigment-print technique for some photographs with little cut-out figures even in the early 1930s – it is clear that Rössler remained loyal to the bromoil print far longer, using the technique even in 1948 when printing earlier shots from Paris. Together with a classic of Polish photography, Jan Bulhak, who as late as the post-World War II years made pigment prints of his photos of ruined Warsaw, Rössler was probably the last important European photographer continuously to exploit the pigment processes that had been so widespread in their works in the late nineteenth and early twentieth centuries. (Indeed, some pigment processes, particularly the platinum print, are now back in vogue.) This contradiction is heightened by the fact that the Czech avant-garde artists associated with the theorist and collagist Karel Teige, in whose periodicals Rössler sometimes published in the second half of the twenties, vehemently rejected prints made with pigment processes and gave clear preference to the pure gelatin-silver print. Rössler, however, was probably rather unconcerned with contemporaneous changes in preference for certain photographic techniques. In any case, he made most of his bromoil prints as more or less private works and, with rare exceptions, never exhibited them. In their intermixing of Pictorialism and Modernism, Rössler's photographs closely resemble the works of Alvin Langdon Coburn and Pierre Dubreuil.

Among the works of Rössler where old and new tendencies come together is the now missing photograph (we know only its rather poor quality reproductions) that joins together in a pyramidal composition a photograph of a naked man posing as the Thinker or the Creator and a photograph of two kneeling naked women with their heads bowed and Cubist-Futurist drawing (*fig. 3*). The male model was Rössler himself, probably photographed by Gertruda Fischerová. The American collector Michael Mattis owns an unpublished oil print of the Rössler nude used in this montage, which is signed by both Fischerová and Rössler (*fig. 2*). This is probably the only extant collaborative work of the couple, which closely resembles several of the chaste but for their time exceptionally daring male nudes from 1922, in which Fischerová has depicted a standing and seated Rössler on a black background.[9] We may probably never know whether they too were once intended for a photomontage or whether they were conceived as independent works. Be that as it may, these nudes are evidence of the close relationship between Rössler and Fischerová, an intelligent woman eight years his senior. Before she began to train in Drtikol's studio in 1913, she had been a pupil at the Minerva school for girls in Prague (the first secondary school for girls in Bohemia to prepare young women for university, founded in the late nineteenth century).[10] Although Drtikol had been married to the dancer Ervina Kupferová since 1920 and they had a small daughter, he and Ervina were not happily married. He began to show interest in his young assistant Fischerová, but she preferred Rössler. Owing simply to the fairly marked age difference between them it is certain that the relationship between Rössler and Fischerová must have seemed rather scandalous to their society, yet it was extraordinarily deep and strong. It was Fischerová, the more realistic and extroverted of the two, who played the dominant role in her marriage to the shy, introverted Rössler. She often helped him to solve practical problems, such as finding work and looking after his correspondence. It is typical of their relationship that for most of their lives together they used the formal 'Vy' (or 'Vous') form of address. After the birth of Sylva, Gertruda, despite the dominant position she held in their relationship, willingly gave up her own photographic career, satisfied to be a housewife and occasionally helping to retouch prints.

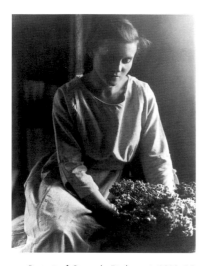

Portrait of Gertruda Fischerová, 1912–15

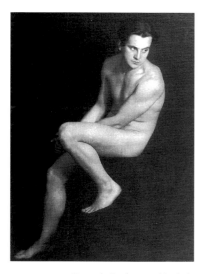

Gertruda Fischerová: Untitled, (Jaroslav Rössler), 1922

But we are getting too far ahead of ourselves in the chronology of Rössler's life and works. One of the best-known pieces by Rössler is the *Portrait of the Dancer Ore Tarraco* (the stage-name of a Czech dancer named Kulhánek, who was influenced by Oriental dance). The portrait has been published many times, including in the *Dějiny českého výtvarného umění* (A History of Czech Fine Art) published by the Czech Academy of Sciences,[11] as an example of a photographic portrait completed with the bromoil technique. This view, shared by Antonín Dufek, curator of the photography collection at the Moravian Gallery, Brno, and other historians of photography, is confirmed by Rössler's own reminiscences recorded by Martin Stein, according to which Rössler initially made the photographic portrait of his friend Jaroslav Fábera. It was not until he caught sight of the photograph of Tarraco in the shop window of the Schlosser & Wenich photo studio that he began to use the bromoil technique (enabling expressive painterly changes to an original photograph by applying paint with a brush) to turn his own photograph of a friend into the imaginary portrait of Tarraco. This work apparently was of great interest to Drtikol, who then tried to do something similar in the form of a portrait (now, unfortunately, lost) of Marinetti, the Italian Futurist, using a brush to paint onto a glass negative.[12] Upon closer analysis of the portrait of Ore Tarraco, I believe it is based not on a photograph but on a drawing. The portrait exists in two versions: a gelatin-silver print in the postcard format (*fig. 47*) and a unique bromoil print (owned by the Moravian Gallery, Brno). The latter is distinguished from the former in its details, especially in the simpler diagonal stripes around the head, which were painted on later with a brush, using the bromoil technique. No photographic detail is visible in either version, and the gelatin-silver version in particular clearly looks like a reproduction of a drawing. Rössler, who was 82 years old when interviewed by Stein, probably forgot that he had made his Cubist-Futurist drawing based on a photograph of his friend, and that he had taken a photograph of that drawing, which he then altered using the bromoil technique. This supposition is supported also by the existence of a very similar charcoal and pastel drawing with diagonal outlines of a head, which Rössler made in 1923, and, like his imaginary portrait of Ore Tarraco, is reminiscent of the Cubist drawings and sculptures by Otto Gutfreund, as well as stylized portraits by Vlastislav Hofman. The fact that the bromoil version of Ore Tarraco bears the date 1922 means little, in light of the slight errors Rössler sometimes made in post-dating his own works. In any event, the gelatin-silver version of the *Portrait of the Dancer Ore Tarraco*, now in a private collection, bears the date 1923 written in Rössler's own hand.

Jaroslav Rössler: Untitled, 1923, Charcoal and pastel drawing

The influence of Futurism, Cubism, and other avant-garde trends is evident not just in the Portrait of Ore Tarraco. It appears also in a number of Rössler's photographs made while he was an assistant in Drtikol's studio. These are among the earliest examples of Czech avant-garde photography. The first is *Opus I*, made in 1919. Its geometric composition with a little polygonal bottle for chemicals and two pieces of cardboard placed diagonally is, according to Antonín Dufek, the first Constructivist photograph in Europe or, in Dufek's words, "Constructivism before Constructivism."[13] One could in fact say the same about Coburn's diagonally composed, bird's-eye-view photographs made in New York seven years earlier, yet this is indeed the first Czech avant-garde photograph. Just how much Rössler valued this technically inferior photograph (inspired, according to him, by Cubist "planes superposées" and the rather surprisingly similar composition of *H O Box* by the American photographer Paul Outerbridge, made in 1922) is evident from the fact that even in his old age Rössler had a contact print of it exhibited on his enlarger. (The print is now owned by the Museum of Decorative Arts, Prague.) He later developed its compositional principles in photographs of small objects on a background of variously colored pieces of paper, which he made in 1923–25, as well as in several photographs for advertisements, which he made during his first Paris sojourn. Since Rössler apparently destroyed most of the photographs he had made before 1922, one can now only guess whether he in fact made other equally radical, forward-looking works.

Judging by works they made in the twenties, it is clear that both Rössler and Drtikol were seriously interested in Cubism and Futurism. Thanks to several exhibitions of French art in Prague and to the acquisitions made by the collector and art historian Vincenc Kramář, who had since 1911 been in Paris purchasing works by Picasso and Braque, Czech artists before World War I could become acquainted with innovative Cubist works, and many of them, mainly members

of the Group of Fine Artists (Skupina výtvarných umělců), responded quickly and originally to the trend with their own paintings, sculptures, architecture, and industrial designs. Prague, where unique Cubist architecture was being made and a special uniting of Cubism and Expressionism was taking place in works by artists such as Bohumil Kubišta, Otto Gutfreund, Antonín Procházka, and Josef Čapek, was with good reason considered the second center of Cubism. Some young Czech artists saw the warm reception accorded Expressionism, Fauvism, and Cubism as a manifestation both of revolt against the Art Nouveau and Decadent orientation of Vienna and of the emancipation of Prague from the center of the Austro-Hungarian monarchy. Rössler used to say that for him the most interesting Czech Cubist was Procházka.

The contacts with the Italian Futurists were also quite intensive. As early as December 1913, an exhibition of works by pioneers of Futurism, including Gino Severini, Umberto Boccioni, Luigi Russolo, and Carlo Carrà, was mounted in the Havel Gallery, in Prague. The artist and writer Josef Čapek, who, together with Kubišta, Gutfreund and Vlastislav Hofman, was also influenced by it, wrote about Futurism several times in the *Umělecký měsíčník* (Art Monthly). In October 1921, Enrico Prampolini organized an exhibition of Italian modern art for the Krasoumná jednota (Fine Arts League) in Prague, at which the Futurists were well represented – for example, more than twenty works by Boccioni were exhibited there. In the same year, productions of Futurist "syntheses" (sintesi), directed by Filippo Tommaso Marinetti, were mounted in the Švanda Theater, Prague. The stage sets by Prampolini and De Pistoris consisted of simple three-dimensional constructions and abstract geometric hangings. The following year, the Theater of the Estates, Prague, presented Marinetti's *Il Tamburo di fuoco*, directed by Karel Dostal, with sets by Prampolini. These stage designs apparently inspired Rössler's interest in simple geometric forms, which also appeared in the work of Drtikol. Prampolini paid a visit to Drtikol's studio, but Rössler apparently only caught a glimpse of him there. Rössler was not particularly taken with his work, and used to mention Prampolini only as someone who had once been a fundamental influence on him.[14]

Abstract Art, another trend Rössler responded to in an original way, did not really find a place in Czechoslovakia until the 1930s, even though something of it is expressed in the Artificialist works of Toyen and Jindřich Štyrský in the previous decade. Although František Kupka undoubtedly rates among the great pioneers of abstract painting internationally, a remarkable set of abstract oils and watercolors was also made by Alois Bílek in 1913–14, and František Foltýn, who worked in France and was therefore little known among the Czech artists and theorists at that time, painted a number of abstract pictures with geometric and biomorphic faces in the second half of the 1920s. All the more exceptional, then, is the position held in Czech art by Rössler's photographs with minimal static motifs or his photographs of light patterns made in the first half of the 1920s, which surely rank among the best of his oeuvre. Even in the international context they constitute very early, highly radical expressions of abstract tendencies in photography; yet, owing to the lack of writing on Rössler's work, they are rarely mentioned in the specialist literature abroad.[15] On the other hand, some Czech historians of photography and other writers on the subject have tended, inaccurately, to place Rössler's works at the very beginning of abstract photography.[16] Rössler was hardly the first pioneer of nonfigurative tendencies in photography, but that does not diminish the extraordinary importance of his contribution.

The term "abstract photography" is looked at askance by some theorists, who argue that photography, unlike painting or sculpture, can never completely free itself from the depiction of some form of reality. The term, however, was quite consciously used by Alvin Langdon Coburn as early as 1916, when he was planning to mount a photography exhibition, at which interest in the depicted object was to be shifted to the background while form and structure were to play the primary role.[17] His exhibition, however, was never mounted, and the first big show on the development of abstract photography did not take place until one was held in Bielefeld, Germany, in late 2000.[18] On that occasion, at the initiative of Gottfried Jäger, a conference was also held, and the term "abstract photography" was routinely used there, though some of the participants did so only with reservations.[19]

But even the exhibition in the Bielefeld Kunsthalle (at which Rössler was properly represented) did not reveal the earliest nonfigurative tendencies in photography. One probably has to

Man Ray: Untitled rayograph
from the portfolio Champs délicieux, 1922

look for them in photographs coming out of Occultism, Theosophy, Anthroposophy, and other esoteric and hermetic trends, which exerted a strong influence also on the revolutionary abstract painting by Kupka, Wassily Kandinsky, and Mikaloius Konstantinas Čiurlionis. One could, with some caution, rank among the earliest of them the various Spiritualist photographs of ghosts, which were so popular in the late nineteenth century, as well as the attempts to photograph human brain waves. The German historian of photography Rolf H. Krauss, for example, has written how Louis Darget, as early as the 1880s and 1890s, placed photographic plates on the foreheads of various people, and after exposures of several minutes and then developing, obtained photographs showing various irregular shapes, which he ascribed to brain waves evoked by various emotions.[20] To the uninitiated today, Darget's photographs – as well as similar photographs by the Parisian neurologist Hippolyte Baraduc – appear to be imaginative abstract compositions. These photographs, however, were not made as works of art; their emotional impact is similar to the latent aesthetic value of certain astronomical photographs, microscopic photos, and the photographs of sound waves and bullets in flight, which were made by Ernst Mach in Prague in the 1880s and 1890s, as well as the "chronophotographs" showing changes in light patterns, which Etienne-Jules Marey made in the same period.

Alvin Langdon Coburn: Vortograph, 1917

By contrast, the German chemist and photographer Erwin Quedenfeldt had already discussed the possibility of making subjective experience visible in what he called "Lichtbildkunst" (the art of photography), distinguishing it clearly from the unimaginative, objective depictions of conventional photography.[21] In the 1910s and 1920s, using a combination of photographs and gum prints, he made compositions of various symmetrical geometric shapes. As early as 1912 he was granted the patent for the technique of making geometric patterns with the help of photography,[22] and showed fifteen examples from his series *Symmetrische Muster aus Naturformen* (Symmetrical Patterns from Natural Forms) at the 1914 Werkbund exhibition in Cologne. For this reason, Krauss argues, that Quedenfeldt is the first person to have exhibited nonfigurative photography publicly.[23]

Francis Joseph Bruguiere:
From the series of the "Clavilux"
of Thomas Wilfred, 1922

Far better known in the history of abstract photography are the photographs of elementary forms of bowls and furniture or details of light and shadow on a table or wall, which were made by the American photographer Paul Strand in Twin Lakes, Connecticut, in the summer of 1916.[24] An absolutely fundamental position in this area is held by Coburn's *Vortographs*, consisting of about eighty variants of photographs of simple glass and wood objects (and, in one instance, a portrait of the poet Ezra Pound). Made between three mirrors in a sort of kaleidoscope in 1916 and 1917,[25] they were definitely not a mere game of chance, but the result of a concerted effort to make photographic works as abstract as those being achieved in painting. Coburn commented on this in his autobiography:

*It was in 1914 that Wyndham Lewis founded the avant-garde movement named by the American painter and writer Ezra Pound "Vorticis," the ideas of which derived partly from Futurism and partly from Cubism. I did not see why my own medium should lag behind modern art trends, so I aspired to make abstract pictures with the camera. For this purpose I devised the Vortoscope late in 1916. This instrument is composed of three mirrors fastened together in the form of a triangle, and resembling to a certain extent the Kaleidoscope – and I think many of us can remember the delight we experienced with this scientific toy. The mirrors acted as a prism splitting the image formed by the lens into segments. … The objects I photographed were usually bits of wood and crystals.[26]*

Not only was Coburn present at the birth of abstract photography, but in his renowned bird's-eye-view of Madison Square Park, New York City, imaginatively titled Octopus (1912), as well as in some diagonally composed shots of New York skyscrapers and details of Liverpool Cathedral under construction (1919), he also anticipated the compositional principles of Constructivist photography. His role was therefore as ground-breaking in American photography as Rössler's was in European.

Rössler's photographs of light have most in common with some works by the American photographer Francis Joseph Bruguière.[27] As early as 1921 he made a set of abstract photographs of light patterns using the "*Clavilux*," the color organ invented by the musician and poet Thomas Wilfred, with which one could, by playing keyboards, change the intensity, color, shape, and movement of projected light patterns on a white screen. Some of the photographs

from this cycle, consisting of light of various intensities and shapes on a black background, were published by Bruguière in the January 1922 issue of *Theatre Arts*. That, however, most likely never made it into Rössler's hands, and Rössler's similar light abstractions from 1923–25 were probably made completely independently of Bruguière's works, which were almost certainly not exhibited in Europe until they were shown in Der Sturm gallery, Berlin, in 1928, and at the legendary "Film und Foto" exhibition, Stuttgart, a year later. Parallels with Rössler's works appear in *Design in Abstract Forms of Light*, which Bruguière began to make in 1922 using multiple exposures of paper cut-outs placed over photographic paper, lighting them from various angles with a single lamp. Thus emerged his photographs of the play of light, reminiscent of photograms.

These pioneering works in abstract photography, like the photos of light coming out of the "*Color-organ*," which were made by Ludwig Hirschfeld-Mack in 1922–24 while a student of the Bauhaus,[28/] the unique early abstract photographs *Winter Landscape* (1909) by George H. Seeley,[29/] and *Shadows* by Alfred Cohn (c.1920),[30/] the elegant shots of projected light, made in 1921 by the American photographer Ira W. Martin,[31/] Dubreuil's works,[32/] as well as Purist shots of simple objects by Paul Outerbridge,[33/] Margaret Watkinson, and Bernard Shea Horne, were probably all – perhaps with the exception of some of Strand's works published in the photography journals that Drtikol subscribed to – unknown to Rössler. Undoubtedly, however, he must have seen at least some photograms by Man Ray and László Moholy-Nagy, which were first made in 1922. In particular, Man Ray's Rayographs from the album *Champs délicieux* were highly popular among Czech avant-garde artists. In late 1922 they appeared in the Prague anthology *Život II* [Life II] (which was probably the first time they were published outside France) and were also exhibited at the "*Modern Art Bazaar*" exhibition organized by the Devětsil artists' group in the Rudolfinum, Prague, in November 1923, on the model of the "*Dada-Messe*," Berlin. Even fewer people in Czechoslovakia were aware of the existence of the earlier photograms ("Schadographs") of Christian Schad, which had first been made in 1918.

Rössler did not devote himself to photograms until about 1925. Nevertheless, he was probably the first Czech to make them, and he also published them in the avant-garde journal *ReD*. With a camera, however, he had previously made photographs that tended toward the abstract. With an intentionally unfocused Tessar lens on a Mentor camera (which he bought in installments in 1923, having before that used mainly a borrowed 9 x 12 cm camera), 9 x 9 cm negatives, and long exposure times, he photographed light projected from moving spotlights onto a black background (*figs. 25, 26, and 27*). The result was emotionally charged, exceptionally effective photographs of blurry rings, lentil-shaped bodies, curves, and cones of light, which at times suggest some sort of primal matter or something imagined in a delirium. Rössler was thus among the first photographers to make light itself the center of interest, assigning it the leading role in the photograph. Light no longer served merely to create a mood as it once had in, say, Impressionist and Art Nouveau Pictorialism, but had now instead become the central motif. Together with Bruguière and Man Ray, Rössler undoubtedly played a pioneering role in this, because he developed Strand's photos of shadow and light from 1916 into a far more radical form, in which one can hardly tell anymore whether it is a photograph or a photogram. His novel photographs of light patterns, made in 1923–25, deserve a place in the history of photography right beside the photograms of Man Ray and Moholy-Nagy, which had been made a bit earlier, and beside the very similar blurry photographs of lights on the boulevard Edgar-Quinet, Paris, which Man Ray made in 1924 using a camera with a long exposure time, and published in the January 1925 issue of *La Révolution Surréaliste*. Here, Rössler has, by several years, anticipated the work of another Czech avant-garde photographer, Jaromír Funke. In his *Abstract Photographs* (or *Compositions*) from the second half of the 1920s, using a camera to photograph shadows, Funke tried to come up with an alternative to the Rayographs (made without a camera in the darkroom by capturing the outlines of various objects on photographic paper) that he, unlike Teige, considered a dead end.[34/] While Funke gradually worked his way to those abstract compositions by slowly eliminating the depicted kitchenware, bottles, and panes of glass, and substituting shadows for them, Rössler, probably as early as 1923, made the most radical photographs of light patterns in parallel with compositions of simple

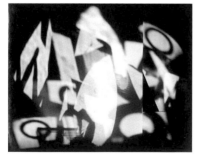

Jaromír Funke: Abstract Photograph (Composition III), 1927–29

objects. In most of these photos from 1923–25, he was satisfied to merge bright and soft light in various geometric shapes, but in the composition of at least two extant photographs he included the more concrete motif of a board with the numeral 2 (*fig. 28*). Typically, he appears to have been unable to decide on the most effective position or even a working title for one of the best photographs of this loosely conceived set, which has the motif of a hooked light pattern in the shape of a hooked corner and three interconnected lentil-shaped bodies (*fig. 26*). The only extant period print of it is signed on a different edge than the later copy and several sketches, in which the photograph is alternately called *Tessar* (named after the lens it was photographed with), then *Chauffer* (whose light pattern is vaguely reminiscent of a driver with his or her hand on the wheel), and then *Printing Room*, named after the part of Drtikol's studio, where it may have been made). Probably some of the abstract compositions could be varied by rotating them, and in his earlier works Rössler usually did not wish to inhibit the viewer's imagination by giving specific titles to the pieces.

In 1923–25, in parallel with these abstract photographs of shadow and light he made compositions with simple objects – a box, a candle, a coil, an ashtray, an inkwell, a lid, a wineglass – on a background made of white and black cardboard cut into expressive geometric shapes (*figs. 18, 19, 20, 21, 22, and 23*). Sometimes, too, the principal motif in the foreground was made only of a sheet of paper or a paper strip formed into an arch. In many photographs Rössler accentuated the contrast between the three-dimensional objects in the foreground and the flat-looking backgrounds. The backgrounds were now merely decorative, as for example in certain portraits of Gertruda Fischerová, but they usually played more important roles than the seemingly dominant objects. Rössler was eventually photographing only the background itself, and like Drtikol in his Symbolist photographs of cut-out little figures, which were made at least five or maybe even eight years later, Rössler was the sole author of both the objects photographed and the photographs themselves. He was a true design engineer. He was often content simply to capture flat patterns of white and black paper, but sometimes he also photographed shadows cast diagonally by cardboard fragments lit from the side (*figs. 33 and 36*). In the photograph *Abstraction*, dating from 1923, on the other hand, he used montages of two identical overlapping negatives. Some of these shots he used in his 1925 collages called *Photographs* (two of which, *Photograph I* and *Photograph IV*, are owned by the Museum of Decorative Arts, Prague; the others are probably now missing), which he glued on to large pieces of paper and added black strips of cut-out paper and expressive signatures (*figs. 29 and 30*). The result was early, highly effective examples of the inventive linking of avant-garde photography and typography, which Aleksandr Rodchenko, El Lissitzky, Gustav Klutsis, László Moholy-Nagy (whose *Malerei, Fotografie, Film* was published in the same year), Herbert Bayer, and Karel Teige, for example, had been promoting in their artwork and theoretical writings. *Photograph I*, moreover, is a photomontage of two photographs of geometrical cardboard cut-outs. It is a striking example of the multimedia nature of Rössler's work, which one does not encounter, say, in the work of Funke, who was oriented exclusively to photography. Rössler later made some of the final prints of these compositions using the bromoil technique. Quite possibly he was not even aware of the archaic nature of the technology, because he worked almost totally isolated from current avant-garde trends in photography.

Sometimes he also used a slightly out-of-focus shot in order to dematerialize depicted reality and to emphasize the autonomy of the photographed image, little concerned with the reality captured there. In his photographs of geometric shapes made from white and black pieces of paper he seemed to be visualizing Plato's *Theory of Forms*, which maintains that concealed behind the great many shapes in the world there are in fact elementary geometric shapes, which are also the building blocks of the cosmos. Many of Rössler's photographs exist in several variants with different compositions: for example, a candle in one is placed almost at the edge of the photograph (*fig. 18*), whereas in another it occupies the center of the composition.

A special place among Rössler's earliest photographs with minimal motifs is held by several variants of *Skylight* (*fig. 24*), which he made in the printing room of Drtikol's studio, probably in 1923. (Considering the 9 x 9 cm negatives, which Rössler began to work with that year, the earlier date, 1922, is probably incorrect.) In these photographs the nineteen-year-old photo-

grapher has advantageously wrenched the main motif free from its usual spatial context. By using the diagonal composition he has intensified the dynamism of the photograph, which is further emphasized by the diagonally hanging chain. With the resourceful addition of a black stripe in the right-hand part of one version he has changed the shape of the square skylight into a triangle. Shortly after making the Art-Nouveau-influenced portraits of Gertruda, Rössler made a work that was now clearly Constructivist, having stripped it of the symbolic and literary references of many of his preceding photographs. Although it was probably made a year later than is stated in the earlier literature, this is still a year before Aleksandr Rodchenko, the most important representative of Constructivist photography, began to take photographs.

We do not know for sure which photographs Teige had in mind when, in 1923, he wrote that Rössler was "better than Man Ray,"[35] but possibly they were the abstractive photographs of light patterns or elementary compositions with simple, static objects or white and black paper cut-outs. In a letter to Dufek written in March 1969 Rössler recalled his earliest meeting with Teige: "I first visited Teige in spring 1923, to ask his permission to take photographs at the Alexander Archipenko exhibition in the Rudolfinum. When Teige asked me whether I did art photography as well, I showed him several of my photographs, and he liked them. That was when he asked me to join Devětsil. After that, Teige published all my works in *Pásmo, Disk, Stavba*, and the publication *Stavba a báseň*."[36]

Devětsil, founded in Prague on 5 October 1920, eventually became the most important Czechoslovak avant-garde artists' association, bringing together mostly very young painters (including Josef Šíma, Toyen, Jindřich Štyrský, Adolf Hoffmeister, and Otakar Mrkvička), fiction writers and poets (Vladislav Vančura, who was the first chairman of Devětsil, Jaroslav Seifert, Vítězslav Nezval, František Halas, and Konstantin Biebl), architects (for example, Jaromír Krejcar, Bedřich Feuerstein, Jaroslav Fragner, Karel Honzík, Vít Obrtel, and Antonín Heythum), people involved in theatre (Jindřich Honzl and Jiří Voskovec), musicians (Miroslav Ponc), and theorists (Teige and Bedřich Václavek).[37]

Rössler, owing to his introverted nature, was unlike most other Devětsil members. He later recalled that he had been an utterly passive member, taking part in hardly any of the daily meetings in Prague cafés or the stormy debates: "There were no membership fees, so I joined. I went to about three meetings, but that wasn't for me."[38] Nor did he take part in the Devětsil exhibitions or even the "*Modern Art Bazaar.*" Much of his work was not made public until Teige put it into the third Devětsil exhibition, also in the Rudolfinum, in May 1926, where it was installed near works by Man Ray. Rössler's photographs, collages, and photograms appeared more frequently on the pages of avant-garde periodicals and volumes published by Devětsil, where they were usually published next to works by Moholy-Nagy, Man Ray, El Lissitzky, Paul Strand, and other artists of international renown. Teige, who became a sort of unofficial promoter and manager of Rössler, included most of Rössler's works without his knowledge. Although he undoubtedly respected his work, as is clear from the fact that he did not hesitate to publish Rössler's collages on *ReD* covers or to use fragments of Rössler's photographs in his own Surrealist photo-collages, Teige never wrote an extensive article about Rössler, nor did he try to promote him in the foreign journals with which he collaborated or at exhibitions he helped to organize.

And yet Teige, like many other Devětsil members, was greatly interested in photography as a medium of modern art. As early as 1922, in his essay "*Foto, kino, film*" (Photography, Cinema, Film), he expressed his enthusiasm for photography, even though it was a photography that, unlike Pictorialism (which was dying away), emphasized its own particular qualities: "The beauty of photography, as the beauty of a work of modern technology, is a consequence of its simple, utter perfection and conditioned by usefulness: the beauty of photography is of the same genus as the beauty of the airplane or the transatlantic liner or the electric bulb: it is the work of a machine and also of the labor of human hands, the human brain, and, if you like, the human heart as well."[39]

Admiration for modern technology united Rössler with other Devětsil members, who in their poems, articles, and collages enthused about the airplane, cinematography, photography, and radio. (Recall, for example, Seifert's collection of verse *Na vlnách TSF* [On the Waves of the Wireless] from 1925.) Many of Rössler's photographs from the period up to 1926 contain

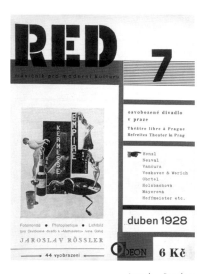

Jaroslav Rössler:
Photomontage for the Osvobozené divadlo
(Liberated Theater)
for the cover of the journal ReD, 1928

details of the radio. Rössler was fascinated with radio, and, from his youth to his old age, he assembled amateur radio sets. He took photographs of himself or Josef Sudek's friend Plaček (*fig. 43*) wearing headphones and with a ham-radio set in the background. In a photomontage of several negatives he made the compelling *Radio World* (*fig. 45*). He made a still life with the detail of a radio tube (*fig. 41*), and a number of descriptive photographs of his own radios. In collages from 1926 he included a view of a radio tower with the words "Marconi Radio" in creative lettering (*fig. 54*) and fragments of condensers (*fig. 53*). Although most of the photographs and collages with a radio theme were made in the first half of the 1920s, photographs of radio receivers and self-portraits with a radio appear among Rössler's later work too. The motifs of technological civilization, however, were not limited to radio. Rössler's minimalist compositions of exteriors, for example, contain fragments of insulators and telephone wires (*fig. 39*) and highly stylized details of isolated parts of the steel structure of the Petřín Hill observation tower in Prague, which are sometimes erroneously included among his later photographs of the Eiffel Tower (*figs. 37 and 38*). Apart from condensers and radio towers, airplanes, and skyscrapers (*Unlife*, 1926, *fig. 51*), his collages also include pictures of phonograph records and neon signs (as in the missing photomontage for Jindřich Honzl's production of Ivan Goll's *Mathusalem ou l'éternel bourgeois* in the Liberated Theater (Osvobozené divadlo), Prague; the photomontage is now known only from the cover of the April 1928 issue of *ReD*).

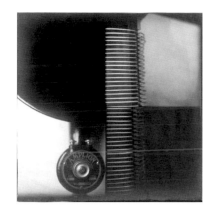

Jaroslav Rössler: Composition II, 1924

Although Rössler was the sole professional photographer in Devětsil, he was hardly the only one making photomontages and collages. Many other Devětsil members – for example Teige, Štyrský, Toyen, Heythum, Voskovec, and the Brno physician Evžen Markalous – also devoted themselves to "picture poems," the special collages that met Teige's requirement of a fusion of poetry and the visual arts, which he had set forth in the 1923 article "Malířství a poezie" (Painting and Poetry).[40] Picture poems, including Rössler's, are among the most distinctive expressions of Poetism, which was the first avant-garde style to have originated in Czechoslovakia.

In October 1924 Rössler finally exhibited his work for the first time in public. It was at the *19th Paris Photo Salon*, organized by the French Photographic Society. The jury accepted three of the four photographs he had submitted, and thus his work, together with nudes by Drtikol, a minimalist composition of shadow and light by Funke, and romantic shots of old Prague by Jaroslav Krupka, was the first to represent Czechoslovak photography at an international forum. The critic Robert M. Thomas praised Rössler's works in the *Revue française de Photographie*, and noted that the exhibited photographs from Czechoslovakia revealed a pronounced Cubist influence:

*Intersecting the transparent cylinder of a bottle with white and grey rhomboids of paper cards and balancing them out with the projection of their shadows, Jaromír Funke puts us in mind of the theory behind this trend. It is best expressed, I believe, in a beautiful portrait by Rössler: a face in an oval frame of shadow, which, at its black contact point, joins with curves describing a torso – nothing forced, an interpretation consciously Modernist, unexpected and logical, wise, and pleasing to the eye as well. Also by the same artist are Radio and Solitude, two daring attempts at a rare attractiveness, which, comprising a mixture of shadow and light – as well as ideas – constitute pure emotion: they radiate impressions of a silent intimacy, which cannot be expressed in words.*[41]

This success probably contributed to the fact that in late 1925 and early 1926 Rössler and Gertruda Fischerová left for Paris, which was in those years the center of modern art. Whereas Josef Šíma, Karel Teige, Jindřich Štyrský, Toyen, Adolf Hoffmeister and many other Czech artists had at the time set out for the French metropolis in search of contacts with avant-garde artists, the shy Rössler remained outside that group. Although the notebooks with his short screenplays, ideas for photo compositions, various technical notes and also, intermittently, impressions, dreams, and attempts at verse contain the Paris addresses (written in somebody else's hand) of Man Ray, André Kertész, Germaine Krull, Florence Henri, Maurice Tabard, and other famous photographers, Rössler probably never tried to get in touch with them.

This was probably because, apart from his shyness and introversion, he had so far an only rudimentary knowledge of French. At first he was therefore dependent on Gertruda, who

could speak the language. She also found him a job in the photo studio of the brothers Gaston and Lucien Manuel beginning in February 1926. In this large business, which apparently employed about sixty people, he was mainly to do retouching and affix the company signature onto photographs. The same year, another Czech, the photographer and painter Rudolf Schneider-Rohan,[42/] began there as a retoucher of prints, and he became one of Rössler's few friends. Schneider-Rohan went on to make portraits of Maurice Chevalier, Jean Cocteau, and a number of other celebrities, and is only now just beginning to be appreciated as an artist of what were for their time often daring male and female nudes. In the Manuel brothers' studio Rössler also befriended the business manager of the company, Lucien Lorelle,[43/] a modern-thinking photographer in his own right, whose Surrealistic photographs are now in important collections, for example in the Pompidou Center.

In Paris Rössler made not only inspired photographs for advertisements but also many photographs strictly for himself as well as several photomontages and collages. Like a number of other photographers, he too was drawn to the modern beauty of the Eiffel Tower, and photographed it in a variety of low-angle, diagonal compositions and also striking details of it (figs. 69, 70 and 71). Some of these photos he used also in his photomontages, where, for example, the motif of a spiral staircase appears together with a bird's-eye-view of the river Seine and Paris, the shot of a bridge, or fragments of signs on Parisian boulevards (figs. 66, 67, and 68). Rössler's photomontages and collages (which were sometimes made by enlarging details from several negatives in one print, using masks, or by pasting on pieces of cut-up photographs) are very similar to collages with the motif of the Eiffel Tower, which were made by another Devětsil member, Josef Hausenblas, and were published in the second volume of ReD. The photographs themselves share aspects with Moholy-Nagy's photographic details of a steel tower, Germaine Krull's photographs of the Eiffel Tower, and Rodchenko's Constructivist photos of the Moscow radio tower; there are also a number of similarities with details of iron structures by Charles Sheeler, Paul Strand, Margaret Bourke-White, Erich Comeriner, and Karl Hermann Haupt.

From Rössler's correspondence it is clear that he knew Moholy-Nagy's photograph of the Eiffel Tower, which was published in the December 1925 issue of Pásmo. In a letter to Gertruda, who was staying in Prague at the time, he wrote: "Pásmo. I have that Moholy-Nagy in my hands. It's a pity we won't be able to do this until we have space."[44/] In other works, however, the similarity is probably coincidental – after all, many of these works were not published until later; Rodchenko's photographs of the Moscow radio tower, for example, were not published until 1929;[45/] and the earliest similar photos of this kind, Coburn's photographs of steel structures in Liverpool Cathedral under Construction (1919), were, as we have seen, most likely unknown to Rössler. Several of Rössler's large photograms, which combine the outlines of various objects on photographic paper with prints from negatives, were made in Paris. At the invitation of the architect Jaromír Krejcar, a fellow Devětsil member, Rössler showed them at the 1926 exhibition mounted by the left-wing Rote Fahne association in Berlin. The unique photograms, however, were not returned to him, and remain missing to this day.

It was also during his Paris sojourn that Rössler made his first screenplays, writing the short pieces into his notebook. Other Devětsil members, including Vančura, Teige, Vítězslav Nezval, Jaroslav Seifert, Artuš Černík, and Jiří Voskovec, were writing similar screenplays at the time, following the example of the French avant-garde. Until recently, it was not even known that Rössler had made any. Aware of the commercial orientation of Czechoslovak cinematography at the time, these authors usually did not count on their films ever being made; instead, they considered their screenplays a kind of final product, which, like the picture poem, combined visual art with literature. Rössler's screenplays and fragments of screenplays are less literary and far more specific in their descriptions of visual effects and technical instructions than the screenplays of other Devětsil members. Considering he was a professional photographer, that is quite natural. In them, for example, Rössler envisages montages of two negatives as well as multiple exposures, reflections in mirrors, the striking movement of camera and lights, the sudden turning off and on of spotlights, expressive details. In one screenplay from 1926, for instance, he writes:

*Darkness – a spotlight, part of a column (of soldiers) – movement of light along the whole column – the whole column is lit up. The column makes a move; words appear above.*

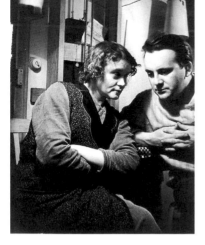
Gertruda and Jaroslav Rössler, Paris

*Diagonal lighting across the column – exit. Another column diagonally lit intersects them – first column reprinted. A printed photo against a black background. Action reprinted with a structure or printed from two negatives. (A positive printed from two negatives – perhaps by projection). Several identical figures printed in front of the background – various movements. Climbing up a ladder – into a white circle (perhaps a cut-out). – Action in the circle (perhaps a car drives through; cars, one after another, pass by). The cars become silent. They run into the distance – stop – run. The circle changes into a clock face – quick movement of the clock face – 12:10 (the clock stops) – a procession of people crosses. A head with a black blindfold. Perhaps printed into the black blindfold. Strips of tinfoil on the perforation – a relay automatically starts – musical instruments – blows – etc.[46/]*

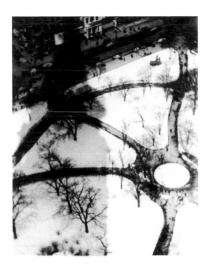

Alvin Langdon Coburn: Octopus, New York, 1912

It is not known whether these screenplays were intended for short commercial films he had been commissioned to make or for experimental films of his own, which he made or wanted to make. He was clearly interested in filmmaking, and appears in several family photos with a movie camera. In 1927 he even tried to sell an invention of his to Metro-Goldwyn-Mayer studios, Hollywood. The invention, which consisted of a system of mirrors, enabled several objects or scenes to be placed into a shot. But no deal was struck. I have so far been unable to find more information on Rössler's films, but there is a hope that, providing they were actually made, they may be deposited in some French film library. These would probably be the first avant-garde films made by a Czech – Alexandr Hackenschmied's *Aimless Walk* (Bezúčelná procházka), for example, was not made until 1930.

Rössler's original plans regarding life in Paris soon changed. Gertruda Fischerová, shortly after her arrival in France, realized she was pregnant. Rössler wanted to marry her in Paris and remain there for ever, but the two of them ultimately decided to return to Czechoslovakia. On 16 June 1926 he quit the Manuels' studio, and shortly afterward they left for Prague, where he and Gertruda were married on 24 July. On 7 September of that year their daughter Sylva was born. Not having an apartment of their own, they lived with Rössler's mother in her house in the Prague district of Vokovice. Gertruda gave up photography, and never took it up again, choosing instead to devote herself fully to her family. (Her career was unprolific; her surviving work, apart from the nudes for which Rössler sat as the model, dating from 1922, consists mainly of a photograph of dancers, much indebted stylistically to Drtikol.)

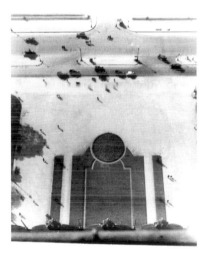

Jaroslav Rössler: View from the Eiffel Tower Paris, 1929

The return to Prague was not easy, because Rössler did not find a steady job. On the basis of Teige's recommendation to the journalist Milena Jesenská (a former love of Franz Kafka), Rössler began to work part-time for the new illustrated weekly *Pestrý týden*. The collaboration, however, was not particularly intense. In 1984, Stein, in collaboration with Rössler, identified a mere 37 of Rössler's photographs in 13 places in the first two volumes of the journal (1926 and 1927). Only one of the photographs, taken at the Christmas market in Prague, was genuine reportage; the others are of Paris, Liberated Theater productions, and, mainly, standard photographs of sundry goods.[47/] Photojournalism, in short, was not of great interest to Rössler, and where documentary shots do appear among his statically oriented works – for example, his photographs of the horse races in Paris from the early 1930s – they tend to be unexceptional. A number of his shots of Paris boulevards, cafés, and railroad stations were probably intended only as raw material for his photomontages, collages, and films (which were ultimately never made). The difficulties the young family faced in making ends meet at the time (and also who played first fiddle in the Rösslers' practical life) is revealed in a letter Gertruda sent to the avant-garde theater director Jindřich Honzl in January 1927:

*We are, Mr. Honzl, in a dire straits financially. We have a four-month-old child and if my husband is without work, we have to live on credit. Before Christmas my husband had work (with* Pestrý týden*), but since that time Mrs. Milena Jesenská has not given him any jobs at all. That was our sole source of income, and in her first letter Mrs. Jesenská wrote that it would be a steady job. It seems, however, that* Pestrý týden *continues to publish, yet needs nothing from Jaroslav. Please, Mr. Honzl, if you know how to approach the editor, Mrs. Jesenská, could you bring Jarka to her attention, so that she does not forget him? I think it matters to her as an editor. Moreover, before Christmas she always wrote. I have been promised a position beginning in March; if only my Jaroslav could get something at least until then. Please, Mr. Honzl, do not*

*let Jaroslav know I wrote to you. It would vex him, even though he himself can't negotiate at all, and I'm terribly distressed that nothing has yet come from* Pestrý týden.[48/]

Although Honzl probably was not very successful in his attempt to recommend Rössler to Jesenská, it was undoubtedly thanks to him that Rössler got a good deal more work with the Liberated Theater, which at that time was a semi-professional theater, established by Devětsil in February 1926. Here, Rössler did odd jobs and took photographs, particularly of Honzl's Poetist productions, accentuating the metaphors of the stage. The repertoire included Czech productions of Apollinaire's *Les Mamelles de Tirésias* (*fig. 62*), Adolf Hoffmeister's *Nevěsta* (The Bride), Goll's *Mathusalem* and Vančura's *Učitel a žák* (Teacher and Pupil). But Rössler also photographed Voskovec's and Werich's renowned *Vest Pocket Revue*, which marked the beginning of his collaboration with this famous duo, as well as for some of Jiří Frejka's productions. For the Liberated Theater he also made two posters and the remarkable collage in the style of Poetist picture-poems for the production of *Mathusalem*. Rössler's well-crafted theater photographs (made on 9 x 9 cm glass plates) capture not only the playfulness and even extravagance of these productions but also the inventiveness of the avant-garde stage sets and costumes. They are mostly shots of the whole stage as seen from the first few rows and, less often, half-length shots of the actors. In comparison with Drtikol's theater photographs they are livelier, more immediate; in the context of Rössler's overall work, however, they are a rather insignificant episode.

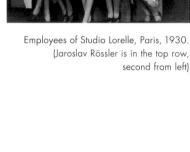

Employees of Studio Lorelle, Paris, 1930.
(Jaroslav Rössler is in the top row,
second from left)

In late 1927 Rössler received an offer (mediated by Schneider-Rohan) from Lucien Lorelle to come and work in the new three-story Studio Lorelle on the boulevard Berthier, Paris. In this period, the Rösslers were thinking about leaving for the United States, where Gertruda had an uncle, and so they accepted the offer, seeing Paris as a temporary stopover on the way to America. On 12 December 1927, Rössler began to work in Studio Lorelle, which primarily made photographic portraits, though it was also involved in advertising, postcards, and cinema. Rössler was concerned mainly with advertising and technical photography, as well as more demanding jobs in the laboratory; he was also an expert in airbrushing and lettering. Although his notebooks contain a number of other screenplays for short films as well as detailed technical notes, and although Studio Lorelle made films (as is clear from their own advertisements), no film by Rössler from this period has yet been found.

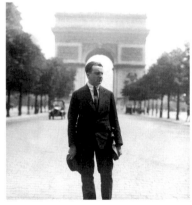

Rudolf Schneider-Rohan: Jaroslav Rössler
at the Arc de Triomphe, Paris, 1931  34

For various photographs he was commissioned to take, Rössler made sketches in his notebook and on slips of paper, and also recorded – alternating between Czech and French – the technical approaches to be taken. Despite his being an employee of Studio Lorelle and, later, Studio Piaz and Lucien Lorelle, and despite his not being freelance, he was still able to carve out sufficient creative space for his private work. Most of Rössler's photographs for advertisements contain static motifs; only now and then do models appear in them – for example, in an advertisement for toothpaste and an advertisement for perfumes (*figs. 94 and 95*). The face of the strikingly made-up model with a toothpaste-ad smile appeared not only in an advertisement for Acaciosa perfume, but also in one of the best-known of Rössler's photographs from 1931, where he used the photomontage of two negatives in a diagonally composed square portrait to join a photograph of several pieces of paper with a painted circle (*fig. 90*). Today it is unclear whether this montage was commissioned or was private work. Whatever the case, it has become an archetype of Czech avant-garde photography, and was used to promote the exhibition titled "*On the Art of Fixing a Shadow*" when it was remounted in Chicago in 1989 and also as the logo of "*Modern Beauty: Czech Avant-Garde Photography, 1918–48*," an exhibition held in Prague ten years later; it also appeared on the jacket of the first book solely about Rössler. Rössler was quite taken with the portrait of the model with the striking smile and big eyes, and used it for a number of photomontages: the collections of the J. Paul Getty Museum, Los Angeles (*fig. 91*), and Alex Novak (Vintage Works, Ltd.) in Chalfont (*fig. 93*) contain two variants of the montage of the whole face and a multiple detail of the eyes, whereas the collections of the Ubu Gallery, New York, include a photograph with a repeating pair of eyes, reminiscent of a similar work by the Austrian photographer Rudolf Koppitz from 1928.

In some photographs for advertisements and still lifes made in 1934–35, toward the end of his Paris sojourn, Rössler began to use the Carbro process of color photography. Invented

in 1919, it was a relatively complicated technique, in which photographs were made by assembling color prints from three separation negatives. The process was used, for example, by Paul Outerbridge and also the German photographer Willy Zielke. Some of Rössler's still lifes in color differ at first sight from the simple black-and-white compositions, owing to the great quantity of motifs they employ: one includes the detail of a table with a cup of coffee, a box of matches, a bottle of wine, a cigarette, and a newspaper (*fig. 129*); another has a little china bowl, a broken necklace, and handkerchief (*fig. 127*); yet another has a fish on a plate and several kinds of vegetable (*fig. 128*). It seems that Rössler was so fascinated by color that he neglected the composition, sometimes tending almost to a certain chaos, and they were for the most part considerably remote from the modernity of the composition of his black-and-white photographs. Here, too, it is difficult to distinguish a still life made strictly for himself from, on the other hand, a photograph commissioned for an advertisement.

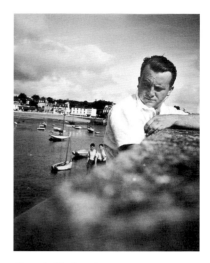

Gertruda Rösslerová: Jaroslav Rössler on holiday in Brittany, 1934

Of Rössler's private work from his second Paris sojourn, in 1927–35, far fewer Constructivist photographs and photomontages are preserved than from his first sojourn. It seems that his fascination with the Eiffel Tower had by this time somewhat waned, and yet it was now, for example, that he made the diagonally composed low-angle shot of part of the steel construction of the Eiffel Tower or a juxtaposition of the Eiffel Tower and traffic lights. In his private work Rössler returned to minimalist details of various technical objects, including the wheel of a locomotive (*fig. 78*), abstractive compositions of light (*fig. 88*), photograms (the Robert Koch Gallery, San Francisco, owns several Rössler's photograms from the late 1920s and early 1930s with the motifs of hands, matches, paperclips, and bits of film and paper – *figs. 81 and 82*; the Museum of Decorative Arts, Prague, owns a photogram with the outline of matches and cigarettes and smoke – *fig. 83*), as well as portraits of himself, his wife, and daughter. It is likely, however, that he had made many other photographs purely for himself, which got lost together with the negatives during his hasty departure from France in the summer of 1935.

In Paris, Rössler, who had been using a Mentor camera, bought himself a Foth Derby with a direct-vision viewfinder. He used this handier instrument mainly to photograph the streets of Paris or people watching the horse races at the Hippodrome de Longchamp. The many photographs of motorcars on the Champs-Élysées, people in cafés, and his daughter drawing at home he continued to make using 9 x 9 cm glass plates. Rössler always preferred static motifs, tending to be a design engineer and experimenter rather than a hunter of special moments. In this respect, attempts by some interpreters of Rössler's oeuvre to reserve a place for him as a pioneer in the development of live photography or to compare him with Henri Cartier-Bresson seem untenable.[49]

Jaroslav Rössler: Horse Races (Hippodrome de Longchamp), 1931–32

Throughout their second Paris sojourn Gertruda Rösslerová was a housewife and worked only occasionally to earn some extra money by retouching negatives from studios where her husband was employed. The Rösslers lived at 83, rue de Villiers in Levallois-Perret, a district on the northwest edge of Paris. They were in touch with hardly anybody, though they could have used Teige's many contacts with the French avant-garde. In Paris, Rössler apparently met only once with Josef Šíma, whose paintings would later influence some of his drawings. He did not seriously keep track of the contemporary arts scene, and apparently went only once to the theater and twice to the Louvre in almost eight years. One small diversion from his quiet life was a summer holiday in Brittany with his wife and daughter.

In this period Rössler did not correspond with Teige either. When, in 1929, Teige put together a Czech collection for the legendary "*Film und Foto*" exhibition in Stuttgart, Rössler's photographs were not included. Consequently, works of two of the most important Czech avant-garde photographers of the 1920s were missing from the most important show of modern photography at the time because Teige had lost touch with Rössler and had not yet made contact with Funke. Surely the inclusion of Rössler and Funke's photographs in the Stuttgart exhibition, which was extensively reviewed and commented on in many countries, would have contributed to their earlier international recognition because these were pieces that could hold their own in competition with the far more famous works of artists such as Rodchenko, Moholy-Nagy, Albert Renger-Patzsch, Edward Weston, Man Ray, Germaine Krull, and André Kertész. Fortunately, Rössler was not overlooked for the "*New Photography*" exhibition, which Hackenschmied and friends, under the influence of the Stuttgart show, organized in the

Aventinum Garret, Prague, in the spring of 1930. Rössler's works, probably lent by Teige, appeared at this first group exhibition of Czech avant-garde photographers in Prague, together with the work of Jaromír Funke, Eugen Wiškovský, Jiří Lehovec, Ladislav Emil Berka, and Josef Sudek, as well as a number of scientific and technical photographs. At the next such exhibition, in January 1931, Rössler's work was not included.

The Rösslers now wanted to settle permanently in Paris, but in summer 1935 something happened that radically changed their lives. On 18 July Rössler was accompanying his wife, her two sisters (who were visiting), and his daughter Sylva to the station to catch the train back to Prague. On the way home he came across a demonstration of civil servants on the Grands Boulevards and began to photograph it, but was detained by the police and taken to the police station. There seems to be no precise information about what happened next. The claim that he was imprisoned for six months can be discounted,[50] for it is most likely he spent only one night in prison, but even that was a great shock to him. What is most puzzling, however, is the reason for his arrest and deportation. In 1963 Rössler wrote in a letter to Dufek that he was deported for his having been a member of the influential but short-lived Ciné-Club les Amis de Spartacus, a Communist cinema association,[51] and Martin Stein recorded Rössler's recollection that a policeman had accused him of being a German who was sending pictures of a Paris demonstration home to the Reich.[52] Whatever the case, it is surprising that that should have been sufficient reason for democratic France to deport a citizen of its ally Czechoslovakia, particularly as it was only shortly before Rössler was due to be granted French citizenship. Sylva Vítová recalls that this was a taboo topic at home. Only later did she learn from her aunts that her father had attempted suicide following his arrest.[53] For a long time afterward he sent no news of himself even to his wife, who, upon her return to Paris, found the apartment empty, and began to search for Rössler by taking out classified ads in the newspapers. She finally tracked him down in a Strasbourg hospital. On 9 September 1935, the Czechoslovak consul in Strasbourg wrote to Gertruda Rösslerová:

*In reply to your letter I wish to inform you that today an officer of the consulate personally handed Jaroslav Rössler the letter, and he read it with utter indifference. The officer asked Mr. Rössler to write to you immediately, which he promised to do. When asked whether his family could visit him, the doctor treating him answered "yes" but said Mr. Jaroslav Rössler could leave the clinic only in the company of a senior nurse. The consulate wishes to bring it to your attention that you yourself are responsible for all expenditures relating to the transport of your husband.*[54]

With the help of her mother-in-law, Gertruda took him back to Prague. The extent of Rössler's shock from the whole affair is evident from a letter Gertruda wrote in French to the Lorelles, dated 9 November 1935: "My husband now goes out, but only in the evening when everything is closed and the streets are empty. He is still afraid of people. … He is doing a bit of photography and beginning to work in color, which is a good sign."[55] At about the same time, she also wrote to the theatre director Honzl: "I am turning to you with a request. If there's anything you can do anything for my husband, please find him work. We returned on 11 September after eight years in Paris. Since that time my husband hardly ever leaves the house, and has become a complete loner and melancholic."[56]

Back in Prague, the family lived at the home of Rössler's mother before moving in with his brother at Poděbradova street (now Koněvova) in the Žižkov district of Prague. Rössler opened a small photography studio in the same building in 1936, where he made mainly conventional portraits, as well as processing film and printing pictures for amateurs; his wife helped him to mix the chemicals and do the photofinishing. He occasionally also devoted himself to photographs for advertisements, for example, color photos for Foma photographic supplies, made using Carbro material he had ordered from Autotype, London. He spent even less time on his private work. Only several important works from the first two decades following the Rösslers' return to Czechoslovakia are known to exist, and they are in the collections of the Museum of Decorative Arts, Prague, the J. Paul Getty Museum, Los Angeles, and of Sylva Vítová: a simple composition with an apple (1938), reminiscent of Sudek's still lifes (*fig. 106*), a photomontage of an evening scene of the avenue de Wagram, Paris, taken in 1927, combined with a later portrait of his daughter Sylva, dating from 1947 (*fig. 108*), the abstract *Optical Study* also

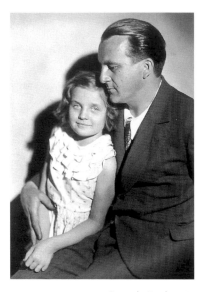

Gertruda Rösslerová:
Jaroslav Rössler with daughter Sylva, 1935

from 1947, which develops ideas used in similar works from the first half of the 1920s (*fig.107*), several portraits, and photomontages of fragments from earlier photos taken in Paris, which were done in the bromoil technique. Thus, it seems, Rössler's most important creative period came to an end, the period in which he made work that belongs to the apex of Czech avant-garde photography.

NOTES

1/ Some important works by Rössler are included in the collections of Anna Fárová, Prague, Manfred Heiting, Amsterdam (in 2002, a fundamental part of his collection, including Rössler's photographs, became the property of the Museum of Fine Arts, Houston), Galerie Kicken, Berlin, Marjorie and Leonard Vernon, Los Angeles, Thomas Walther, Berlin and New York (part of his collection was purchased by the Museum of Modern Art, New York), the Robert Koch Gallery, San Francisco, and Dorothy and Eugene Prakapas, New York. The largest set of Rössler's negatives and photographs from the 1950s to the 1970s is owned by Sylva and Jaroslav Vít, the daughter and son-in-law of Jaroslav Rössler.

2/ Martin Stein, "Jaroslav Rössler," M.A. diss., Film and Television Faculty, Academy of Performing Arts (FAMU), Prague, 1984, p. 9.

3/ See, for example, Anna Fárová and Manfred Heiting, *František Drtikol: Photograph des Art Deco* (Munich: Schirmer/Mosel, 1986); Vladimír Birgus and Antonín Brány, *František Drtikol* (Prague: Odeon, 1988); Kateřina Klaricová, *František Drtikol* (Prague: Panorama, 1989); Vladimír Birgus, *Fotograf František Drtikol* (Prague: Prostor, 1994); Vladimír Birgus, *František Drtikol: Modernist Nudes* (San Francisco: Robert Koch, 1997); Jan Mlčoch, *František Drtikol: Fotografie z let 1901–1914 a album Z dvorů a dvorečků staré Prahy/ Photographs from the Period Between 1901–1914 and the Album from Large and Little Courtyards of Old Prague* (Prague: Museum of Decorative Arts and KANT, 1998); Stanislav Doležal, Anna Fárová, and Petr Nedoma, *František Drtikol – fotograf, malíř, mystik / Photographer, Painter, Mystic* (Prague: Galerie Rudolfinum, 1998); Vladimír Birgus, *Photographer František Drtikol* (Prague: KANT, 2000).

4/ Antonín Dufek, "Vladimír Jindřich Bufka," *Československá fotografie*, 1977, no. 3; Monika Faber and Josef Kroutvor, *Fotografie der Moderne in Prag 1900–1925* (Schaffhausen: Edition Stemmle, 1991); Pavel Scheufler, *Galerie c. k. fotografů* (Prague: Grada Publishing, 2001).

5/ See, for example, Jaroslav Anděl and Anne Wilkes Tucker (eds.), *Czech Modernism 1900–1945* (Houston: The Museum of Fine Arts, 1989); Jaroslav Anděl and Emmanuel Starcky (eds.), *Prague 1900–1938. Capitale secrète des avant-gardes*, Dijon: Musée des Beaux-Arts, 1997; Timothy O. Benson (ed.), *Central European Avant-Gardes: Exchange and Transformation, 1910–1930* (Los Angeles: Los Angeles County Museum of Art, and Cambridge: MIT Press, 2002).

6/ Stein, "Jaroslav Rössler."

7/ Drtikol's handwritten note to the catalogue for the exhibition of the Czech Amateur Photography Association, Prague, 1923. Drtikol Papers, Museum of Decorative Arts, Prague.

8/ František Drtikol, "Oči široce otevřené," *Listy o fotografii – Acta photographica universitatis silesianae opaviensis* (Opava), 1994, no. 1, p. 43.

9/ Vladimír Birgus and Jan Mlčoch, *Akt v české fotografii / The Nude in Czech Photography* (Prague: KANT, 2001), figs. 34 and 35.

10/ Petr Tausk, "Gertruda Rösslerová-Fischerová," *Revue Fotografie*, 1979, no. 2, pp. 74–75.

11/ Antonín Dufek, "Fotografie dvacátých let," in *Dějiny českého výtvarného umění (IV/2) 1890/1938* (Prague: Academia, 1998), p. 215.

12/ Stein, "Jaroslav Rössler," pp. 16–17.

13/ Antonín Dufek, *Czechoslovakian Photography – Jaromír Funke and Jaroslav Rössler* (London: The Photographers' Gallery, 1985).

14/ Stein, "Jaroslav Rössler," p. 18.

15/ Rössler's contribution to the development of abstract photography has received considerable attention, for example, in catalogues and other publications, which were not specialized in Czech photography; see, for example, Peter Weiermair, *Photographie als Kunst 1879–1979 / Kunst als Photographie 1949–1979* (Innsbruck: Allerheiligenpress, 1979); Renate Gruber and L. Fritz Gruber, *Das imaginäre Photo-Museum* (Cologne: DuMont, 1981); *Europa, Europa: Das Jahrhundert der Avantgarde in Mittel- und Osteuropa* (Bonn: Kunst- und Ausstellungshalle der Bundesrepublik Deutschland, 1994); Annick Lionel-Marie and Alain Sayag, *Collection de photographies du Musée National d'Art Moderne 1905–1948* (Paris: Centre Georges Pompidou, 1996); Michel Frizot (ed.), *A New History of Photography* (Cologne: Könemann, 1998); Thomas Kellein and Angela Lampe, *Abstrakte Fotografie* (Ostfildern-Ruit: Hatje Cantz, 2000); Timothy O. Benson (ed.), *Central European Avant-Gardes: Exchange and Transformation, 1910–1920* (London: Los Angeles County Museum of Art, and Cambridge: MIT Press, 2002), pp. 119–20; Gottfried Jäger (ed.), *The Art of Abstract Photography* (Stuttgart: Arnoldsche, 2002).

16/ For example, Petr Tausk, "Nad fotografickým dílem Jaroslava Rösslera," *Revue Fotografie*, 1979, no. 2, pp. 54–73; Josef Moucha, "Dýmy liany světelné: přezíraná abstrakce," *Ateliér*, 2001, no. 8, p. 1.

17/ Alvin Langdon Coburn, "Die Zukunft der bildmässigen Fotografie," in Wolfgang Kemp (ed.), *Theorie der Fotografie II – 1912–1945* (Munich: Schirmer/Mosel, 1979), p. 55.

18/ "*Abstrakte Fotografie*," Kunsthalle, Bielefeld, 3 December 2000–18 February 2001. Catalog by Thomas Kellein and Angela Lampe, *Abstrakte Fotografie* (Ostfildern-Ruit: Hatje Cantz, 2000).

19/ The main papers from the conference were published in Gottfried Jäger (ed.), *Die Kunst der Abstrakten Fotografie/ The Art of Abstract Photography* (Stuttgart: Arnoldsche, 2002).

20/ Rolf K. Krauss, "The Spiritual in Photography, or: The Photographic Path to Abstraction," in Gottfried Jäger (ed.), *Die Kunst der Abstrakten Fotografie / The Art of Abstract Photography* (Stuttgart: Arnoldsche, 2002), pp. 106–7.

21/ Erwin Quedenfeldt, "Die abstrakte Lichtbildkunst": Photographische Korrespondenz, 1927, pp. 321–24, 337–40, and 368–74.

22/ Elke and Herbert Müller, *Erwin Quedenfeldt 1869–1948* (Essen: Museum Folkwang, 1985), p. 8.

23/ Krauss, "The Spiritual in Photography, or: The Photographic Path to Abstraction," in *Die Kunst der Abstrakten Fotografie*, ed. Gottfried Jäger, p. 115.

24/ Maria Morris Hambourg, *Paul Strand, Circa 1916* (New York: The Metropolitan Museum of Art and Harry N. Abrams, 1998), pp. 33–35.

25/ Mike Weaver, *Alvin Langdon Coburn: Symbolist Photographer* (New York: Aperture, 1986), pp. 64–74; Nancy Newhall, "Alvin Langdon Coburn: The Youngest Star," in *Alvin Langdon Coburn: Photographs 1900-1924*, ed. Karl Steinorth (Zurich: Edition Stemmle, 1998), pp. 41–43; Reinhold Mißelbeck, "Alvin Langdon Coburn's Vorticist Experiments," ibid., pp. 177–79.

26/ Alvin Langdon Coburn, *Alvin Langdon Coburn, Photographer: An Autobiography*, ed. Helmut and Alison Gernsheim (London: Faber & Faber, 1966), p. 102.

27/ James Enyeart, *Bruguière, His Photographs and His Life* (New York: Alfred Knopf, 1977).

28/ Krauss, "The Spiritual in Photography, or: The Photographic Path to Abstraction," in *Die Kunst der Abstrakten Fotografie / The Art of Abstract Photography*, ed. Gottfried Jäger (Stuttgart: Arnoldsche, 2002), p. 111.

29/ Kellein and Lampe, *Abstrakte Fotografie*, p. 32.

30/ Keith F. Davis, *An American Century of Photography*: The Hallmark Photographic Collection (New York: Harry N. Abrams, 1995), p. 92.

31/ Ibid., p. 108.

32/ *Pierre Dubreuil: Photographies 1896–1935* (Paris: Centre Georges Pompidou, 1987).

33/ Graham Howe and Jacqueline Markham, *Paul Outerbridge Jr.: Photographien 1921–1939* (Munich: Schirmer/Mosel, 1981).

34/ Antonín Dufek, *Jaromír Funke – průkopník fotografické avantgardy. / Jaromír Funke: Pioneering Avant-Garde Photography* (Brno: Moravská galerie, 1996).

35/ Stein, "*Jaroslav Rössler*," p. 19.

36/ Letter from Jaroslav Rössler to Antonín Dufek, 6 March 1969. Copy in the personal archives of Sylva and Jaroslav Vít.

37/ Šmejkal (ed.), *Devětsil: Česká výtvarná avantgarda dvacátých let* (Brno: Dům umění města Brna and Galerie hlavního města Prahy, 1986); František Šmejkal and Rostislav Švacha (eds.), *Devětsil: Czech Avant-garde Art, Architecture and Design of the 1920s and 1930s* (Oxford: Museum of Modern Art and Design Museum, 1990).

38/ Stein, "*Jaroslav Rössler*," p. 19.

39/ Karel Teige, "Foto, kino, film," *Život II*, Prague, 1922, p. 156.

40/ Karel Teige, "Malířství a fotografie," *Disk*, 1923, no. 1.

41/ Quoted from Robert M. Thomas, "O české fotografii na XIX. Pařížském salonu fotografickém," *Rozhledy fotografa amatéra*, 1924, no. 11, p. 157, a Czech translation of the French article.

42/ Vladimír Birgus and Jan Mlčoch, *Akt v české fotografii / The Nude in Czech Photography* (Prague: KANT, 2001), figs. 54–57.

43/ *Lucien Lorelle*, Paris: Galerie Bouqueret & Lebon, 1992; Annick Lionel-Marie and Alain Sayag, *Collection de photographies du Musée National d'Art Moderne 1905–1948* (Paris: Centre Georges Pompidou, 1996), pp. 274–77.

44/ Letter from Jaroslav Rössler to Gertruda Fischerová, 6 February 1926, personal archives of Sylva and Jaroslav Vít, Prague.

45/ The photoreportage by Rodchenko about the radio center and radio tower in Moscow was published in *Radioslushatel*, 1929, no. 41.

46/ Rössler's notebook is in the personal archives of Sylva and Jaroslav Vít, Prague.

47/ Stein, "*Jaroslav Rössler*," p. 24.

48/ Letter from Gertruda Rösslerová to Jindřich Honzl, Honzl family archive. I thank Matthew S. Witkovsky for pointing this out to me.

49/ Tausk, "Nad fotografickým dílem Jaroslava Rösslera," *Revue Fotografie*, 1979, no. 2, p. 55.

50/ Daniela Mrázková, Příběh fotografie, Prague: Mladá fronta, 1985, p. 93; Daniela Mrázková and Vladimír Remeš, *Cesty československé fotografie* (Prague: Mladá fronta, 1989), p. 69.

51/ Draft letter from Rössler to Antonín Dufek, dated 6 March 1969, personal archives of Sylva and Jaroslav Vít, Prague.

52/ Stein, "*Jaroslav Rössler*," p. 35.

53/ An interview by the author with Sylva Vítová, 14 January 2001.

54/ The letter is deposited in the private archives of Sylva and Jaroslav Vít, Prague.

55/ Ibid.

56/ Letter from Gertruda Rösslerová to Jindřich Honzl, Honzl family archive. Again, I express my gratitude to Matthew Witkovsky for bringing this to my attention.

# Photographs for Advertisements

JAN MLČOCH

The advertising photography of Jaroslav Rössler from the 1920s and 1930s constitutes an essential part of his artistic legacy. Many of these pieces have, right to the present day, retained the freshness of the photographer's autonomous works, and most interpreters of his photographic oeuvre have devoted attention to them.[1] As a relatively large collection of Rössler's work for advertising has been preserved (several dozen pieces are in the Museum of Decorative Arts, Prague; others are dispersed throughout the world), one may attempt to categorize them from the point of view of time, development, and technique.

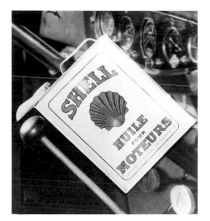

Jaroslav Rössler:
Advertising photo, 1932

Rössler gained his first experience of advertising photography indirectly during his apprenticeship with František Drtikol,[2] who, in the early 1920s, devoted himself to, among other things, fashion photography, and published his photos mainly in the society magazines that were just then starting up. Unlike Drtikol, Rössler was burdened neither by an Art Nouveau past nor by the need to defend his own studio work. He made studies chiefly for himself. He was surely acquainted with articles on advertising and the connection between photography and print copy, such as László Moholy-Nagy's "Typophoto," which was published in Czech translation in the second volume of the journal *Pásmo*.

Rössler's real commissioned work in advertising probably began during his first Paris sojourn. From Christmas 1925 to spring 1926 he was employed in the reputable studio of the Manuel brothers. Apart from working in calligraphy he gradually established himself in the bromoil-print department. The bromoil technique, one of the pigment processes used for making more exacting photographs, was familiar to him from his work in Prague, which he did both for customers and strictly for himself. It was in this department that he became acquainted with Lucien Lorelle, his future employer, and Rudolf Schneider-Rohan, a colleague from Pilsen, both of whom would later be among his closest friends. His work in the demanding field of advertising photography did not, however, begin quite yet. In 1926, Rössler and Gertruda Fischerová returned to Prague, got married, and started a family.

In the Prague interim he worked with the hugely popular, leftist Osvobozené divadlo and with the new periodical *Pestrý týden*, to which he contributed various reportage photographs. This was the period in which he made the poster for the "Second Exhibition of Photographic Pictures by the Czech Amateur Photography Association" (II. výstava fotografických obrazů Českého svazu klubů fotografů amatérů), which was mounted in late 1926 and early 1927. In the poster, which shows a large detail of a camera, Rössler was also able to apply his work with lettering and color.

Jaroslav Rössler:
Advertisement for the Printemps
Department Store, 1929

He returned to his long-desired Paris in late 1927, and found new employment. He did so with the help of Schneider-Rohan, and his employer became Lorelle, who, owing to the financial support of another partner, went independent at this time. Apart from portrait work, the Studio Lorelle was also involved in advertising, industrial photography, and, later, fashion photography.[3]

In the area of advertising photography Rössler could draw on his experience with Drtikol and on his own works made in the productive milieu of Prague, where he had been in touch with Karel Teige. The Devětsil group, which Rössler was also a member of, promoted ideas about a new perception of "all the beauties of the world" (a phrase that later became the title of the former Devětsil member and future Nobel Prize winner Jaroslav Seifert's memoirs). Industrial objects, which people working in "art photography" had previously not considered photogenic, became the center of the young artist's interest.

The people who came to the studio to have their portraits done were mainly actors and artists. Rössler was responsible for the demanding task of processing the photographs in the laboratory and also worked as second photographer (Rudolf Schneider-Rohan was the main photographer). In his work for advertisements Rössler used the most demanding techniques of avant-garde photography – the photogram, the large detail, the montage of several negatives, photomontage, the inclusion of lettering in the composition, and airbrush work on the back-

ground. On the basis of written testimony and the extant photographs we can see that he achieved outstanding results with all these approaches.

Rössler's photographic work for the Au Printemps department store in Paris dates from 1928. Here he made technically complicated compositions and used a wide range of photographic techniques: a photomontage of a park with columns together with an elegant fox-fur stole and a twig with falling leaves. This is completed with Rössler's characteristic "typomontage."[4] Similarly, in a photograph advertising a Bakelite switch (fig. 99), he made a montage of several negatives using a mask. The forerunners of these advertisements were the excellent Constructivist photomontages of several negatives with an Eiffel Tower theme (figs. 66, 67, and 68) and the banks of the river Seine (fig. 64), which had been made during the artist's first Paris sojourn in 1926. Teige later wrote about this approach: "Photomontage is a simultaneous optical synthesis on a surface."[5] What is important here is the possibility of linking together parts of pictures and combining them in surprising variations of content and composition, without restraint. The artist thus becomes the constructor of a new visual reality, whose use in advertising moves toward emphasis and emotional impact. Teige set forth the basic precondition: "The photographs we wish to use for photomontage must above all have a precise mutual relationship, and their grouping together graphically must result in a logically organized movement."[6] Rössler used a similar approach in his photomontage of a negative of a phonograph record and a negative of a little sculpture of a dancer. In the extant copy, however, the final title has not been printed into the center. In his advertisement for Shell he also chose a dynamic composition, using a montage of shots of automobile interiors and a can of motor oil. His approach was similar in advertisements for cosmetics, which are now in the collections of the Museum of Decorative Arts, Prague, and the J. Paul Getty Museum, Los Angeles (fig. 95 and 96).

A live model was used in a 1930 advertisement for Acaciosa perfume: a girl's face appears in the background behind a scent bottle and its reflection (fig. 94). She is probably the same model Rössler used a year later for what is perhaps his most frequently published photograph (Untitled, fig. 90). The face, which lacks any distinctive features, is more an indefinite mask of a pale face with expressively made-up eyes and lips. A similar type appears, for example, in the paintings and drawings of Toyen. A somewhat less puppetlike girl's figure in a negligee was inserted in a more intricately composed advertisement for Lux soap, which dates from 1931 (fig. 98). In that year, Rössler also made a photograph for an advertisement that consists of a home interior with a stone fireplace and a seated man and woman holding a book.

His series for the Gibbs cosmetics company was made in 1931–32. Here he has drawn on experience from his period with Drtikol, in particular the way in which the works are composed, with the essential role played by the dividing-up of light and dark fields and also the compositional planes. In the extant photos, the bird's-eye view predominates, and the diagonal composition is frequently used. Several times Rössler also used the montage of more than one negative, including the shot of a girl's face. Typical of these photographs, as of many of his other works, is the expressive, almost graphic division of fields of light and the technique of double exposure.

In the early 1930s Lorelle's partner sold his own share in the business and, in accordance with the wishes of the new, probably financially stronger owner, the company was renamed Studio Piaz. Nevertheless, Lorelle held his position, and Rössler was also largely unaffected. Among the many large companies for which Studio Piaz worked were Michelin rubber, Bernard Grasset publishers, Palmolive cosmetics, and Bayer pharmaceuticals. In his notes Rössler mentions Citroën cars as well.

The work for Gibbs (in the collections of the Kicken Gallery, Berlin, and the Museum of Decorative Arts, Prague) is highly refined, already heading toward Functionalism, and sometimes Rössler used a transparent glass plate as a base. These works were anticipated by the 1930 photograph Files (Pilníky) and an advertisement for Monsavo soap, which, with detailed shots of textures, also reveal the influence of the New Objectivity. The photograph Collars (Límce) is similarly expressive, but was made using a double exposure of a negative turned around 180 degrees (fig. 100). The principle of symmetrical composition was also

Studio Piaz, Paris, 1930s

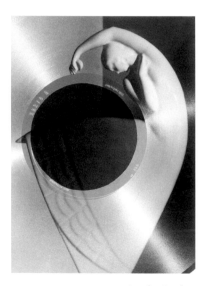

Jaroslav Rössler:
Advertising photo, 1932

used a year later for the photograph of a boat on the river Seine. Much later, in the 1950s and 1960s, symmetrical pictures became a key theme in works Rössler was making strictly for himself.

After leaving Studio Piaz, he worked briefly, in late 1934, with his original Paris employers, the Manuel brothers, and again with Lorelle, now in an independent company. In the studio in 1934–35, a new photographic technology was being experimented with, employing natural colors – it was the Carbro system, developed by the London-based Autotype Company (figs. 127, 128, and 129).

Even after his forced return to Prague, Rössler worked with the Carbro system in late 1935. This is evident in the composition of an advertisement for Foma, a Czech photographic-supplies company. The theme of color reappears often in his work in the 1960s and 1970s, when, using colored gels, he drew on his earlier experience of working with the Carbro system.

Czech advertising photography has been only partially considered by academics.[7/] In Czechoslovakia between the two world wars, it was systematically studied by the photographer Bohumil Šťastný (a member of the editorial board of Pestrý týden), and, from 1926, also by Josef Sudek (for the Družstevní práce publishing house), as well as by a number of occasional photographers. Two books, Fotografie v reklamě a Neubertův hlubotisk [Photography in advertising and Neubert's photogravure], with photographs by, among others, Alexandr Hackenschmied, Josef Sudek, Bohumil Šťastný, Jaromír Funke, and Karel Hájek,[8/] and Zdeněk Rossmann's Písmo a fotografie v reklamě [Lettering and photography in advertising][9/] provide a a basic overview of work in this field at the time. Two other Czechoslovaks, the Bauhaus graduate Jindřich (Heinrich) Koch and the Bohemian German Grete Popper, also did important work in this field. Advertising and technical photography was, moreover, taught at several art schools in Prague, Brno, and Bratislava. The influential publication Fotografie vidí povrch [Photography sees the surface] was coauthored by three highly respected professionals from different fields: graphic designer Ladislav Sutnar, the photographer Jaromír Funke, and the art historian V. V. Štech.[10/]

In Paris, of course, Rössler was able to compare his work mainly with the local competition. Two artists in particular are worth recalling, both of whom were connected with interwar Czechoslovakia. Both – like Rössler – chose the French metropolis as the place they wanted to work, but they had better luck than he had: both were able to remain there, working as artists and integrating into Paris society. The first was František Kolár (later called François Kollar), a Slovak who had come to Paris in 1924, and excelled in fashion photography, working with, among others, the editors of Harper's Bazaar. He also established himself as an artist of high-quality photographs for advertisements, winning the Grand Prix at several exhibitions.[11/] No evidence exists of his having met Rössler. The story of the other photographer was different: Schneider-Rohan had come to Paris a bit before Rössler, though also in 1925. Their working together for the Manuel brothers and, later, for Lorelle turned into a friendship that continued even after Schneider-Rohan established his own company, Studio Rudolph, in 1931. Only recently has the inventive artist Rudolf Schneider-Rohan and his work (oriented to the portrait, the male nude, dance and advertising) received the acknowledgement or publicity they deserve.[12/]

The nature of the advertising work that Rössler devoted himself to in the 1920s and 1930s was shaped by the milieu and aesthetic in which it was done. When judging this, one cannot overlook the fact that the themes of the advertising photographs were assigned to Rössler; he was working as an employee, not as a free creative artist. Nor was it customary in the press of those days for his name to appear below an advertisement; the name of the company was the signature. Rössler later authorized some of the photographs that had survived, and provided them with a date and information about where they had been made. Although commissions, they did provide him with an opportunity to develop numerous variations, which met with a response only after he had returned to making photographs strictly for himself about twenty years later.[13/] It was there that he again applied the broad range of photographic techniques used by the avant-garde between the two world wars – sometimes in a form that had now become traditional, but more often enhanced with new technology and approaches.

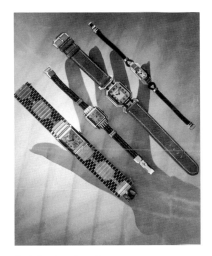

Rudolf Schneider-Rohan:
Advertising photo, 1930s

His work in advertising in the years before World War II was an important starting point for Rössler's modernized oeuvre of the 1950s and 1960s, when he again developed an unmistakable, individual photographic style.

NOTES

1/ Anna Fárová, "Výtvarný, reklamní i divadelní fotograf a grafik Jaroslav Rössler," *Československá fotografie*, 1972, no. 2, pp. 34–37; Martin Stein, "Jaroslav Rössler," M.A. diss., Prague: Academy of Performing Arts (FAMU), 1984; Vladimír Birgus, *Jaroslav Rössler* (Prague: TORST, 2001).

2/ Vladimír Birgus, *The Photographer František Drtikol* (Prague: KANT, 2000).

3/ Annick Lionel-Marie and Alain Sayag, *Collection de photographies du Musée National d'Art Moderne 1905–1948* (Paris: Centre Georges Pompidou, 1996), pp. 274–77.

4/ The department-store advertisement, however, is far removed from the proclaimed proletarian simplicity of Devětsil; elegant Paris dominates entirely here. Man Ray, American-born but working in Paris, was similarly "conformist" in the aesthetics of some of his later commissioned work. Apart from their strictly geometric compositions, a number of Rössler's other works for advertisements also use this elegant, nearly Art Deco line.

5/ Karel Teige, "O fotomontáži," *Žijeme*, 1932, nos. 3–4, pp. 107–22.

6/ Zdeněk Rossmann, *Písmo a fotografie v reklamě* (Olomouc: Index, 1938), p. 18.

7/ See *Česká fotografie 1918–1938*, the catalogue of an exhibition from the collections of the Moravian Gallery, Brno, with an article on advertising photography by Antonín Dufek, Brno, 1981; Jaroslav Anděl (ed.), *Czech Modernism 1900–1945* (Houston: The Museum of Fine Arts, 1989), with an article on advertising photography by Willis Hartshorn; and Vladimír Birgus (ed.), *Czech Photographic Avant-Garde 1918–1948* (Cambridge: MIT Press, 2002), with an article on advertising photography by Jan Mlčoch.

8/ Miloš Bloch and Vilém Ambrosi, *Fotografie v reklamě a Neubertův hlubotisk* (Prague: Neubert, 1933).

9/ Zdeněk Rossmann, *Písmo a fotografie v reklamě* (Olomouc: Index, 1938).

10/ Ladislav Sutnar and Jaromír Funke, *Fotografie vidí povrch* (Prague: Státní grafická škola and Družstevní práce, 1935).

11/ Ľubomír Stacho, *František Kollár* (Martin (Slovakia): Osveta, 1989); Patrick Roegiers and Dominique Baqué, *François Kollar* (Paris: Ministère de la Culture, A.F.D.P.P. & Philippe Sers, 1989); and Françoise Denoyelle, *François Kollar: Le choix de l'esthétique* (Lyons: La Manufacture, 1995).

12/ The work of Rudolf Schneider-Rohan (Pilsen, 1900–Paris, 1970) was first presented to the public in an exhibition at the Josef Sudek Gallery (Galerie Josefa Sudka), Prague, from August to November 2000, and then in "The Nude in Czech Photography" exhibition, held in the Imperial Stables, Prague Castle, from December 2000 to February 2001. See Vladimír Birgus and Jan Mlčoch, *Akt v české fotografii / The Nude in Czech Photography* (Prague: KANT, 2000).

13/ A parallel tendency appears in Czech photography in the late 1950s and early 1960s, most often in works associated with the Olomouc-based DOFO group. See Antonín Dufek, *Fotoskupina DOFO* (Brno: Moravská galerie, 1995).

# Zones of Visuality:
## Rössler's Drawings, Photomontages, and Radio

KAREL SRP

Ten years before the Italian photographer Ferruccio A. Demanins made his dynamic photo-montage *Marinetti on the Radio* (1932), one of the most forward-looking portraits by a leading member of the European avant-garde, whose extreme views required a similarly extreme method of portrayal, the Czech photographer Jaroslav Rössler considered the radio to be the determining motif of his portraits and self-portraits. Like Demanins, but many years before him, he also worked with the photomontage method.

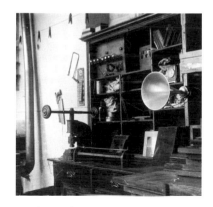

Jaroslav Rössler:
A corner of Drtikol's studio, c.1924

The avant-garde's relationship with radio broadcasting, which went into regular operation in the United States in 1920 and in Czechoslovakia in 1923, was less direct than their approach to film, which had become a commonly accepted medium after World War I. The main reason it did not immediately appropriate radio was that the avant-garde was one-sided-ly oriented to the visual at the expense of the aural. In his "Druhý manifest poetismu" [Second Poetist Manifesto], a synthetic text first published in the journal *ReD* in 1928, which looked back over the Twenties, the leading Czech avant-garde art theorist and founder of the Devětsil artists' group Karel Teige somewhat underestimated the role of hearing in the development of human senses. "Hearing, recognized de facto and de jure as the second aesthetic sense," he wrote, "exhibits far weaker potential in depth psychology than even the other so-called 'lesser extra-aesthetic' senses, such as touch and smell."[1] He saw radio as the instrument that would effect a change in this, stating: "It is, however, fair to expect the rehabilitation of hearing under the influence of broadcasting."[2] And he even claimed: "Poetism is inventing a new radiogenic poetry similar to the photogenic picture poetry, whose auditorium is the cosmos and whose audience is the international masses. Radio-poetry, auditory, non-spatial, has a wide range of animating possibilities."[3] Whereas numerous film scripts were written, however, "radiogenic poetry" remained quite rare. In fact, at first there was only "Mobilisace" [Mobilization] by the leading Devětsil poet Vítězslav Nezval, which concludes his collection *Básně na pohlednice* [Poems for Postcards] (autumn 1926); originally titled "Válka" [War], it later acquired the subtitle "Drama pro radio" (A Drama for Radio). Nezval even dedicated his "first radio script" to Teige, at whose instigation he had probably written most of it. Teige was fascinated by wireless communication from the moment it began to spread. When his girlfriend Emy Häuslerová left for Paris, he foresaw, in his avant-garde zeal, the mobile telephone: "It would be so lovely if we had an opportunity to use the achievements of our century, if we had a small TSF [radio] station, portable and convenient. You, somewhere in the middle of the most beautiful bouquet of a crowd, of the flowers, in the Jardins du Luxembourg or on the Champs-Élysées, in the bustle and lights of Paris, and I, in Prague, could more easily have a nice wireless chat."[4] The notion that everybody would in the future have his or her own portable radio station was so widespread that it even made its way into costumes for masked balls. *The 1920s: Decades of the 20th Century* (The Hulton Getty Picture Collection), a popularizing anthology of photographs, contains a photo of similarly conceived clothing worn by a man with headphones over his ears and a rhomboidal antenna on his head.[5]

The abbreviation TSF (télégraphie sans fil or telegraphia senza fili) came to embody a certain kind of poetry for the avant-garde. It was inscribed not only into plans for new buildings, for example Jaromír Krejcar's Olympic department store in Spálená ulice, Prague (1925–26), but also, and indeed mainly, it appeared in various poems, and even became part of the title of the Devětsil poet Jaroslav Seifert's important collection of verse *Na vlnách TSF* [On the waves of the wireless] (1925), where new words taken from radio terminology now appeared. Seifert makes explicit mention of the "wireless telegraph," of an antenna touching the sky, and, in particular, the Radio Bar. Despite these occasional appearances, radio, in the Twenties, was not a principal interest of Devětsil, as is evident from the contributions of Vilém Santholzer, the chief "engineer" informing the avant-garde of new technological advances. His essay on the latest research is among the most inspiring works then being published in the

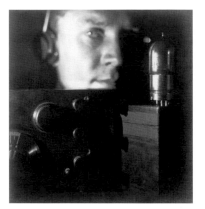

Jaroslav Rössler:
Untitled (Plaček), 1924–26

journals *Disk*, *Pásmo*, and *ReD*. Santholzer, who spent some time in Berlin, reported briefly on the state of local radio broadcasting there, commenting critically, as a member of the avant-garde, on its officious idiocy. At the end of a report called "Berlínský rozhlas" [Radio Berlin] he emphasized the social differences between those who owned radio receivers and those who did not: "Lastly, recall the thousands of antennas in the quarter where the rich of Berlin live and the infinitely sad streets of north Berlin, which unfurl and furl up before your eyes, the sad streets of proletarian children with rickets; houses with crumbling plaster but no antennas. Streets where broadcasting and the radio receiver are completely outside the sphere of life."[6] Even several years after the commencement of regular broadcasting the radio receiver was still not part of the standard equipment of every household. Bedřich Václavek, a Devětsil literary critic from Moravia, was even more radical than Santholzer in his criticism of radio programming. In the July 1928 issue of *ReD* Václavek published some observations titled "O svobodný roz-hlas" [Concerning Free Broadcasting],[7] in which he did not hesitate to claim: "one aspect of the new technological inventions in the capitalist period is their abuse." And he pointed to the monopolization of radio: "Today's monopoly over radio makes this useful tool of cultural work completely remote from life." Like Santholzer, Václavek understood radio in class terms: "The workers must count on the fact that radio is today controlled by the bourgeoisie, which uses it for its own purposes in the social struggle." Rössler, however, was attracted by the radio itself, and was interested in the purely technical side of transmission, not the content of broadcasts, at which most members of the avant-garde in the 1920s shrugged.

Rössler was so fascinated by wireless transmission that, according to witnesses, he even preferred it to photography.[8] He was probably one of the first photographers in the world to make a portrait of somebody using headphones to listen to the radio (*fig. 43*). Rössler's frontal self-portrait (among the extant contact prints there is another, similar one, made at a slightly turned angle) as a passionate listener became a starting point in his work: he photographed himself and his wife at the radio and telegraph, but also made a double-portrait; later, he made a self-portrait, with a pipe in his mouth and the sound horn turned partly toward the lens (*fig. 42*). He was equally interested in speakers and the whole range of radio components. When he moved to Paris in 1926, he claimed he would put up an antenna before doing anything else. His radio receiver at the time is even captured in several contact prints of individual compo-nents: coils of the resonant circuits, insulators, tubes, dials, speakers. He made radio the subject of collages and photomontages, capturing the key stages of broadcasting. In photomontages made mainly from his own photographs, for example *Radio* (1923–24; *fig. 44*) and *Radio World* (1924; *fig. 45*), he highlighted the relationship between the whole and the detail; they can even be read from left to right as he moved from the transmitter to the receiver to the speaker. His interest in radio was also manifest in his collages: in one, the vertical line of a broadcasting tower is intersected by the words Marconi Radio in modern lettering (1926–27; *fig. 54*); into another he pasted a condenser (*Condensateur*, 1926–27; *fig. 53*).

At the time, Rössler was interested in radio as a motif for his photographs, photomon-tages and collages, and had already gone through a brief spell in the early 1920s when he had simultaneously devoted himself to drawing and photography. From these early years more drawings than photographs have been preserved. Rössler's interest in these two forms of expression was probably awakened by František Drtikol, who had been his employer and, initially, a great inspiration to him. The switch from Spiritualist observations, still evident in the bromoil print of his brother's portrait (ca. 1924; *fig. 9*), whose head seems to radiate a bright aura, to everyday life in the post–World War I period made work with Devětsil easier for Röss-ler. It impelled him to try and create his own visual language, which would be independent of his teacher Drtikol's. Before he began this, however, he made one of his most interesting works, the *Portrait of the Dancer Ore Tarraco*, 1923 (*fig. 47*), which is analyzed by Martin Stein in his dissertation on Rössler.[9] The likelihood that Rössler came to Ore Tarraco by way of a drawing is suggested by the watercolor of the Cubist-like portrait of a man (fig. 48), as well as several impromptu figurative drawings in which the human body has been thrust into abstract geometric forms (similarly to Otto Gutfreund's technique in his pre–World War I drawings), and one pyramidal, strongly Symbolist, figurative photograph in which Rössler has included himself at the apex of a triangle, while a nude woman crouches at each of its two

lower angles (*fig. 3*). In several sketches Rössler tried out the possibilities to which he would give definitive form in Ore Tarraco.

The conception of the head of Ore Tarraco, which seems to emerge from a corner of the demolished Jewish Town of Prague, clearly reflects contemporary art about 1920. It is particularly reminiscent of works by members of the Tvrdošíjní (Stiff-necked) group, which culminated in 1921: Josef Čapek's series of linocuts and small drawings, as well as Vlastislav Hofman's imaginary portraits of the protagonists of Dostoevsky novels. It is there in particular that one sees examples whose conception of form closely resembles that of Ore Tarraco.

In Ore Tarraco Rössler has made an exceptional psychological portrait, which is situated at the limits of acceptable form. He demonstrated how unusually he was able to adopt modern methods initiated by others. The sharp diagonal outlines of the head, the distinct vertical axis of the nose, and the precisely laid-out contrasts of shadow and light form a mask that the inhabitants of Prague would have already come across, either in the chamfered edges of the front of the Materna Company building (in Dělnická ulice, Holešovice, Prague) designed by Rudolf Stockar in 1920 or the first poster for the exhibition of the Tvrdošíjní artists, which was designed by Václav Špála in 1918, showing a lozenge-shaped head probably inspired by West African sculpture. Even more directly connected to Ore Tarraco is the linocut by Hofman, characteristically titled *Maska* [Mask], which was published as a supplement to the spring 1920 issue of the modern-art magazine *Musaion*. In Ore Tarraco the crystallike line that was first asserted in Czech art in 1912–13 and peaked about 1920 when its Expressionist core was recast with Constructivist features, is now seen for almost the last time in its pure form. *The Portrait of the Dancer Ore Tarraco* is generally considered to occupy an important place in the history of Czech photography. During the recent cataloguing of Rössler's œuvre, however, Vladimír Birgus questioned the extent to which photography had actually played a role in the making of Ore Tarraco. Was it not, he asked, merely a bromoil drawing on photographic paper, which was then developed using a photographic process? In the literature, when Ore Tarraco is described from the point of view of style, all the main contemporaneous trends in art are recalled. Antonín Dufek has written: "in figurative work he used the Cubist and Futurist idioms at least once in the strongly Expressionist imaginary *Portrait of the Dancer Ore Tarraco*."[10]

When one looks at Rössler's figurative drawings the tension in his work from the early Twenties becomes evident. It is clear from them that in about 1923 he had a two-track approach to the human body: on the one hand, a solitary stylized female figure similar to Drtikol's "ghosts" (which in Rössler's drawings, however, no longer wander over steep rocky hillsides or stony plains or cosmic spheres; *figs. 11 and 12*) led to dematerialized, abstract planes; on the other hand, using the waning Cubist and Expressionist idioms he made woman's body highly geometric. This is because Rössler had approached abstract photographs by way of late Art Nouveau stylization or Cubo-Expressionist deformation.

The gradual breaking away from Drtikol's influence was also partly the result of a short intermezzo when Rössler was drawn to the work of Enrico Prampolini. He saw Prampolini's stage sets for Marinetti's *Il Tamburo di fuoco* in the Theater of the Estates, Prague, in December 1922. Unlike the German Expressionists the Czech avant-garde did not reject Italian Futurism, and Teige was said to have even put Marinetti up at his own place during the Italian's Prague sojourn.[11] Rössler was most fascinated by Prampolini's conception of the stage sets for *Il Tamburo di fuoco*. Its folded, slanting surfaces, which made spatial relationships relative, most probably enabled him to surmount the preceding post-Symbolist orientation, which, owing to Drtikol's long-term influence, was stronger for him than for other avant-garde artists. Rössler, after 1923, turned exclusively toward the Constructivist idiom, which was stripped of any extra-artistic allusions. The magnitude of Prampolini's influence on Rössler is evident from two charcoal drawings, one of a factory and the other of houses in a landscape (inspired perhaps by his native Smilov, Bohemia), whose extremely concise forms give dynamism to the inner space of the drawing.

Rössler's photographs and collages corresponded in many respects with the theoretical conclusions Teige reached in the first half of the 1920s. Rössler was not content simply to record the technological elements of the new beauty of modern civilization. His photomontages and collages betray the polarization of opinions held by the early avant-garde, which ran from black-

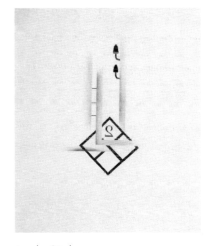

Jaroslav Rössler:
Untitled, 1926, ink drawing

and-white photogénie to picture poems that combine collage and drawing. Rössler, who quickly went over to purely abstract photography, often made dematerialized surfaces concrete by subtly placing an inconspicuous detail in the corner of the photograph (for example, *View of the Courtyard*, 1924–26). Teige allowed for pure abstraction only when it was a matter of the photogénie typical of the first half of the 1920s, which, regarding all previous theories, he described by a variation on observations published by the Parisian film theorist Louis Delluc in 1920. Teige stated: "'Photogénie,' a technical term, means a kind of harmony between photography and cinematography. The photogenic is that which is born of light. We say reality is photogenic if the light ratio, proportion, harmony, the contrast of shadow and light, and the modeling in a photograph or film provide an effective picture that is balanced between black and white."[12]

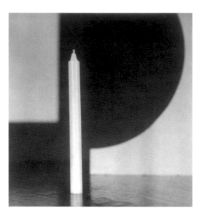

Jaroslav Rössler: Untitled, 1923

Teige's requirements for the photogenic are met particularly by Rössler's abstract photographs from 1923 to 1925. Rössler did not necessarily remain only with his own photograph: in some cases he affixed it to paper and bordered it with a black strip (*Photograph I*, 1925; *Photograph IV*, 1925; figs. 29 and 30). Sometimes he approached his photographs as only one of several visual motifs that can be completed only by the new context. If both these photocollages were in fact made in 1925 (the photographs themselves date from 1923–24), they most probably preceded Teige's graphic design for Nezval's *Abeceda* with photographs of Milča Mayerová's taut movements placed into black orthogonal strips.

Once he had stopped trying to achieve intricate figurative compositions, Rössler's gradual simplifying of the shot and his search for the most suitable angle led him to autonomous works made with cardboard. Here, he began to play with the scale of contrasts between shadow and light, which he both photographed and then used as the basis of his collages (*Photograph I* and *Photograph IV*, 1925). Rössler allegedly said that Cubist "papiers collés" had inspired his own compositions of bent pieces of cardboard. They can reasonably be compared also with Man Ray's well-known photograph of the hanging spiral strip, which was published also in the second volume of the *Život II* anthology (1922, p. 159), and would later so fascinate Jaromír Funke. Teige commented on it in a chapter called "Případ Man Ray" [The Man Ray Case]: "The paper spiral, hung on a rod, which nihilistic Dadaistic taste considers modern sculpture, in other words art, is for Man Ray, however, nothing but transitory reality, whose beauty he renders with his photograph."[13] Unlike Man Ray, Rössler made the photographed subject matter indecipherable and went beyond it, making it serve as a mere shell of space, a pretext for his own photograph. The background, which played a predominately decorative role in Rössler's earlier, Symbolist, figurative photographs, became the foreground, which itself acquired an autonomous value of expression, and determined the character of the shot. Rössler's photographs met the requirements of the photogenic, which were advanced by Jiří Voskovec: "to have the photograph of suprareality leave purely optical impressions . . . , to lead the viewer into a world where optical beauty does not dissolve into saccharine theatricality . . . , not to destroy the evident, magically primitive language of light by Symbolism and Romanticism, which have most reproachfully been adopted from hackneyed bestsellers."[14] In the somewhat imprecisely titled photographs *Abstrakce* [Abstractions] (1923–25; fig. 35) Rössler came to what was perhaps the most experimental method, counter to the photogram, where he illuminated cardboard cut-outs from the side and the back, so that he could then give new value to the shot by working on the negative. In photographs existing only as contact prints, he increased the dematerialization all the way to an abstract aura of light without fixed contours. Where Drtikol would have placed a female nude and fixed border, auralike ovoids seem to rise out of the photographic paper.

Unlike *Photograph I* and *Photograph IV*, the collages, titled according to the words in them – *Unlife*, *Omto*, *Condensateurs*, and *Radio Marconi* (1926–27; figs. 51, 52, 53, and 54) – have black orthogonal surfaces thrust directly into the concrete motifs. Their choice is a reflection of the requirements of modern beauty as demanded by Teige's theory: a fraction of an instrument, a metropolitan milieu, sports, and physical activity (which was often referred to by Devětsil members in the Twenties, but came into the collages and theoretical discussions only of Evžen Markalous.[15] In Paris, the Eiffel Tower, an icon of the avant-garde in the 1920s, held a strong allure for Rössler, and he made photo-collages and photomontages with motifs of it (figs. 66, 67, and 68). Like several other artists (for example, Josef Hausenblas's *Eiffel Tower*,

1928; the photomontage published in *ReD*, no. 9, 1929) he was particularly fascinated by the spiral staircase. Like the collages and photomontages from the first half of the 1920s and ink drawings he made in Paris in 1926 (*fig. 58*), their purpose remains unclear. They may have been drafts for advertisements that were never made, developed in accordance with the avant-garde principles of typography, which link together concrete fragments of architecture and fragments of objects and signs. In late July 1926, Rössler made six drawings, which were most probably intended as advertisements for theater and music performances (*fig. 61*).

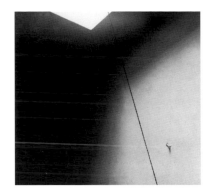

Jaroslav Rössler: Skylight II (Printing Room), 1923

Rössler's relationship with Teige was determined not only by the close connection between Rössler's works and Teige's theoretical requirements. Teige's early drawings from 1918–20 are not unlike those made by Rössler in the early 1920s.[16] Both artists, using sharply defined surfaces and refracted lines, quickly adopted the then modern subject matter of telegraph poles, which made their way into both poetry and the visual arts: Teige drew a road with telegraph poles in 1920; Rössler devoted himself to this motif about 1923. Nor did this dialogue cease in later years. Teige's first journey to Paris, where he went on holiday in 1922, is connected with several drawings and linocuts made of flat, interpenetrating planes, which link traffic signs with ordinary signs, often advertisements for department stores. Similar groups of subject matter were also photographed by Rössler after his arrival in Paris in 1926. They did not serve him as illustrations for *Pestrý týden*, but fixed simple motifs to be used in some future photomontage. His contact prints are of street and railroad signs (similar to Teige's well-known drawing *Traffic Lights*, exhibited in the "*Modern Art Bazaar*" in 1923), only some of which appeared in photomontages. The way Rössler made his photomontages becomes clear from one that bears the distinctive sign "*Nord–Sud*" (1926–27; *fig. 65*), for which two original photographs also exist. Clearly, Rössler was most fascinated by signs and iron structures. He probably made the photo-collage out of four shots, three of which record various types of signs from the Metro, a café, and the *Le Matin* newspaper (whose name appears also in a drawing from 1926). Rössler, who often photographed the material for his photomontages himself – which was unusual in the avant-garde of the 1920s – conceived the out-of-context motif as an emblem that would serve to make a new whole out of autonomous fragments related to each other by content. His photomontages and collages come from the period when the means of unification was determined by metonymy. Rössler's photomontage on the cover of the April 1928 issue of *ReD*, as an advertisement for a Czech production of Ivan Goll's *Mathusalem ou l'éternel bourgeois* at the Liberated Theater, consisted of nightclub dancers, bottles, phonographs, and the words "Bal Kermesse" and "Empire," some of which he took from his own photographs.

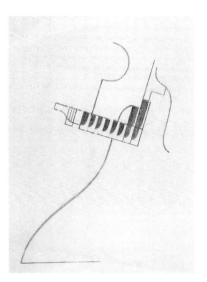

Jaroslav Rössler: Untitled, 1926, ink drawing

Although Teige made no particular mention of him in his writings, Rössler was the first photographer who began to work with Devětsil. Teige had allegedly known Rössler since spring 1923, yet he did not include any of his work in the "*Modern Art Bazaar*" organized for the autumn of that year. (Apart from Man Ray, no photographer exhibited work there.) Rössler's works were published in *Disk*, *Pásmo*, *Fronta*, and *ReD*, he took part in the second Devětsil exhibition (in spring 1926), and he worked with *Stavba* and the Liberated Theater. Whereas Teige, upon seeing them, allegedly declared Rössler's early works to be better than Man Ray's, the art critic Bohumil Markalous, reacting to Rössler's works in the second Devětsil exhibition, laconically remarked: "Rössler's' shadow photos attain nothing of the spiritual level of Man Ray's, which are perfect."[17] Rössler attended mainly to the visual side of Teige's theoretical program. Teige's great appreciation of him is evident from the space he reserved for Rössler on the cover of the first issue of *ReD* (October 1927), as well as from the fact that he published them together with the work of Man Ray, El Lissitzky, and Lázló Moholy-Nagy. The closeness of the link is suggested by a page of *ReD* (vol. 1, no. 8, May 1928), where Rössler's photogram with the letters V E are published next to Teige's illustration for Biebl's collection of verse, *S lodí, jež dováží čaj a kávu* (With a ship that imports tea and coffee).

Unlike in the "roaring Twenties," in the thirties Rössler was concerned mainly with the search for himself. That, however, was not reflected in drawings or photographs. He did not return to drawing until after World War II, and even then it was only for several weeks, during a protracted illness in early 1949, when he suddenly made linear drawings permeated with a Šíma-like atmosphere (*fig. 110*) and oils on cardboard. Stein has written: "At that time, in

Page from the journal *ReD*
with works by Man Ray, Tršický and Rössler

Double-page from the journal *ReD*
with a drawing by Jaroslav Rössler
and typographic montage by Karel Teige

the short period of two months, he made a great number of drawings. They fall into two markedly different groups. One was probably inspired by the *Old Testament*; the other clearly exhibits memories of Paris in a style similar to Šíma's."[18] Rössler's drawings unconsciously exhibit his later photographic approach, which was systematically developed in the 1950s and 1960s, and is also marked by the method of his combining and reversing the same shot (*figs. 111 and 112*). It represents a sort of revival of original avant-garde positions, whose new thematic sources lay in the artist's growing interest in Orthodox Judaism, especially its negative attitude to empirical depiction, which was never to close to his heart anyway. In a drawing from 23 January 1949, which bears the word "David," Rössler is concerned with surface that was both unrolling and rolling up, which he makes concrete by adding a musical instrument, thus seeming to turn space upside down. In several other drawings he conceived a similar theme as an architectural motif that looks like a staircase freely spreading out in space. It seems that some drawings can even be turned around and observed upside down. Šíma's lesson freed Rössler of the weight of matter. He lets a window with a railing and recess, a typical motif of the Parisian apartment block, flow freely, as if not attached to anything. In drawings from the early Twenties Rössler found himself on the borderline of ambivalence, where the same form depicts both a landscape and a woman's body. Alternatively, in drawings from February 1949, he has projected a woman's face into the chimneys of Parisian roofs, which he was fond of photographing about 1926 (*fig. 112*). Teige was also interested in linking together a woman's body and architectural motifs, and often chose well-known avant-garde photographs for the backgrounds of his collages. Several times he drew even upon Rössler, as in *Collage no. 347* (1948) where he has placed sculptural fragments of women's legs and breasts into Rössler's photo of bent paper. It was the last time Teige would return to the photographer whose work he had widely published in the Twenties. Rössler was a typical example of the openness of Devětsil in this decade: although he stood on the margins, he could be published anytime in the group's periodicals, as could many other leading artists who then developed in a completely different way. One might easily think that Rössler's works were in their day only a mere addition to the range of the avant-garde program in which the photograph and, in particular, the photomontage simply had to be present. From today's point of view, however, they are in fact more than an important buttressing of what the avant-garde had sought to achieve in its manifestos; they also support the idea that Rössler was observing his own creative process, which moved between purely abstract compositions of light and, on the other hand, elemental forms represented by component parts of the radio, which he considered the most modern technological invention, just as other representatives of Devětsil were concerned with various means of transportation.

Rössler always had a clearly defined relationship with reality. How far he went in remolding reality is clear from a photograph he made in 1929, in which a concave reflecting surface distorts a regular checkerboard motif,[19] also capturing a camera on a table and the upper part of the photographer's head (*fig. 72*). Here, Rössler was following on from the radical photos shown at the "*Film und Foto*" exhibition in Stuttgart; he was interested in transformation rather than the obvious. This orientation is already anticipated in one of his drawings from the early Twenties, in which a recumbent figure looks out from the edge of a ravine. The expressive Romantic motif, reminiscent of the well-known painting by Caspar David Friedrich, *Kreidefelsen auf Rügen* (1818), which is a definite prototype of similar visual experiences, acquired another nuance in Rössler's drawing: the shape of the ravine appears to be the negative outline of a woman's head, in which the clouds resemble her hair and the vertical line her nose. Whereas the prone figure is looking to another time and space, and the viewer cannot see her face, a large woman's head appears in front of it, springing up like a link between heaven and earth. Rössler always wanted to touch something that went beyond immediate sensory experience. It is precisely the stylized drawings from January and February 1949 that point to this aspect of his creative process. As a representative of the 1920s avant-garde he began, after years of relative quiet, to exhibit again in the second half of the 1960s. He slowly joined the rising wave of the neo-avant-garde that was reviving the legacy of Dadaism and Constructivism, some of whose representatives were not only alive but were also still artistically active. Rössler created a visual language for himself, dealing

freely with his own shots, which tied into his photomontages from the mid-Twenties. For him, the photograph remained a mere inspiration changed by an innovative photographic methods – the "sandwich" photomontage (when he turned a single negative over onto its other side) and the layering of colors by using a prism. In both cases he avoided making only a direct, empirical copy of a subject that lay before the lens; that subject provided him merely with raw visual material for further shaping. Another characteristic feature of Rössler's later works was "construction," which made its way directly into the essence of carrying out an idea. From an initial interest in the sign and construction in the Twenties, accompanied by the strong dematerialization of a principal feature of his work, he moved on to reconstruction: he no longer assembled photomontages out of various elements that were related to each other in subject matter, but by superimposing to make a new reality, which had not been present before, and at the same time he was aiming at essential aspects of human consciousness. Although his later "montages" look extremely matter-of-fact, in the background there remains a strong Symbolist core based on his musings in natural philosophy. Although the lower and upper halves, as well as the left and right sides, appear the same, they are actually different. For more than ten years, therefore, Rössler moved on the edge of variation, enabling him to return countless times to a single formal principle. In his notebook, on 2 June 1964, he wrote a short remark under the heading "Symmetry": "Symmetry = reality = Symmetry par prisma deux negative. Everything is symmetry – that is to say, cut in half, two symmetries emerge. We are symmetrical: 2 – 2 – Man is symmetrical – the Earth is symmetrical. Only with the joining of two different halves does asymmetry emerge. Vertical symmetry; horizontal symmetry." To Rössler, the last photographs may possibly have become a profounder meditation on the meaning of the world than may appear at first sight.[20]

NOTES

1/ Karel Teige, "Manifest poetismu," ReD. 1, 1928, no. 9: pp. 317–36; republished in Karel Teige, Svět stavby a básně (Prague: Československý spisovatel, 1966), p. 352.

2/ Ibid.

3/ Ibid.

4/ Růžena Hamanová, "Dopisy Karla Teiga Emy Häuslerové," Literární archiv, vol. 24 (Prague, 1990), p. 200.

5/ Nick Yapp, The 1920s: Decades of the 20th Century (The Hulton Getty Picture Collection) (Cologne: Könemann, 1998).

6/ Vilém Santholzer, "Berlínský rozhlas," Pásmo, 1925, no. 2: 33.

7/ Bedřich Václavek, "O svobodný rozhlas," ReD. 1, no. 10 (1928): 10, pp. 354–56.

8/ Zdeněk Kirschner, Eulogy, 12 January 1990 (unpublished); Zdeněk Kirschner, Speech at the Jaroslav Rössler Exhibition Opening (unpublished), Prague House of Photography, 10 October 1991.

9/ Martin Stein, "Jaroslav Rössler," M.A. diss., Film and Television Faculty, Academy of Performing Arts (FAMU), Prague, 1984.

10/ Antonín Dufek, "Fotografie dvacátých let," in Vojtěch Lahoda, Rostislav Švácha, Marie Platovská, Mahulena Nešlohová, and Lenka Bydžovska, Dějiny českého výtvarného umění, 1890/1938 (IV/2) (Prague: Academia, 1998), p. 215.

11/ František Šmejkal, "Futurismus a české umění," Umění, 1988, no. 1, p. 46.

12/ Karel Teige, "Večer fotogenie," in Karel Teige, Film 5 (Prague: Petr, 1925), p. 63.

13/ Karel Teige, "Foto, kino, film," Život 2 (Prague, 1922), p. 160.

14/ Jiří Voskovec, "Fotogenie a suprarealita," Disk, 1925, no. 2, p. 15.

15/ Eugene Markalous, "Sport," Pásmo, 1925, no. 2, pp. 35–36.

16/ Karel Srp, "Umění a turistika: Mladý Teige," in Karel Teige 1900–1951, ed. Karel Srp (Prague: Galerie hlavního města Prahy, 1994), pp. 6–19.

17/ Bohumil Markalous, "SMK Devětsil (Dům umělců)," Právo lidu, 16 May 1926, p. 10.

18/ Stein, "Jaroslav Rössler."

19/ Lenka Bydžovská and Karel Srp, "On the Iconography of the Chess-board in Devětsil," Umění, 1993, pp. 41–48.

20/ Symmetrie in Kunst, Natur und Wissenschaft (Darmstadt: Mathildenhöhe, 1996).

# Works after World War II

ROBERT SILVERIO

In their interpretations art historians usually place an artist in the context of his or her period. Nor can we in this chapter avoid the context of the post–World War II work of Jaroslav Rössler. It must also be said, however, that the circumstances of the period exerted an influence on this artist, which was, at least initially, highly problematic. After being deported from France in 1935, Rössler, it seems, lived entirely immersed in himself, out of step with the times. For almost twenty years he made no art at all, was in touch with no one except his wife and daughter, and, long after his deportation, did not even talk. He never quite managed to get over the trauma and consequences of the deportation, and his life and work were to be marked by them after the war.

Rössler's postwar works are usually less respected than his earlier works. The radical nature of the interwar avant-garde and its faith in everything new was, for a long time afterward, shaken by the war. Avant-garde photography turned into art photography and concentrated far more on established, conventional subjects – the portrait, the landscape, and the nude. Its aesthetic, moreover, is no longer so in confrontation with other aesthetics, either those that came before it or those of its own time. All this, however, took place far from Rössler, who seems to have lived beyond the context of his period; he did not try and keep up to date with what other artists were doing. After returning from France he did not even meet with his former employer and teacher, František Drtikol, or his proponent, Karel Teige.

Rössler probably never belonged to the radical avant-garde artists who dreamt about a new society. He definitely was not noted for a collectivist spirit; more likely he was an introverted manic-depressive with a strong admiration for technology. In this sense his oeuvre, prewar and post-war, is in several respects compact and consistent. When Rössler returned to his work in the second half of the 1950s, he returned, unlike other artists, to something he had left open before the war; he returned to a happy past. Although he did make some pieces now and then in the 1940s and early 1950s, but they hardly constitute anything that might be called a consistent oeuvre.

A certain role in intensifying his interest in strictly private work was perhaps played by Rössler's becoming friends, in 1959, with Olbram Zoubek and his wife Eva Kmentová, two young sculptors. The creative atmosphere around them may have provided an impetus to new work, as may have Rössler's platonic love for Eva. An important role in the 1960s was certainly played by Czech art theorists and art lovers' growing interest in his work. In 1961, probably for the first time since the end of World War II, Rössler's work began to be published again, when a biographical sketch about him appeared in *Revue Fotografie* magazine. In the same year, his photographs were published to illustrate articles in the distinctively intellectual *Literární noviny* [Literary Gazette]. In the 1960s he also began to exhibit his works again. In 1966 they were shown in the "*Surrealismus a fotografie*" [Surrealism and Photography] exhibition and, in 1968, the first independent Rössler exhibition was held in the Lesser Exhibition Hall of the Československý spisovatel (Czechoslovak Writers') publishing house, Prague – this was not just the first exhibition he took part in after the war; it was also the first solo exhibition he ever had. The 66-year-old artist had thus survived long enough to make his debut. The "*Osobnosti české fotografie*" [Great Czech Photographers] exhibition, organized by the historian of photography Anna Fárová in Roudnice nad Labem and the Museum of Decorative Arts, Prague, in 1973 and 1974, was a milestone in this respect. It was the first exhibition at which Rössler was placed in the context of artists such as Drtikol, Jaromír Funke, Josef Sudek, and Jindřich Štyrský. It was followed by a solo Rössler exhibition in the Funke Gallery, Brno, in 1975, also organized by Fárová. In the course of the 1960s Rössler's work made its way into state-owned collections of art. In 1969 the curator and theorist of photography Antonín Dufek purchased some of Rössler's work for the Moravian Gallery in Brno, and a year later Fárová acquired some of Rössler's photographs for the Museum of Decorative Arts, Prague. They were bought at prices that today seem laughable – at first, 200 to 300 Kčs ($25 to $37.50 at the

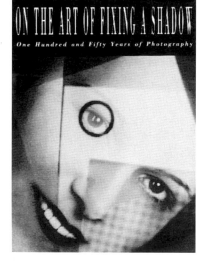

Poster for "On the Art of Fixing a Shadow" exhibition at the Art Institute of Chicago with a photograph by Rössler, 1989

official exchange rate of those days). In the sixties two German gallery owners, Rudolf Kicken and Wilhelm Schürmann, also bought a substantial quantity of his work; thanks to these two men Rössler's work became part of collections around the world. In the 1980s his works were becoming regular parts of important exhibitions abroad. Recognition, however, had really come too late for the tired, ill artist.

Although the range of techniques that Rössler used after World War II is wide, three approaches clearly dominated. They were the "Sabatier Effect" (a technique, in which the developed positive or negative is partially exposed, causing a certain reversal of tonality), various kinds of montage of negatives (particularly the "sandwich montage" – pulling two or more negatives together and enlarging them), and photographs made through a prism, which was Rössler's own pre–World War II invention. There are also photographs combined with projections, negative prints, and photograms. From the late 1960s onward Rössler was also interested in color photography or, more precisely, a technique using different colored gels. He rarely used the individual techniques separately; his works were done mostly with mixed techniques, sometimes so complicated, that it is now difficult to determine the initial approach.

Jaroslav Rossler: Untitled, 1960

For his own oeuvre, however, Rössler regularly used not only new negatives, but also old ones of shots taken in France. One reason may have been his attraction to the sentimental; another is that he was more interested in manipulating the image than in the actual act of taking a photograph. When Rössler worked with old negatives, it was probably so that he could escape to the past, to the fulfilling days of his French sojourn; it is probably no exaggeration to view this as a kind of creative psychotherapy.

For their time, Rössler's techniques and montages were increasingly demanding. After a short stage of simple still lifes in the late 1950s, he began to use the Sabatier Effect intensively, which he regularly combined with montages of various photographs (*fig. 114*). He often made photographs through prisms, which doubled reality into a mirror image, and the similar "sandwich montage" (*figs. 115, 116, 117, 118, 119, and 120*). Rössler also worked with these methods intensively, particularly for his suburban landscapes.

The period of ten years between 1967 and 1977 was when he made his probably most technically complicated works in color. This is a technique that involves combining three colored gels, each of which is one primary color, but together provide the complete spectrum. These works constitute one of the most abstract aspects of Rössler's oeuvre. Reality here is sometimes utterly indecipherable; at other times – for example, with city architecture or Jewish motifs – they are on the verge of visual decipherability (*figs. 130, 131, 132, 133, and 134*). What is important, however, is that these many complicated techniques constitute a continuous development of his prewar methods of manipulating the image. It is equally important that as the pictures were becoming more intricate, they were also becoming more abstract. Rössler's tendency toward technical complexity is therefore not an end in itself: instead, it underscores the path from geometric realism to more abstract forms of expression.

Jaroslav Rössler: Untitled (Bride), 1965

The vast quantity of technical motifs comes as no surprise as soon as we begin to consider the relationship between Rössler's themes and his personality. The motif of electrical and telegraph wires, which appeared in his pre–World War II works (*figs. 115 and 117*), repeats itself intensively after the war. Now, however, trees, landscapes (mainly urban and suburban), and still lifes (flowers, apples, bowls of fruit) were also close to Rössler's heart, and, in addition, he photographed ships and aircraft. In the late 1950s Rössler took up themes that correspond surprisingly to the symbolism of the period; not only were the symbols atypical of Rössler but they were also surprisingly similar to those of Social Realist art, in which the idea of the peaceful development of agriculture and industry was emphasized. They are comparatively realistic, simple, for instance an egg with an ear of grain or a cogwheel. Of course, in this period even Sudek was working with similarly simple motifs. Rössler, however, soon turned away from the realism of these simple still lifes. Although his landscapes, which predominated in the sixties, are usually doubled with a prism or "sandwich montage," they are also clearly readable. Equally frequent are the still lifes with fruit and flowers. In the sixties and seventies Rössler made works that completely ignore spatiality, elaborating instead many varied, flat motifs, both figurative and nonfigurative (*figs. 121, 122, and 123*). Some themes reflect Rössler's proclivity for Judaism (*figs. 124 and 125*): in the sixties and seventies he made

photographs of the Old Jewish Cemetery and the Pinkas Synagogue in Prague as well as abstractions with Hebrew letters. From his correspondence it is clear that he was also trying to get back into commercial photography. His proposals, however, were rejected by the committee of the Union of Czechoslovakian Fine Artists.

Sometimes, substantial interventions in the photographs (mainly in the late 1960s and throughout the 1970s) ended in utterly nonfigurative forms, and the world of real objects, completely as a matter of course, was remade into semiabstract planes. This approach corresponds to trends in Czechoslovak art in those days, where, at the less official (nonstate) level, a tendency to abstraction appeared as a result of the political liberalization and perhaps also as a reflection of developments in Western art.

This tendency was present also in photography, at two levels. The first approach preferred pure photography, using detailed shots to make it more abstract; this is where the works of many photographers with an affinity for post–World II Surrealism belong, in particular some of the art of Čestmír Krátký, Alois Nožička, Vilém Reichmann, and Emila Medková.[1] The second approach to making reality more abstract was based on techniques of manipulation, ranging from various montages to photographs altered during developing or enlarging, which consisted essentially in modifying photographs using graphic design. It is probably most accurate to include Rössler here. The use of the Sabatier Effect or, later, colored gels, which render the image indecipherable, can rightly be considered the photographic counterpart to gesture painting, the "fokalky" of Josef Istler (abstract images made without a camera, by applying chemicals directly on sheets of photographic paper or exposing them to heat), the "Explosionalism" of Vladimír Boudník, and the abstract structures of Mikuláš Medek.[2]

Václav Chochola: Jaroslav Rössler, 1988

Although the link with Art Informel is evident in at least a part of Rössler's work, it is definitely not typical of his oeuvre as a whole. It appears most distinctly where Rössler used the Sabatier Effect or colored gels. The post–World War II sense of strictly geometric form may have changed in other photographs, particularly his landscapes and some montages, but hardly so radically. Moreover, considering that Rössler often returned to his roots, some of his post–World War II works seem to be done in the spirit of pure Constructivism.

Rössler bought, or perhaps was even a subscriber to, the magazines *Československá fotografie* and *Revue Fotografie*. He now knew therefore what was happening in the photography of those days, within the limits, however, of what state censorship allowed to be published. But it remains unclear how much time he devoted to reading about other photographers and how much time to technically oriented articles.

Concerning his simple montages and shots of suburban landscapes photographed through prisms one would be correct to emphasize their thematic (though not technical) link with Miroslav Hák's photographs of the outskirts and with paintings by members of the Skupina 42 [Group 42] such as František Gross and František Hudeček.[3] With regard to later works from the second half of the 1960s through the 1970s, the pieces most similar to Rössler's include some by members of the DOFO group in Olomouc – namely, Antonín Gribovský, Ivo Přeček, and Rupert Kytka.[4] They, however, were artists whose range of expression was quite wide, so that one can actually talk about links in only a small part of their works, those where a strong reshaping of reality has taken place. At this abstract level their works begin to resemble Rössler's. Of the other Czech and Slovak photographers we should mention the technical connection with the work of Jan Šplíchal, Stanislav Benc, and Jiří Škoch, as well as Ol'ga Bleyová, Margita Mancová, and Zuzana Mináčová.

All of them tended to use media similar to Rössler's, including montage, the Sabatier Effect, and the negative print. The results, however, are markedly different; most of these artists inclined to either Surrealism or figurative lyricism. There are, to be sure, technical parallels, but the semantics of these works are remote from Rössler's. Outside of Czechoslovakia, some of what the Germans call the "Subjective Photography" of the 1950s and 1960s was concerned with the creation of a new reality by using montage and reverse tonality. This included works by leading figures of the movement, such as Otto Steinert and Peter Keetman. These artists, however, were extremely versatile, concerned with both manipulated photography, including montage (sometimes approaching Op-art), and direct live photography, works remote from Rössler's.

Rössler's post–World War II photographic work exhibits both the signs of the times he lived in and the legacy of the avant-garde aesthetic it emerged from. It is not usually rated as highly as his prewar work: as a whole it may genuinely lack that extroverted radical quality of the avant-garde, which had made his prewar works so fascinating. Yet, Rössler's postwar work has been disqualified by the distance with which today's critics view the 1960s as well as the montages and nonphotographic approaches of those days. Many of the nonphotographic approaches used by the wide range of artists from the sixties and seventies, when looked at now, often seem to be a merely formal defamiliarization of not particularly distinctive photographs. It is safe to assume that Rössler, too, has been affected by the results of this sort of opinion, though in his postwar work – as I have sought to emphasize here – he differs from most artists in many respects, and in his aesthetic he mixes period trends with thematic ones, and goes on excursions back to the techniques of the prewar period. Clearly, then, at least some of Rössler's post-war work deserves serious reevaluation and recognition.

NOTES

1/ Čestmír Krátký, Alois Nožička, Vilém Reichmann, and Emila Medková were Czech Surrealist photographers. They used the method of object trouvé. This found object could be a crumbling wall, crumpled paper, or rusting machinery. The image was taken using a straightforward, simple method, but because of the nature of the photographed reality the result was often abstract or semiabstract. Some of their work is similar to Art Informel or Art Brut. See, for example, Jan Koblasa, *Čestmír Krátký* (Liberec: Severočeské nakladatelství, 1969), Antonín Dufek: *Vilém Reichmann* (České Budějovice: FOTO MIDA, 1994), Aleš Kuneš, *Surrealistické incidence / Surrealist Incidence* (Prague: Prague House of Photography, 1996), Lenka Bydžovská and Karel Srp, *Emila Medková* (Prague: KANT, 2001), Zdenek Primus, *Alois Nožička* (Prague: KANT, 2003), and Zdenek Primus, *Art is Abstraction* (Prague: KANT, 2003).

2/ Medek was a Czech Surrealist painter, Boudník a L'Art Informel printmaker who invented his own style called "Explosionalism." A combination of nongeometric, and sometimes abstract or semiabstract structures, are typical of their work.

3/ Skupina 42, named after the year in which it was founded, was a Czech artists' group of several painters, one sculptor, and a photographer (Miroslav Hák). Its artists depicted mainly suburban life, a theme reflected in some of Rössler's suburban landscapes. See, for example, Eva Petrová (ed.), *Skupina 42* (Prague: Akropolis and Prague City Gallery, 1998).

4/ Antonín Dufek, *DOFO fotoskupina* (Brno: Moravian Gallery, 1995).

# Experiment in Progress
MATTHEW S. WITKOVSKY

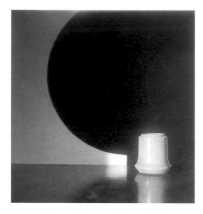

Jaroslav Rössler: Untitled, probably 1923

The work of Jaroslav Rössler is instantly identifiable as belonging to its time. From 1919, the date of his earliest extant photograph, through 1935, when Rössler halted his creative activities in the wake of personal upheaval, the style and content of his art appear uniformly in tune with the innovative trends of his day. It is as if Rössler had sprung full-blown into the modern era – indeed, his earliest works don't reflect that era so much as they anticipate it. At the same time, Rössler didn't give much evidence of stylistic progression, and the work he made after returning to photography in the late 1950s, which continues or even intensifies his pre–World War II interests,[1] reinforces the impression of him as a phenomenon of interwar European modernism. Furthermore, unlike most other photographers and artists of his day, the shy and fearful Rössler hardly ever exhibited his work, and he seldom published it; nor did he articulate his ideas in writing, either privately or in public. How then are we to interpret the significance of his images? Are they a set of variations on themes and styles of the period? Are they happy accidents? Or do they constitute an original authorial voice, an oeuvre? Put another way, what are the contours of Jaroslav Rössler's artistic identity?

In order to answer to these questions, it is necessary to reflect on the nature of "artistic identity" in photography, particularly in the context of interwar modernism. The perennial difficulty in assessing the "art" in photographs stems from a confusion between functional and aesthetic criteria of evaluation – a confusion that is compounded in the 1920s and 1930s by theories of art that take function as their goal and standard. Rössler's photographs are often aligned with these particular theories, loosely grouped under the terms "functionalism" or "constructivism." Rössler may have adopted constructivist principles of design, but I think it is misleading to call his work constructivist. It would be better to say that Rössler was a constructor, someone who preferred to build his photographs rather than take them.[2] This preference is not so much a question of technique or style as of method, and it is Rössler's methods that are so entirely original. Rather than trying to match Rössler's photographs to artistic tendencies first formulated in painting or sculpture, it seems more useful to try to define his place within the photographic practices of his day. Rössler in fact represents an outstanding amalgam of the three main categories of practice within which photographers operated in the interwar period: professional, amateur, and avant-garde.

The first of these categories seems initially the most suitable to describe Rössler's career. He learned his craft in the studio of František Drtikol, then the most successful commercial photographer in the Czech lands, and when he left Drtikol's studio in 1925 it was to seek employment opportunities in Paris together with his wife, also a free-lance photographer. The majority of Rössler's subsequent photographs were in fact made on assignment for Paris studios: advertisements for health and beauty products, plus the occasional magazine cover or newspaper illustration. The works for which he receives greatest attention these days, however, are the photograms, photomontages, and abstract photographs he made of his own volition – works he never offered for sale. What, then, is the relation of this work to his commercial output? Was Rössler a commercial photographer with a part-time hobby, or rather an artist who put his creative principles into practice commercially as well? Should the two areas of his photographic activity be seen as opposed, complementary, or perhaps even continuous with each other?

It would be hard to argue that Rössler's commercial and experimental selves are unrelated or antithetical, along the lines of, say, the painter Piet Mondrian, who even after his zealous conversion to geometrical abstraction maintained a side business making watercolors of flower arrangements. While Rössler undoubtedly accepted assignments out of financial need, as Mondrian did with his floral still lifes, his commissioned photographs bear a distinct visual affinity with his noncommercial experiments. Sharp angles, diagonal compositions, and montage effects may be found in both the commercial and noncommercial work, while the flair for dramatic plays of light and shadow that Rössler learned from Drtikol is a decisive element in both the Paris advertisements and the pre-Paris experimental studies.

This continuity in technique suggests a relation of experimental to commercial work closer to the model of Man Ray, whose sensual commissioned portraits stand at one end of a spectrum that reaches into the erotic and even pornographic, using similar compositional techniques. The common thread in Rössler's case would seem to be his concentration on everyday objects. Whether in a photogram of a smoking cigarette and the matches needed to light it (Smoke, 1929, fig. 83) or the arrangement of an ashtray and tobacco in an advertisement for cigarette papers, Rössler dispensed with the background to focus on sundry objects in their own right. Still, the relation of advertising to work labeled "art" is not as straightforward as that between "art" and portraiture, which after all has long been classed as a genre within the fine arts. The relation between Rössler's experiments and his advertisements seems better described as complementary rather than continuous: two sides of a single interest in form. For this reason, the best model in the end seems to be the Bauhaus, where "laboratory" experiments and professional assignments were seen as distinct but mutually fulfilling activities.

This last explanation comes closest to describing Rössler's work, but it overlooks his very particular approach to form. In so many of his compositions, Rössler wanted to transmute formal properties, rather than intensify our awareness of forms as such. The setting for Rössler's commercial shots is nearly always a stage of sorts: a corner of the universe in which the product, often bathed in an oval of light, floats in motionless defiance of all gravitational orbits. These works are of course legible as advertisements, but they do not insist on legibility as their primary concern, nor do they provide anything beyond the vaguest sense of the use to which these products should be put. Files and soap, moth balls and perfume, all receive the same dreamlike directorial treatment. In staging his experimental photographs, meanwhile, Rössler tended to cloak objects and constructions in mystery, obscuring them at times beyond all recognition. This intellectual preference renders his work quite distinct from constructivist trends in photography, whether experimental or commercial.

Jaroslav Rössler: Advertising photo, probably 1932

Rössler is often said to have adhered to constructivist principles in his compositions, or perhaps even pioneered them as they apply to photography.[3] However, his interest never lay in faktura, the textural quality of materials, which was crucial to constructivist thought in both its politically revolutionary and commercial, utopian varieties. Attention to materials led for Vladimir Tatlin or Aleksandr Rodchenko to a creative program grounded in the concrete needs of class struggle; for László Moholy-Nagy and other Bauhaus instructors, the study of material properties (in various media) served as both a pedagogical tool and a spur to object-oriented advertising and graphic design strategies.[4] In his privately made photographs, by contrast, Rössler used ordinary objects (inkwells, candles, light bulbs) in the manner of theater props, and his photographs of public spaces and industrial structures – in particular the streets and bridges of Paris – served as stock materials for equally fabricated montage compositions. The physical presence of things in these works is blurred, shaded or dissected at times to the point of dematerialization.[5]

For this reason, it is difficult to connect Rössler's commercial and experimental practices as two halves of a single and consistent engagement with the world in the manner of constructivism, whether in the context of communism or capitalism. Christina Lodder pointed out many years ago that the term "constructivist design" is an oxymoron, if constructivism means a set of politically motivated, anti-aesthetic convictions consistent with the experience of the Soviet Revolution. It would be hard to see Rössler as a Soviet-style constructivist in any case, since he never took an overt stand on society or politics.[6] Yet, if constructivist design is understood as "functionalism" – a commitment to unadorned form, rapidity of communication, efficiency of means or dialogue with a mass audience – Rössler fits equally poorly into the program.[7] While his choice of subjects certainly exudes the "technological utopianism" that Herbert Molderings identified as characteristic of the Bauhaus and functionalism in central Europe,[8] Rössler's experiments of the early 1920s cannot be seen as "laboratory" studies on the Bauhaus model. The advertising photographs, meanwhile, have an air of dreamy romanticism that seems far more of a piece with photographic tastes in Rössler's adopted city of Paris – think of the floating images of Ilse Bing, or Maurice Tabard's seductively gauzy lingerie nudes, both produced under the spell of Man Ray – than with the sober, rational details framed by Bauhaus students and affiliates or in the studios of Družstevní práce in Prague.

Paul Strand: Akeley Camera, 1922

Jaroslav Rössler: Untitled, 1927

Jaroslav Rössler: Untitled, 1932

Thus, the term "professional photographer" fails to clarify the relation of Rössler's work done for hire to the studio compositions and other photographs produced for noncommercial reasons. Not even the theories of constructivism and functionalism, which made a place for professional activity within the ranks of progressive art, quite fit what Rössler was doing. This is because Rössler took from the category of "professional" not a subject matter or a style but an approach to photography, a method, which he then adapted to his own purposes. Starting his career in a studio, Rössler was prompted to begin his own photographic work by taking pictures of staged constructions, of fabricated decors. Studios depended on accessories for their photographic illusions: costumes to be rented as status enhancers, potted plants and painted scenery that intimated an exotic setting, or the skulls, architectural columns, and other elaborate stage props favored by Drtikol for dramatic effect. Rössler saw the value of staging, and he made this approach his own — but he turned the process on its head. No seamless theater sets, no illusory realism, but reality as an open-ended sequence of illusions.

Rössler's training as a professional photographer is crucial to his artistic identity. It places the young Rössler light years away from his compatriots Jaromír Funke and Josef Sudek, both of whom started as amateur photographers; in fact, the whole world of amateur photography seems to have been quite foreign to Rössler. This is really one of his most remarkable traits, almost inexplicable in the context of the Czech lands, where amateur photography was not just a hobby but a cultural phenomenon of national proportions. By joining clubs where their work could be published, exhibited, or improved through further instruction, amateur photographers brought the medium closer to established practices in painting and sculpture than any other form of engagement with photography. These clubs functioned in ways comparable to academies of the fine arts – though without the all-important benefit of actual academic status. One might therefore expect that amateur photography, which had expanded into a worldwide network of institutions by the end of the nineteenth century, would be rocked by the same forces of innovation and change that galvanized academic painting beginning in France in the 1860s. If this were the case, Rössler's experiments in construction and composition could be placed within a history of modernist photography growing out of the ranks of the amateur movement, in the way that Impressionism, Fauvism, Cubism, etc., developed from the Salons.

Precisely because amateur photography constituted an "Academy outside the walls," however, camera clubs tended to be anxious to establish their artistic credentials, not to demolish or subvert them. The triviality of most amateur work results from this great desire to defend the medium on aesthetic grounds alone. By choosing to take pictures purely for personal ends, amateur photographers had no recourse to function or purpose in defending their compositional choices, as did professional photographers working on assignment. Furthermore, because the distinction between a mere "family album" picture and a meritorious photograph depended on transparency of form and the mastery of technique, amateur photographers could not easily participate in avant-garde polemics from the 1880s onward, which often devalued technical excellence and the legibility of pictorial representations.

The peculiar status of amateur photography, a socioeconomic category defined largely or exclusively in terms of aesthetics, marked those modernists who initially participated in the amateur movement. An insistence on technical excellence characterizes the work of Funke, Sudek, or international contemporaries of Rössler such as Paul Strand, Edward Weston, and André Kertész.[9] Likewise, their compositions are governed by a conception of beauty grounded in harmony, order, and a sensation of contemplative satisfaction or fulfillment. Rössler fully shares the emphasis on excellent printmaking common to these former amateurs, but his privately made photographs are decidedly less motivated by a search for clarity or completion. Compare a close-up of machine parts with Strand's *Double Akeley, New York* (1922). Both photographers provide a paean to industrial design, and beyond that an allegory of modernity as summed up in the workings of camera vision. However, Strand's crisp details suggest, metonymically, the perfection of a well-ordered societal machine; the internal harmony of the gears and knobs on this film camera stands in for the harmonious workings of the modern world. With equal care and deliberation, Rössler sets his — unnamed — mechanism at the entry to a void, photographing the parts in such a way that they melt into a baffling state of non-existence. Using the distinctive square format he preferred, Rössler creates a composition

that defies genres: neither vertical portrait, nor horizontal landscape, nor still life. We can advance only tentatively through this mechanical scenery, whose real-world function remains unspecified, and as is often the case we find ourselves peering into the distance, trying in vain to make sense of what it is we are looking at.

Rössler's feel for abstraction, incompletion, and visual disorientation is evident already in his earliest compositions, and it attests to the dramatic distance that separates his work from amateur practices. If certain of his techniques in the early 1920s — pigment processes, soft focus, dramatic lighting — match those found in amateur prints, this seems a response to Drtikol (the beloved favorite of so many photo clubs around the world) rather than to anything happening in the amateur associations themselves. His approach to the medium has much less in common with lifelong photographers like Strand than with those innovative painters and sculptors who "stepped in" to photographic careers more or less accidentally in the 1920s: Rodchenko, Man Ray, Moholy-Nagy, El Lissitzky, and others. [10/] At the same time, Rössler is separated from these self-identified members of the artistic avant-garde by a great divide in background. He did not share these artists' conceptual antecedents, meaning that his engagement with photography grew neither out of a reflection on the status of painting, nor out of a desire to cross the line from art to antiart. Indeed, when it comes to theories of art, Rössler may well have been a naif in the land of the avant-garde – but what does this mean exactly for the originality of his work?

The trouble in defining the photographic avant-garde is that photography has often been presented as avant-garde by its very nature – "because it undermined and questioned traditional aesthetic concepts and encouraged explorations of new territories," as Jaroslav Anděl has said in a discussion of Czech modernism. [11/] This reasoning was formulated with particular conviction in the 1920s, nowhere more than in Devětsil, where Karel Teige expended much ink in praise of the possibilities afforded by film and photography. At the same time, Teige rarely treated the work of individual photographers. He invited Rössler to join Devětsil, or so it seems, because he saw in the young photographer a kindred spirit, but he never paused to describe an actual work by Rössler as he did for the paintings of Šíma, Štyrský and Toyen, or poetry by Nezval and Seifert. This attitude is in keeping with avant-garde positions on photography elsewhere. At the Bauhaus, for instance, where Moholy-Nagy and others brought such prestige to the medium in a general way, photography remained for many years simply an aid to study in other media. Walter Peterhans, who headed the photography department that was finally established in 1929, had received his diploma in photography just three years previously.

If Rössler had worked as an unwitting accessory to the avant garde, in the manner of Eugène Atget, his work could be assimilated to the categorical celebration of photography elaborated by thinkers like Teige or the German critic Walter Benjamin. If he had developed into a photographer deliberately from the position of a modern artist, such as Rodchenko or El Lissitzky, or if he had turned to making photo-collages like Hannah Höch, Teige, and others, then his pictures could be understood in the context of an avant-garde art practice that adapted photography to its own ends. But the modernism of Jaroslav Rössler, which may or may not fit customary definitions of the avant-garde, operates in a different vein: it proceeds from the image made, not the image taken. Rössler's photographs, whether soft-focus bromoils or dynamically fragmented montages, whether abstract photograms or product advertisements, all evince a delight in staging experiments. This is a very old source of interest in photography, really, the stuff of the medium's very first practitioners.

Take, for instance, Rössler's *Self-portrait* (1929, *fig. 72*), where the artist's head is reflected in what could be a studio lamp. The photograph resembles Rodchenko's image *Chauffeur* from the same year, which presents a similarly distorted reflection of a driver in his car's side-view mirror — and a self-portrait as well in the background. Like the chauffeur (and Rodchenko), Rössler is memorialized on the job, carrying out his tasks at the center of a maelstrom; the modern world is pictured as a place of constant upheaval and disorientation. There is a magnificent fit between form and psychology in both works, with the self-possession of the pipe-smoking chauffeur magnified in the car mirror as succinctly as Rössler's legendary shyness is figured by the reflected slice of his head, half-hidden behind his camera and what seems to be an intimate kitchen table.

László Moholy-Nagy: Paris, 1932

Aleksandr Rodchenko: Chauffeur, 1929

However, the physical proximity of the subject in Rodchenko's photograph, framed on the left by the car he drives and behind him by a multistory apartment building, pushes us up against a world in transition – a world in which the photographer has visibly intervened, handheld Leica at the ready. Rössler's self-image is formed instead within the confines of his own teatro mundi. He may share the formal language of Rodchenko, but in spirit he is closer to the pioneering French civil servant Hippolyte Bayard, who took a break from photographing studio arrangements of plaster casts one day in 1840 to picture himself, rather melodramatically, as a drowned man. Bayard staged his own death to protest official neglect of his photographic inventions, overshadowed by those of the more famous Monsieur Daguerre; avoiding public scrutiny altogether, Rössler preferred to fashion in secret his self-image as a technician of light.

The remarkable early studies of circa 1919–1923 are in keeping with this exploratory approach, in which Rössler adopts the role of an enthusiast preoccupied with testing the perceptual boundaries of his chosen medium. His versions of *Skylight* (1923, *fig. 24*) are controlled experiments in tonal scale, on the one hand, and the relation of planar to volumetric space on the other: two subjects integral to an investigation of photography. These deceptively casual studies suggest the home laboratories of gentleman photographers in the mid-1800s more than the "laboratories" where a collective revolution was prepared in design at the Bauhaus, or in politics at Moscow's INKhUK. The alchemical satisfaction afforded to Rössler by transforming a swatch of gingham and a cylinder into the face of a woman, or recording smoke and light bulbs as abstract shapes, likewise recalls the joy of discovery palpable in work by the first practitioners of photography. Like a hauntingly soft calotype, or the mutable surface of a daguerreotype plate, which yields its image to viewing only when held at the proper angle, Rössler's studio experiments are suffused with a sense of sweet mystery.

For all this, Rössler's vision is decisively of the early twentieth century. The head of a radio operator, an isolated phonograph needle, a detail of a flash bulb; these are so many metaphors for the fragmentation heralded by modernism, not nostalgic remnants of a decimated yet eternal past but glorifications of the ever-changing, technological present. When Rössler moved to Paris and began working outdoors more often, his subjects shifted to form a still grander paean to modern life: the Eiffel Tower (or its copy in Prague), the Métro, the enamel signs and splendid café awnings lining the boulevards, the neon lights. Rössler rarely left his street shots as they were; these subjects were mainly raw material, and just as he had formerly arranged his subjects in Drtikol's studio, so now did he dissect, rearrange, and superimpose the images collected outside within the privacy of his darkroom. An image meant nothing unless it had been composed. Construction and transformation are the fundamental elements in all of Rössler's work – and of course evanescence as well. Jaroslav Rössler's prints have no memory. As soon as one had been brought into being, that experiment was over, and it became time to set up the next one.

NOTES

1/ The later work seems to be even closer to the means of expression of Constructivist design than does his prewar work. Thus, for example, several studies of various objects, abstract forms, and typographic designs from the early 1960s, now in the J. Paul Getty Museum, Los Angeles, are clear, rationally organized, two-dimensional compositions, which one might easily believe to be the exercises of a Bauhaus student.

2/ The term "constructor" in the essay on photography brings to mind El Lissitzky's self-portrait: *The Constructor* (1924), which is both "constructed" and about a construction. Despite a similarity in terminology, Rössler's work does not give the impression that he saw himself as an engineer of a new society along the lines of the Soviet avant-garde.

3/ See Antonín Dufek and Jaroslav Anděl, "Remaking the Photogram: The Pioneering Work of Jaromír Funke and Jaroslav Rössler," in Jaroslav Anděl (ed.), *El Arte de la vanguardia en Checoslovaquia/The Art of the Avant-garde in Czechoslovakia, 1918–1938* (Valencia: IVAM Centre Julio González, 1993), pp. 144–53.

4/ For Moholy-Nagy, see Eleanor M. Hight, *Picturing Modernism: Moholy-Nagy and Photography in Weimar Germany* (Cambridge: MIT Press, 1995).

5/ Jaroslav Anděl and Antonín Dufek consider dematerialization to be one of Rössler's key interests in the 1920s. See Anděl and Dufek, "Remaking the Photogram," in Anděl (ed.), *El Arte de la vanguardia en Checoslovaquia /The Art of the Avant-garde in Czechoslovakia, 1918–1938*, p. 149.

6/ Christina Lodder, *Russian Constructivism* (New Haven: Yale University Press, 1983).

7/ There is some evidence that Rössler was interested in photography that commented on society. Some documentary views of marketplaces in Paris and Prague and shots of street vendors in the Czech illustrated weekly *Pestrý týden* are framed so as to evoke sympathy with working people. As these shots have been preserved only as negatives, it is difficult to determine what Rössler's intentions were in photographing them. Nevertheless, from one of the superbly executed photographs in the J. Paul Getty Museum, Los Angeles, which shows an elegantly dressed black man talking to a clochard at the crowded Parisian racetrack, it is clear that Rössler valued subject matter from everyday life and with it probably also the depiction of various social conflicts, although even in this particular photograph his intentions are not clear. Last but not least there is the matter of Rössler's being mysteriously deported from France in 1935, which was apparently because he had taken photographs of a political demonstration there.

8/ Herbert Molderings, "Urbanism and Technological Utopianism: Thoughts on the Photography of Neue Sachlichkeit and Bauhaus," in David Mellor (ed.), *Germany: The New Photography, 1927–1933* (London: Arts Council of Great Britain, 1978).

9/ This sort of generalization needs to be made more precise in the case of the individual photographers. Kertész, for example, provided photographs for publication and exhibition only several times in the years he was photographing in Hungary. Nonetheless, his subject matter and approach to photography initially had most in common with the amateur movement.

10/ Here, too, it is a matter of generally pointing out the similarity rather than a precise depiction of the careers of the photographers under discussion. Man Ray, for example, did not learn to use a camera until 1914, when he wanted to document his prints and paintings. Also in this period he was faced with the understanding of photography as an art form on numerous visits to Stieglitz's "291" gallery. Yet, he did not seriously begin to devote himself to experiments in photography and commissioned portraits until after he moved to Paris in 1921.

11/ Jaroslav Anděl, "Modernism, the Avant-garde, and Photography," in Anděl et al., *Czech Modernism, 1900–1945* (Houston: The Museum of Fine Arts, 1989), p. 87.

**Photographs, Collages, Drawings**

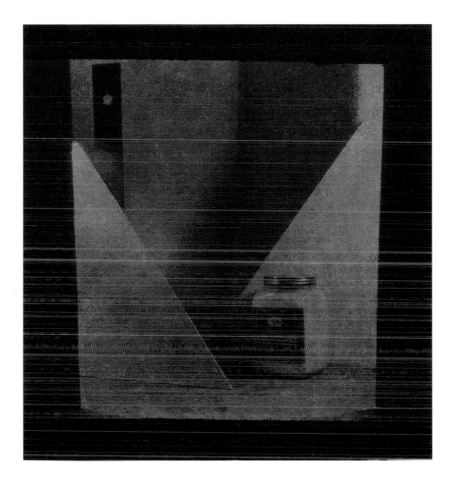

1/ **Opus I**, 1919 (The Museum of Decorative Arts, Prague)

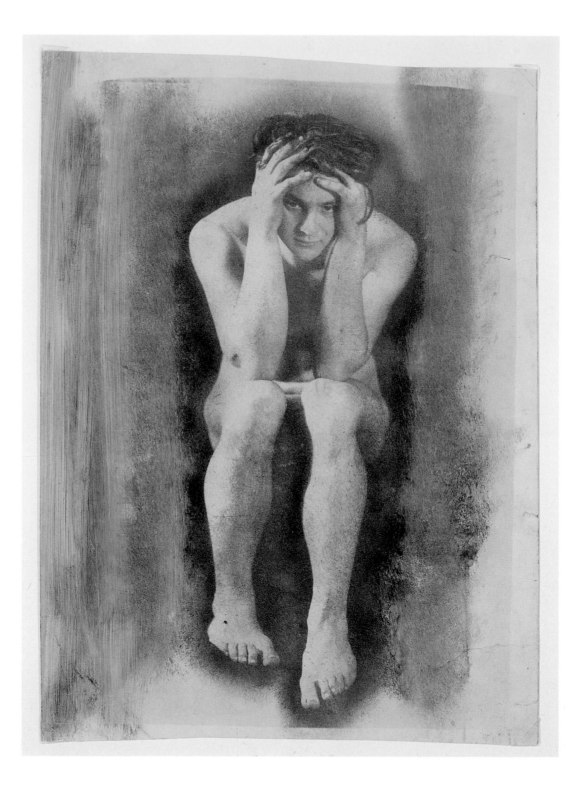

2/ **Seated Nude (Self – Portrait)**, 1922–23, orange toned brom-oil print signet by both Rössler and Fischerová
(Collection of Michael P. Mattis, Scarsdale, New York)

3/ **Untitled**, 1922–23, photograph and drawing (artist's estate)

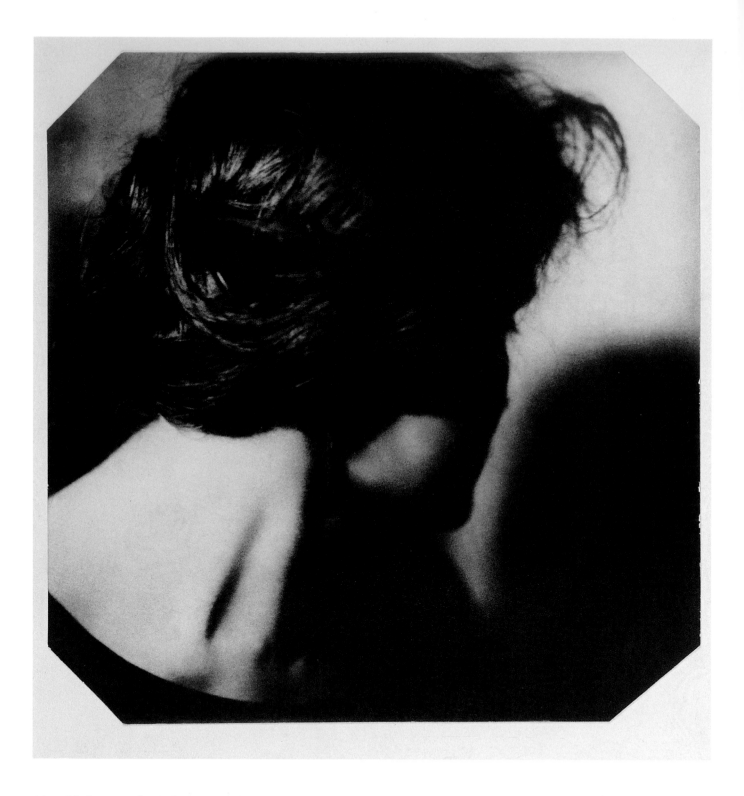

4/ **Untitled (Gertruda Fischerová)**, 1924, pigment (The Museum of Decorative Arts, Prague)

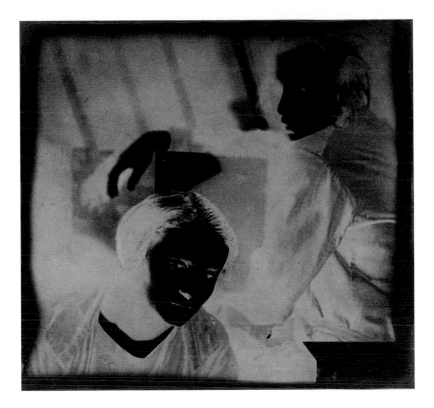

5/ **Double-Portrait of Jarmila Rambousková
and Gertruda Fischerová,**
1924, negative print
(private collection, Prague)

6/ **Double-Portrait of Jarmila Rambousková
and Gertruda Fischerová,**
1924 (Robert Koch Gallery, San Francisco)

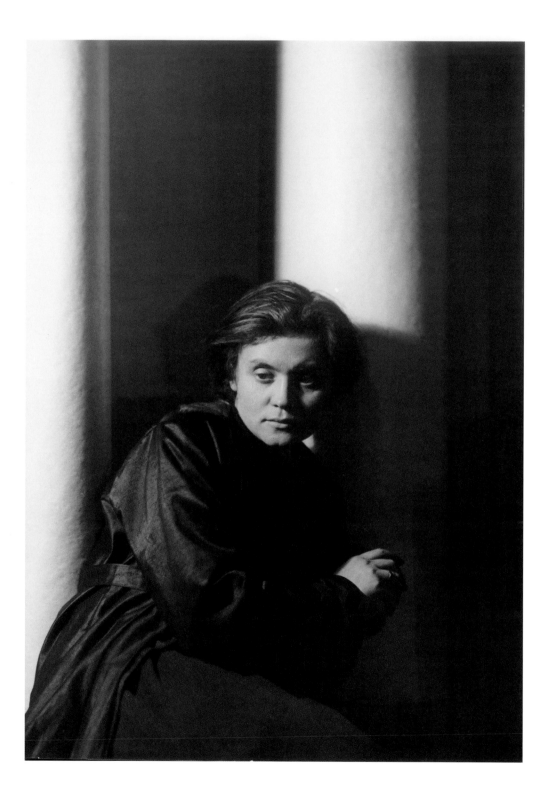

7/ **Miss Gerta**, 1924, gelatin silver print (private collection, Prague)

8/ **Miss Gerta**, 1924, bromoil print (Moravian Gallery, Brno)

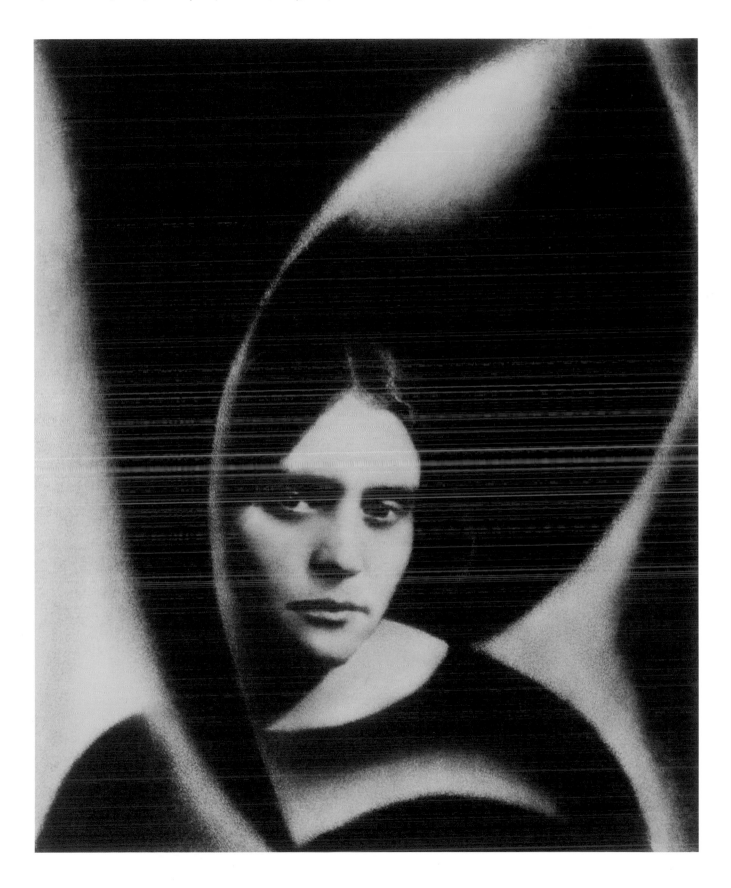

9/ **Brother**, 1924, bromoil print (The Museum of Decorative Arts, Prague)

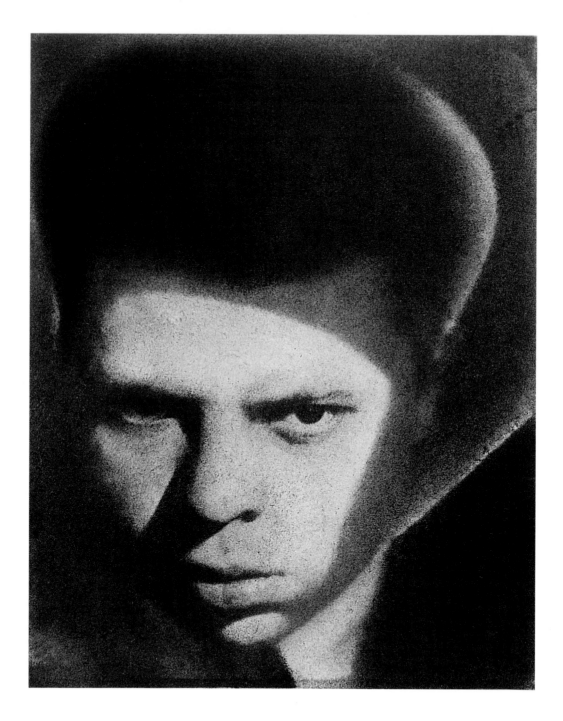

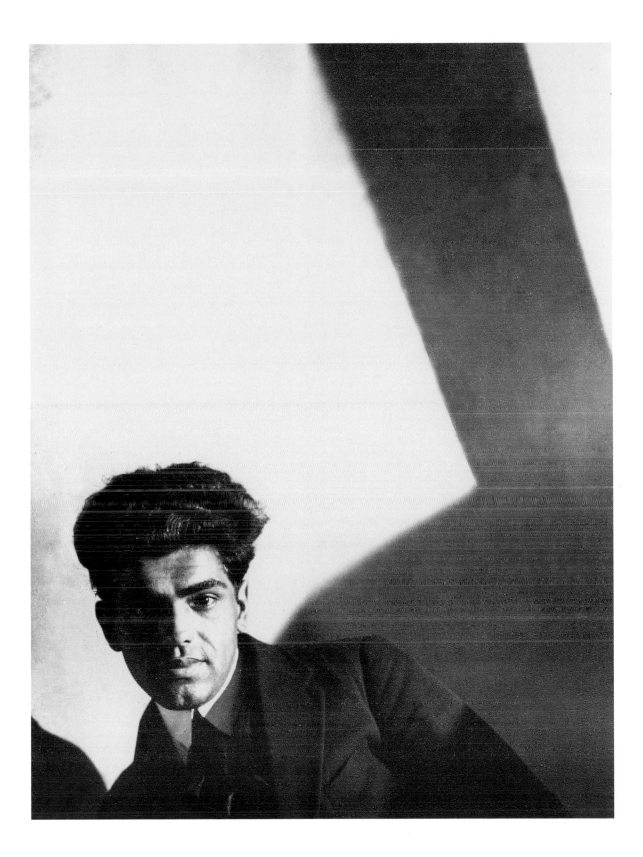

10/ **Portrait**, 1922–23, gelatin silver print (private collection, Prague)

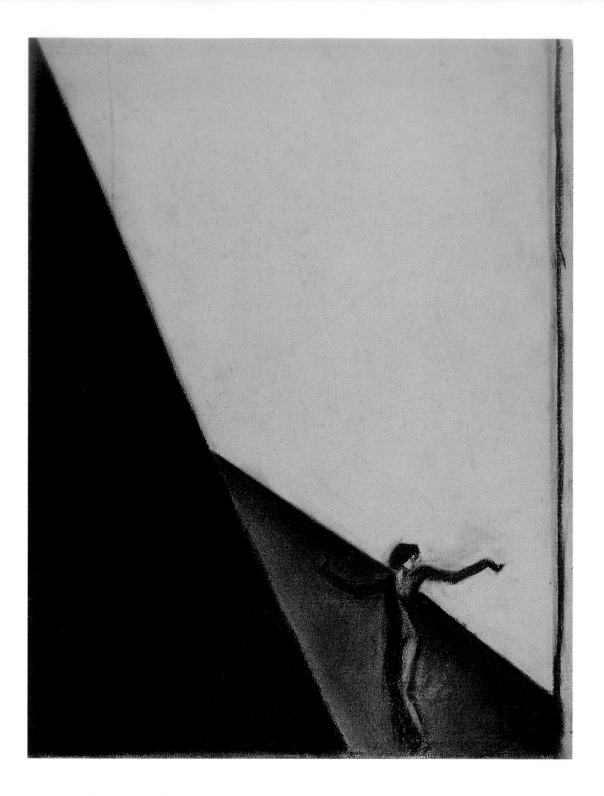

11/ **Untitled**, circa 1923, charcoal on paper (artist's estate)

12/ **Untitled**, circa 1923, charcoal on paper (artist's estate)

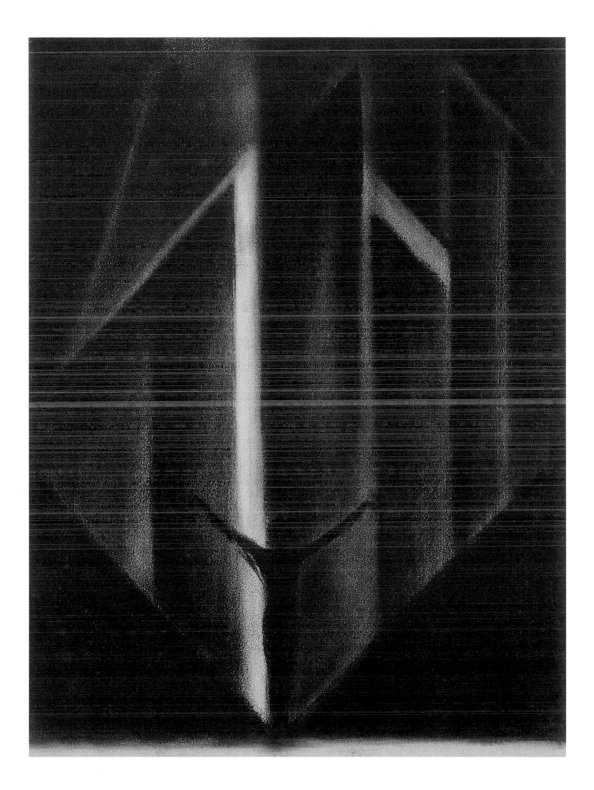

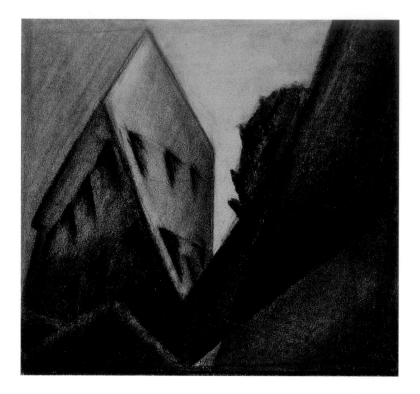

13/ **Untitled (Smilov)**, 1923, charcoal on paper
(artist's estate)

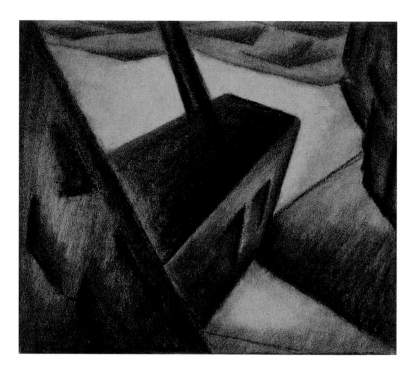

14/ **Untitled**, 1923, charcoal on paper (artist's estate)

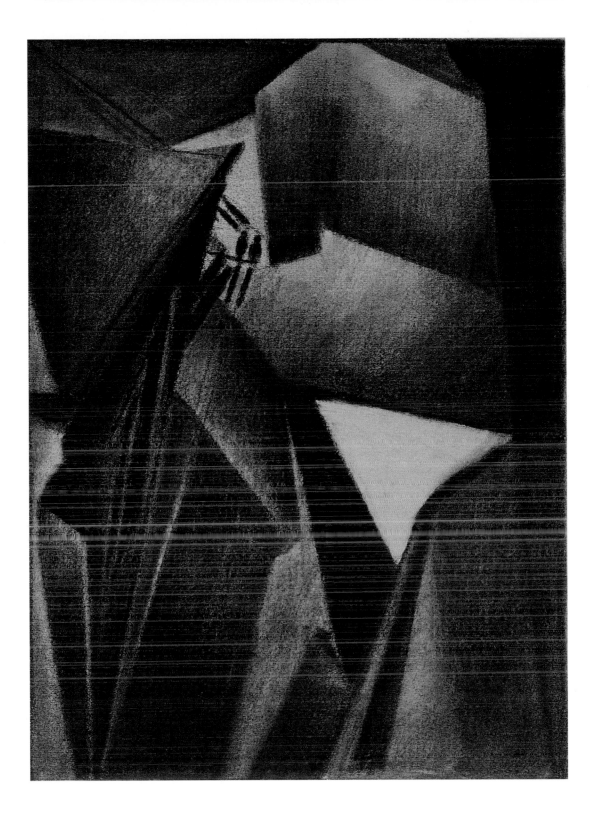

15/ **Untitled**, 1923, charcoal on paper (artist's estate)

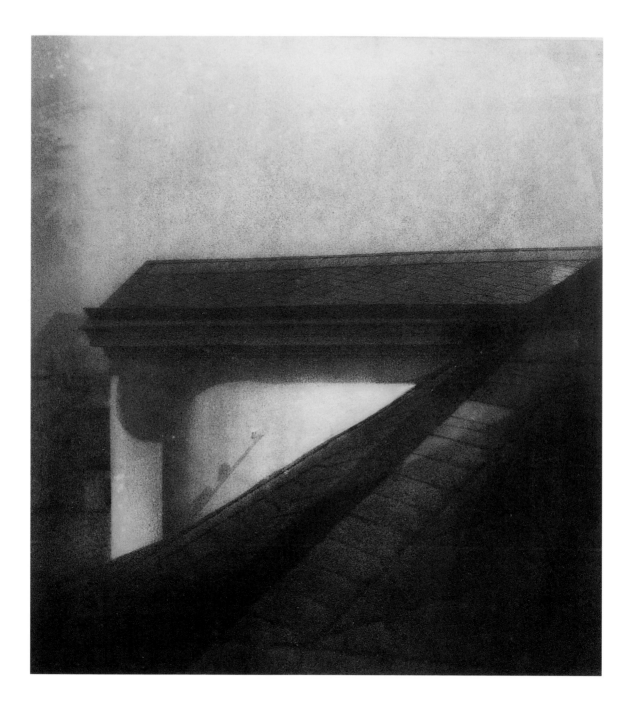

16/ **Untitled**, 1924, bromoil print (The Museum of Decorative Arts, Prague )

17/ **Detail**, 1924, bromoil print (The Museum of Decorative Arts, Prague)

18/ **Composition with Candle**, 1923, bromoil print (The Museum of Decorative Arts, Prague)

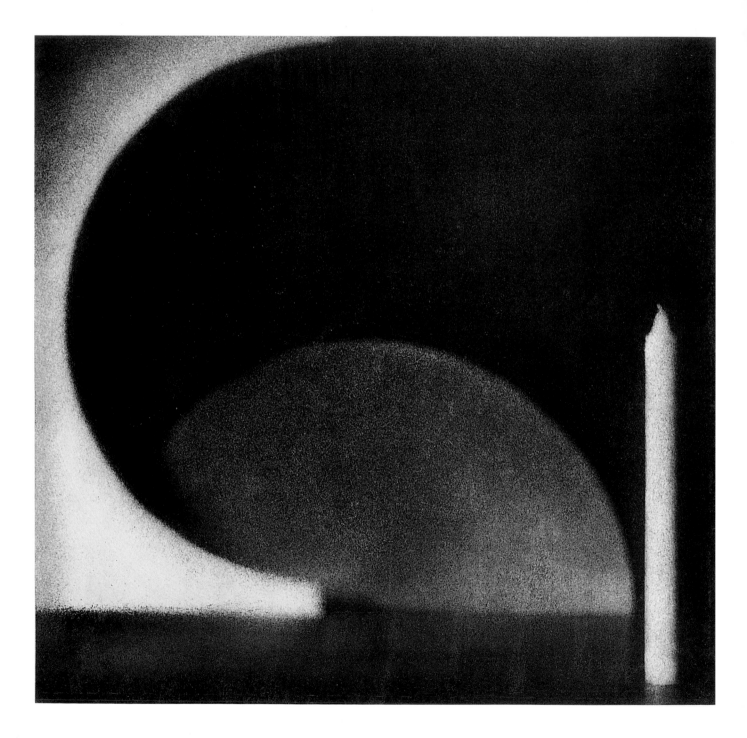

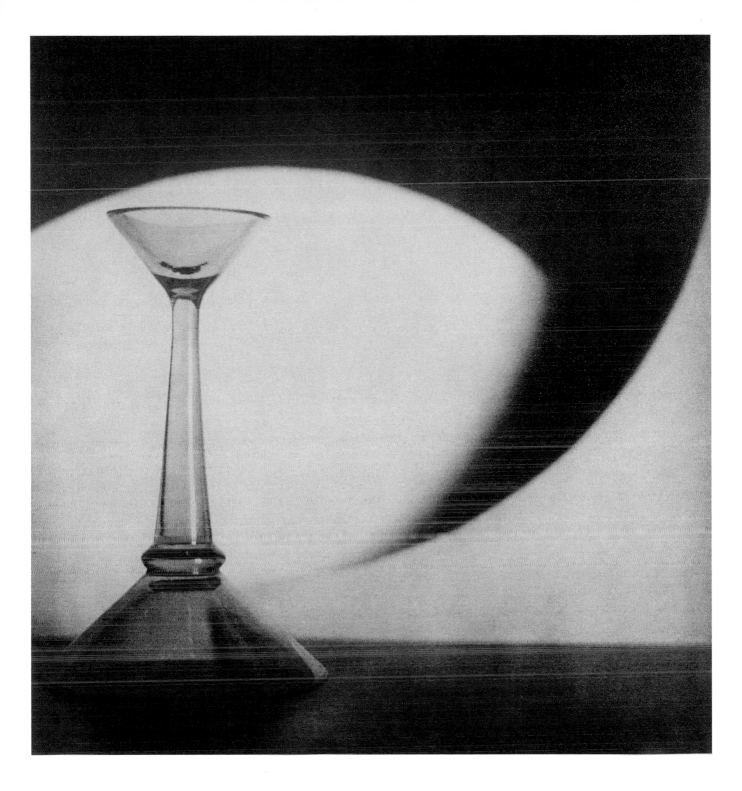

19/ **Study**, 1923, bromoil print (The Museum of Decorative Arts, Prague)

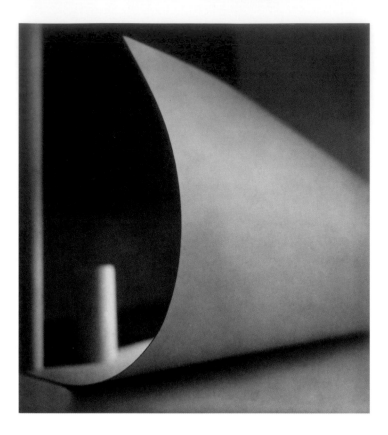

20/ **Untitled**, circa1923, gelatin silver print
(artist's estate)

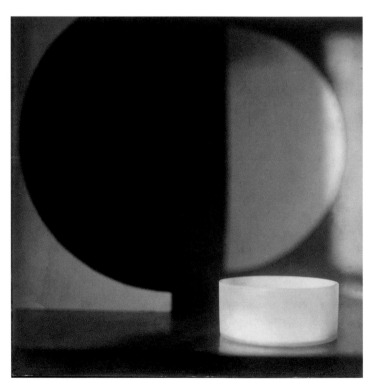

21/ **Still Life with Small Bowl**, 1923, gelatin silver print,
(artist's estate)

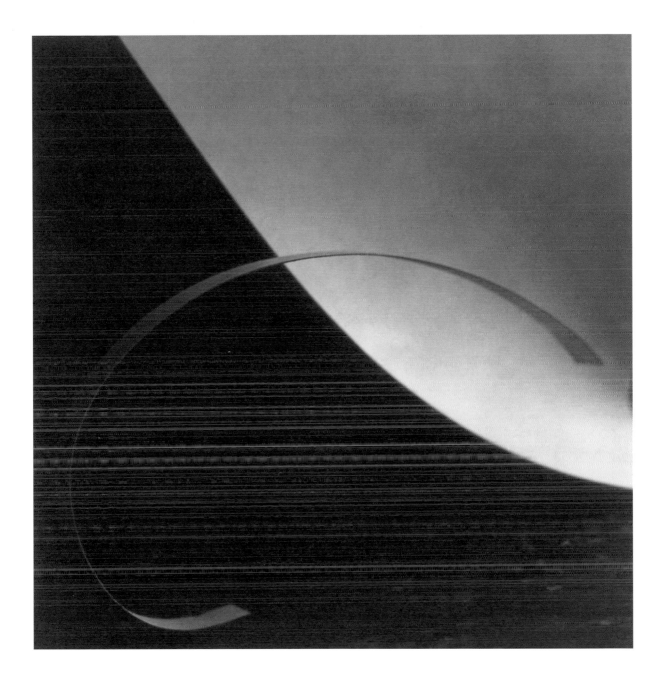

22/ **Untitled**, circa 1923, gelatin silver print (artist's estate)

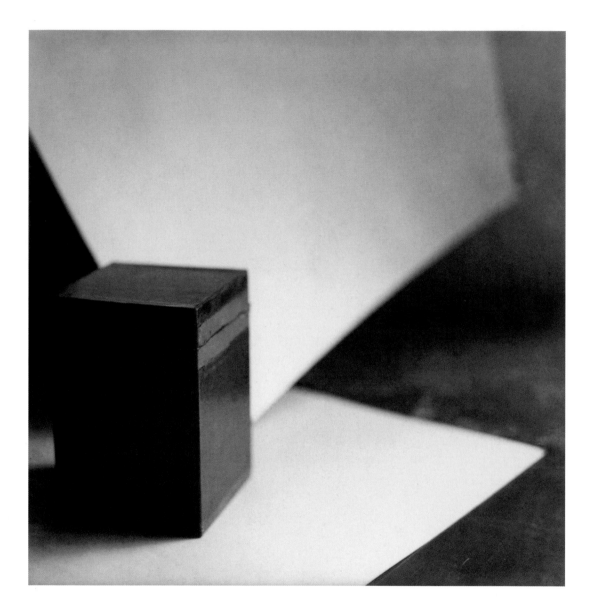

23/ **Untitled**, 1923, gelatin silver print (artist's estate)

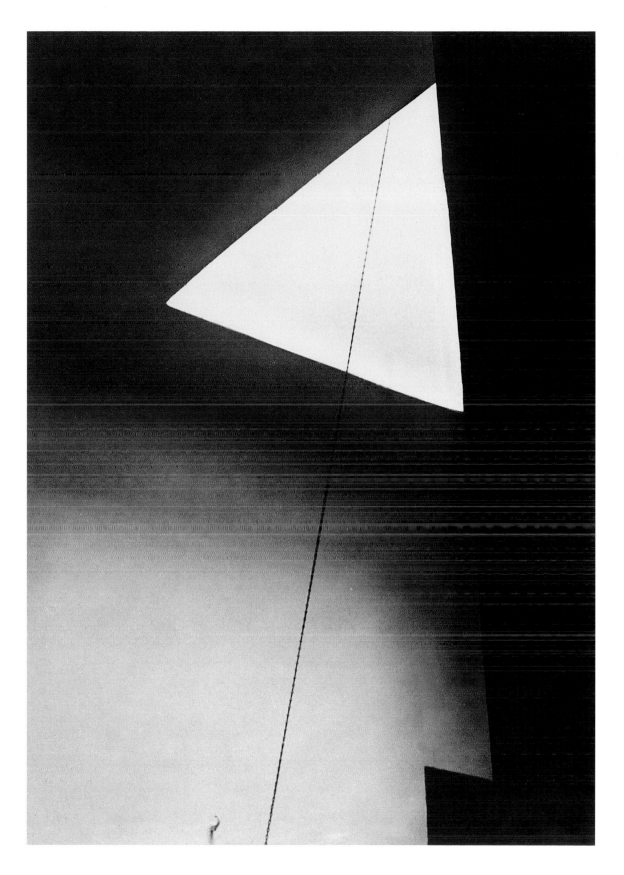

24/ **Skylight (Print Room)**, 1923, gelatin silver print (The Museum of Decorative Arts, Prague)

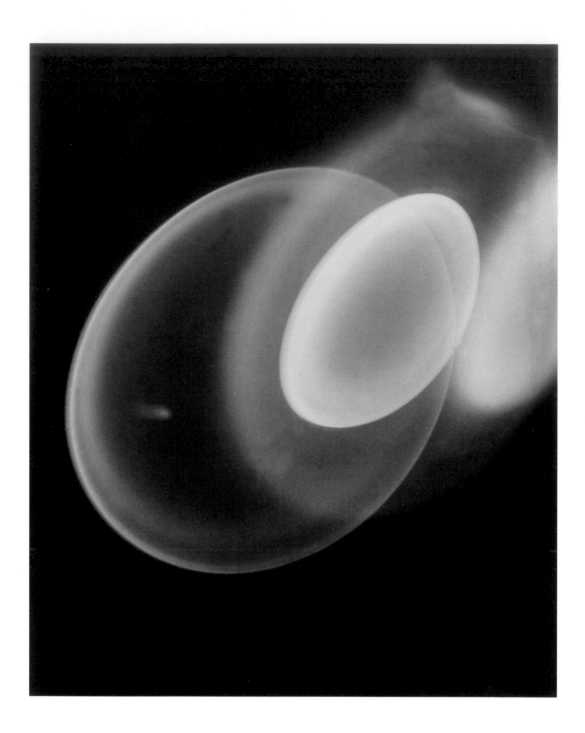

25/ **Untitled**, 1923 (artist's estate)

26/ **Untitled**, 1923, gelatin silver print (private collection, Prague)

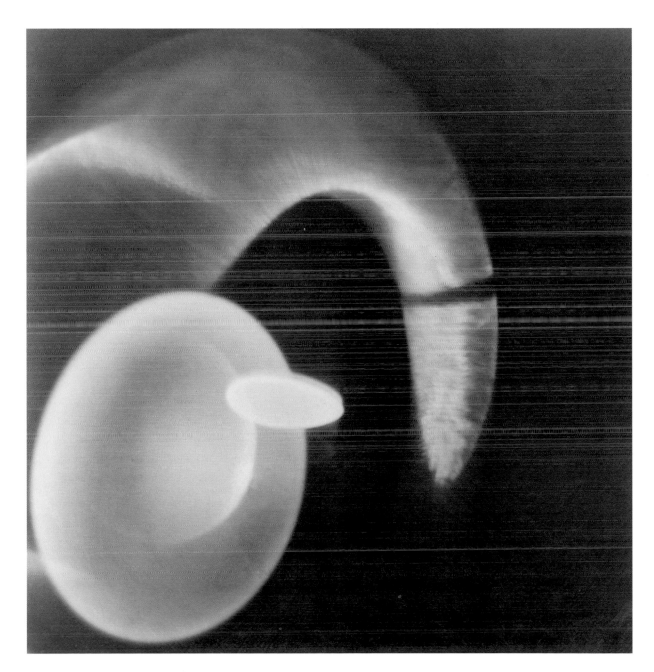

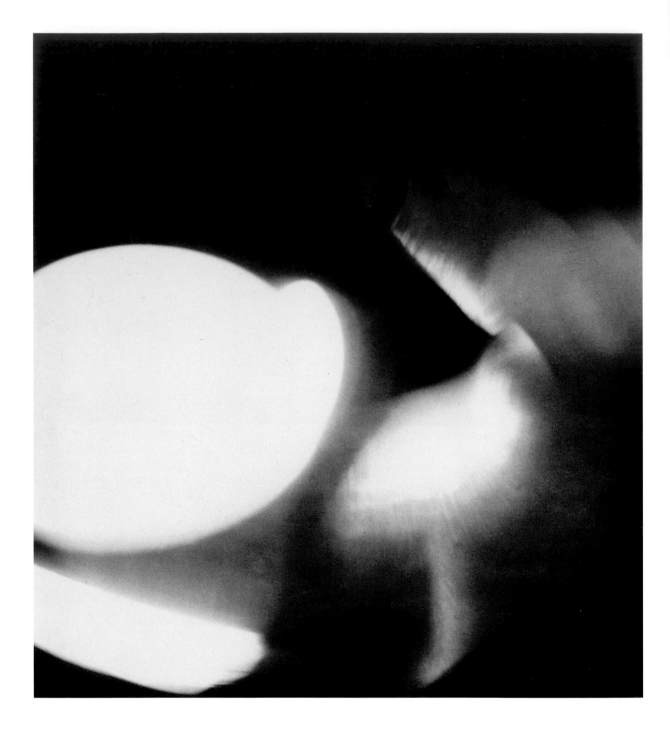

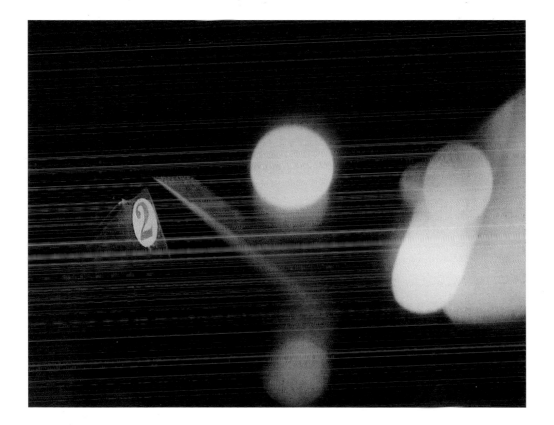

28/ **Untitled**, 1923–25, gelatin silver print (The Museum of Decorative Arts, Prague)

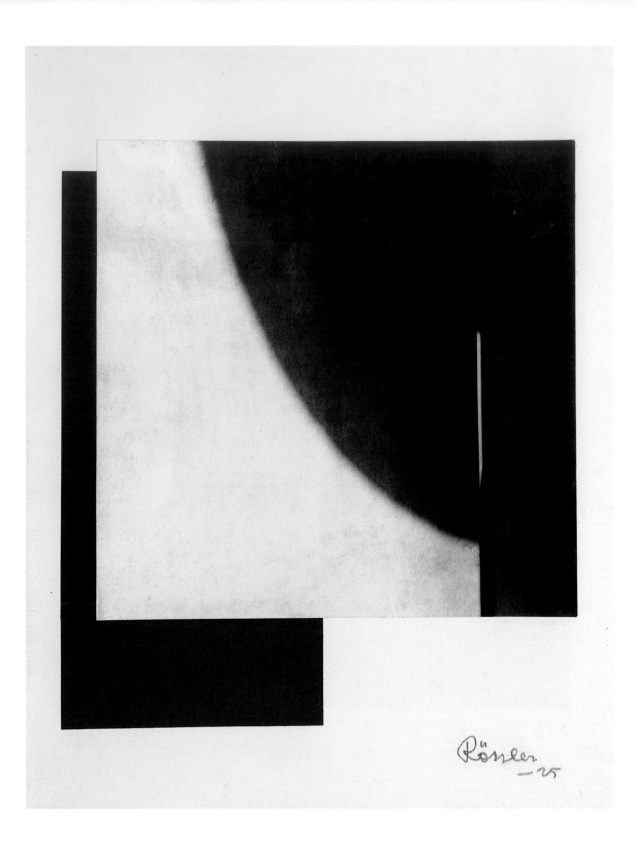

29/ **Photograph IV**, 1925, montage of a gelatin silver print and a paper (The Museum of Decorative Arts, Prague)

30/ **Photograph I**, 1925, montage of a gelatin silver print and a paper (The Museum of Decorative Arts, Prague)

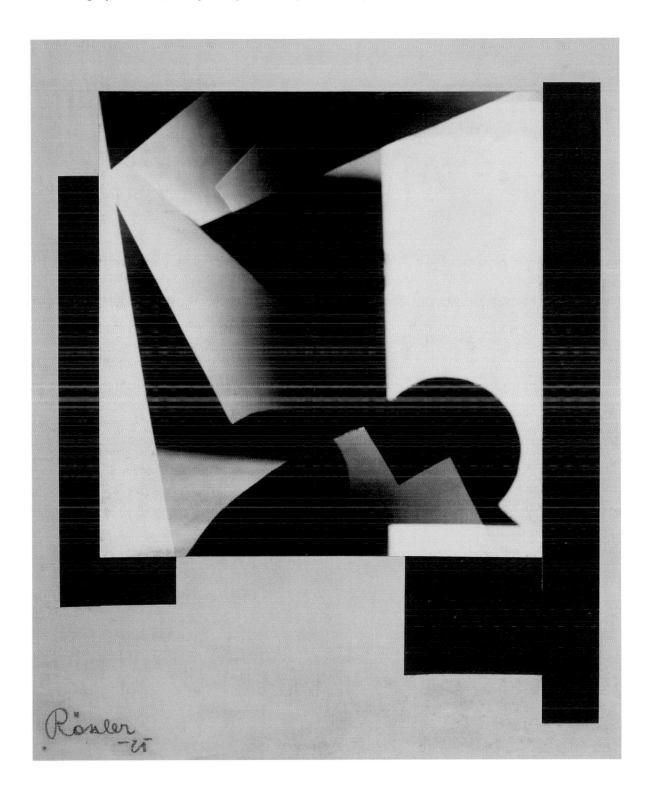

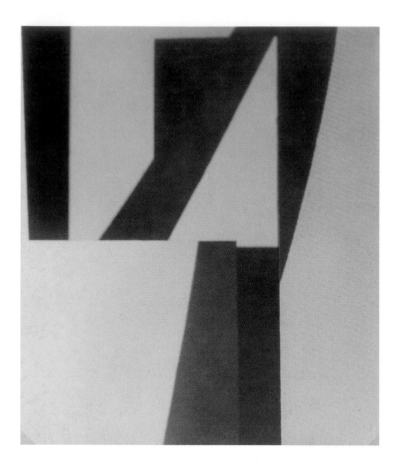

31/ **Untitled**, 1923, gelatin silver print
(artist's estate)

32/ **Untitled**, 1923, gelatin silver print
(artist's estate)

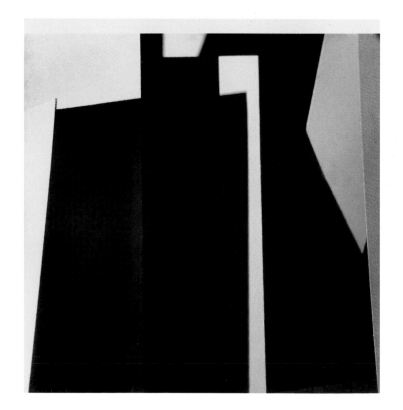

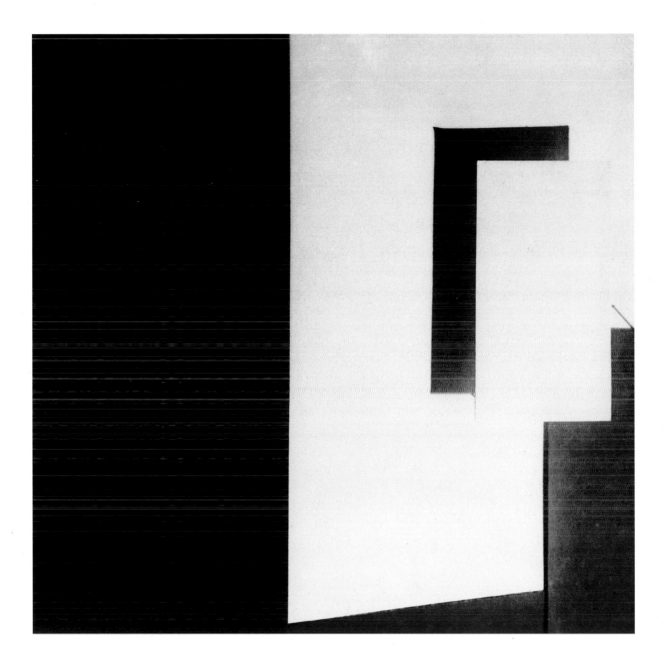

33/ **Untitled**, 1924–26, gelatin silver print (The Museum of Decorative Arts, Prague)

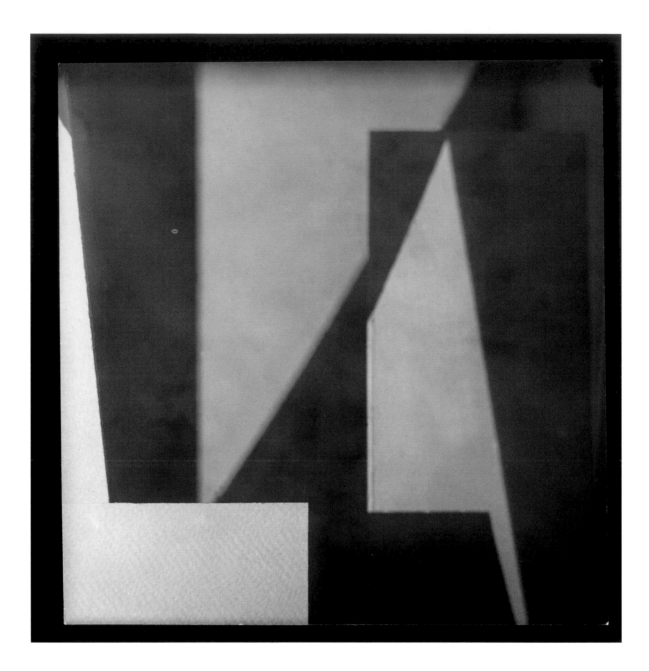

34/ **Untitled**, 1923, gelatin silver print (The Museum of Decorative Arts, Prague)

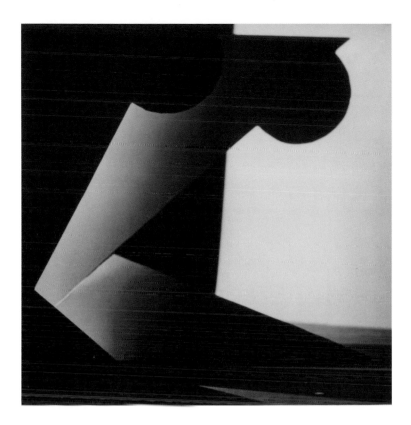

35/ **Abstraction**, 1923–25, gelatin silver print
(artist's estate)

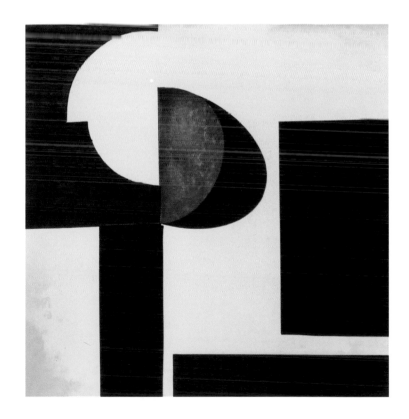

36/ **Untitled (Relief on Pasteboard)**, 1923–25,
from the portfolio Jaroslav Rössler, Rudolf Kicken Gallery,
Cologne, 1982, gelatin silver print
(artist's estate)

37/ **Petřín View Tower in Prague**, 1922–26, bromoil print (The Museum of Decorative Arts, Prague)

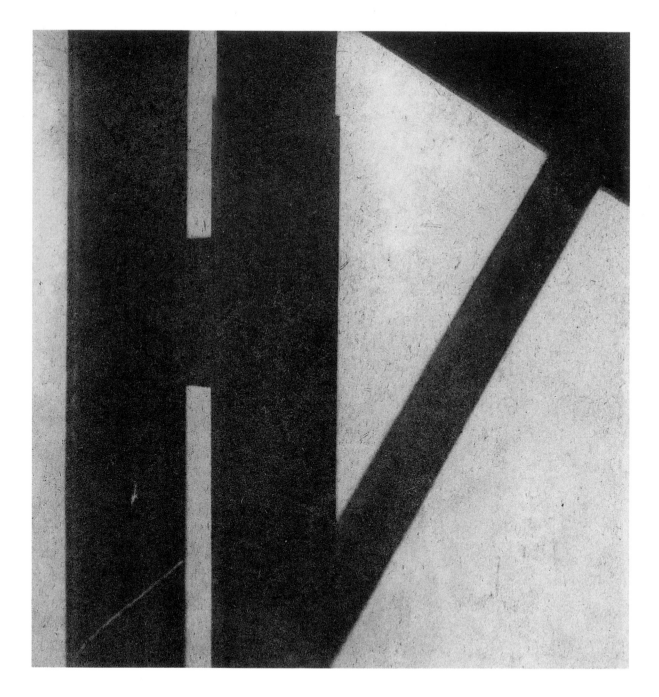

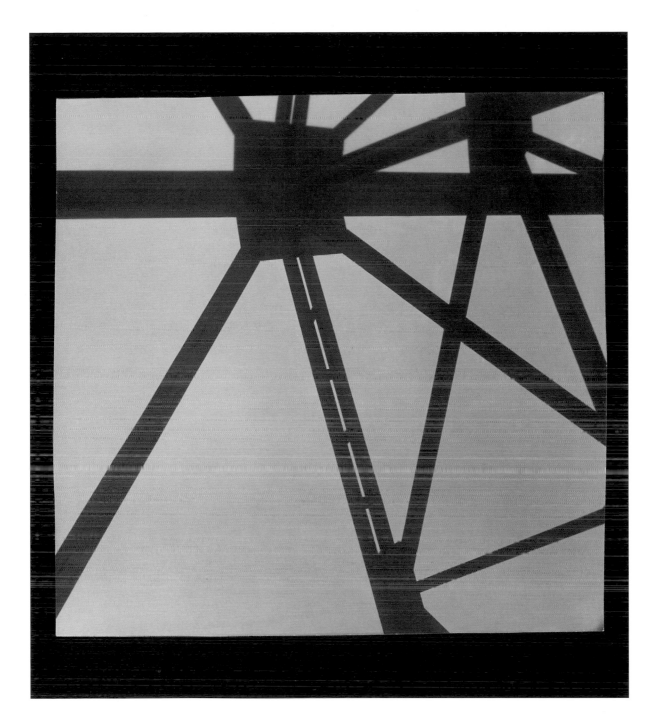

38/ **Petřín View Tower in Prague**, before 1927, gelatin silver print (artist's estate)

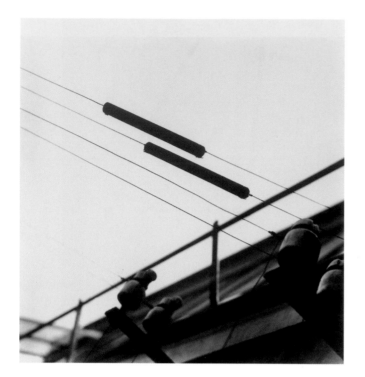

39/ **Untitled**, 1923, gelatin silver print (artist's estate)

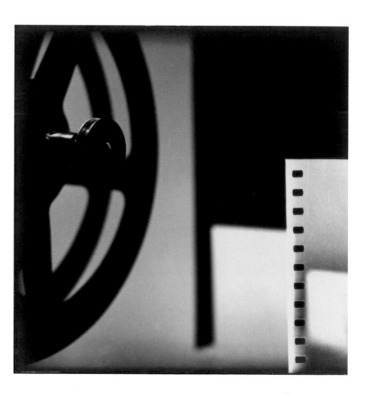

40/ **Transmission**, 1923–24,
gelatin silver print
(artist's estate)

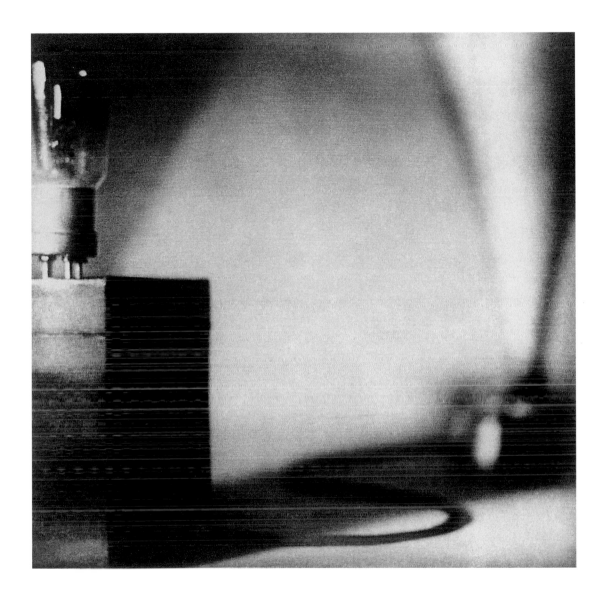

41/ **Untitled**,1922,  pigment print (The Museum of Decorative Arts, Prague)

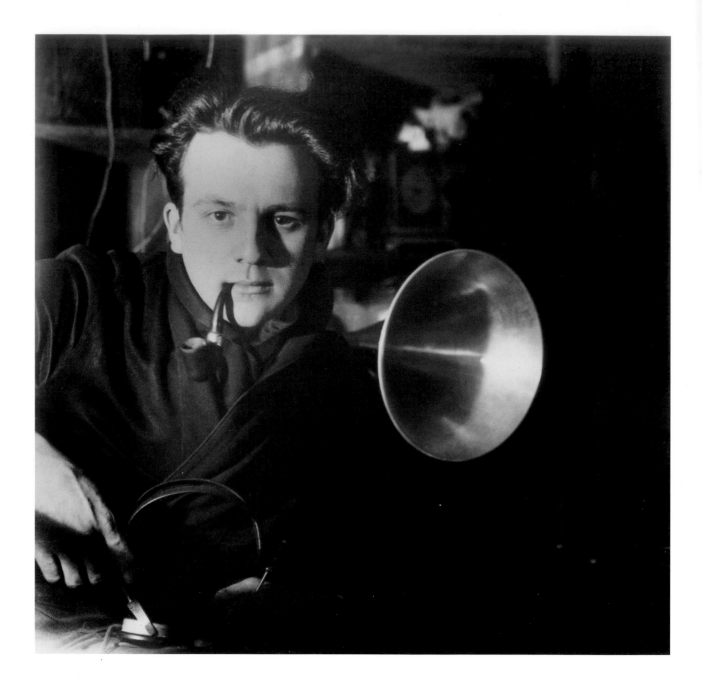

42/ **Self – Portrait**, 1924, gelatin silver print (artist's estate)

43/ **Untitled**, circa 1924–26, gelatin silver print (artist's estate)

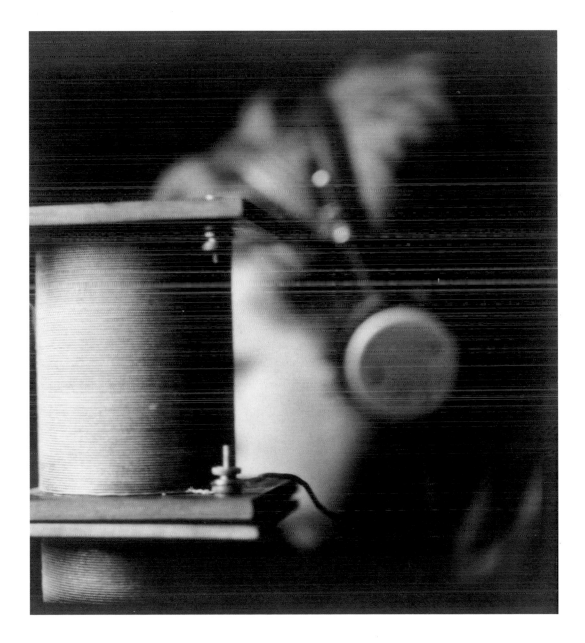

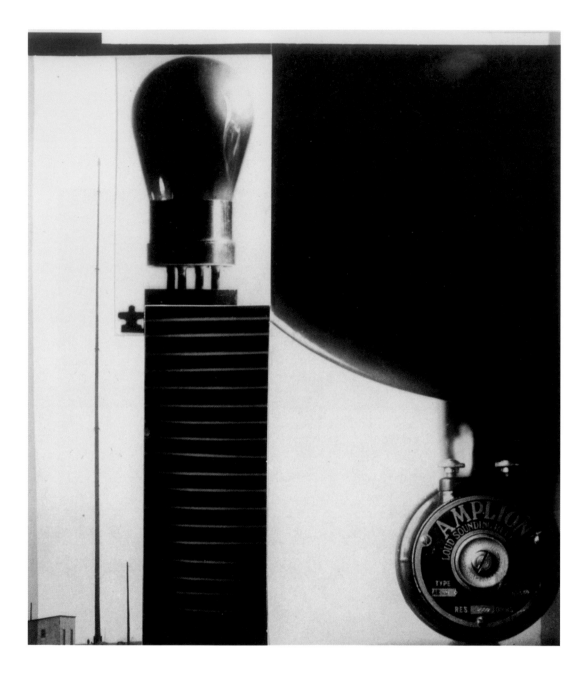

44/ **Radio**, 1923–24, collage (Prakapas Gallery, Bronxville, New York)

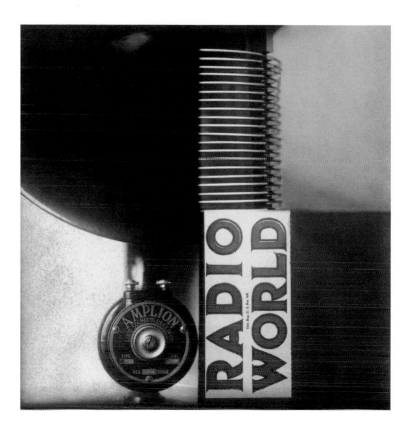

45/ **Radio World**, 1924
from the portfolio Jaroslav Rössler,
Rudolf Kicken Gallery, Cologne, 1982,
gelatin silver print (artist's estate)

46/ **Composition**, 1924, gelatin silver print
(The Museum of Decorative Arts, Prague)

47/ **The Dancer Ore Tarraco**, 1923, drawing, brom-oil print (private collection, Prague)

48/ **Untitled**, 1923, charcoal, and pastel on paper (artist's estate)

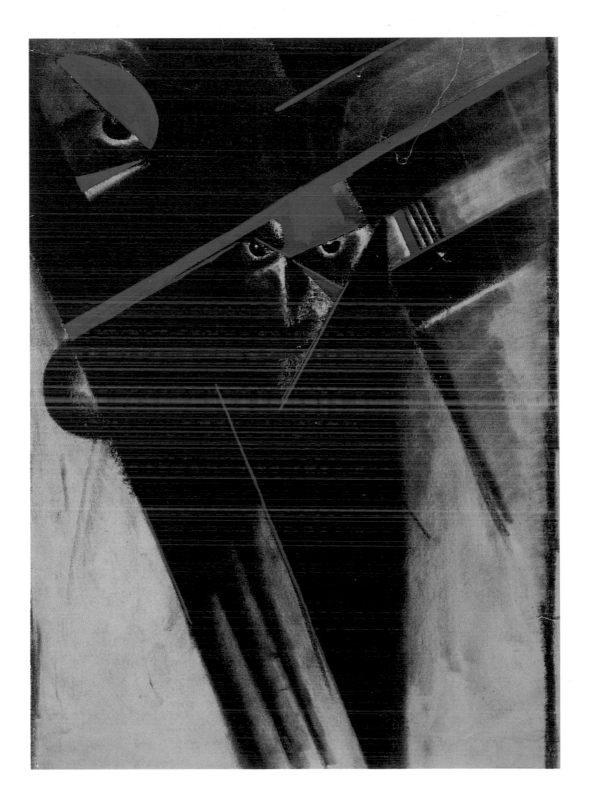

49/ **Untitled**, 1923, oil and gouache on pasteboard (artist's estate)

50/ **Untitled**, 1925, charcoal, pastel (private collection, Prague)

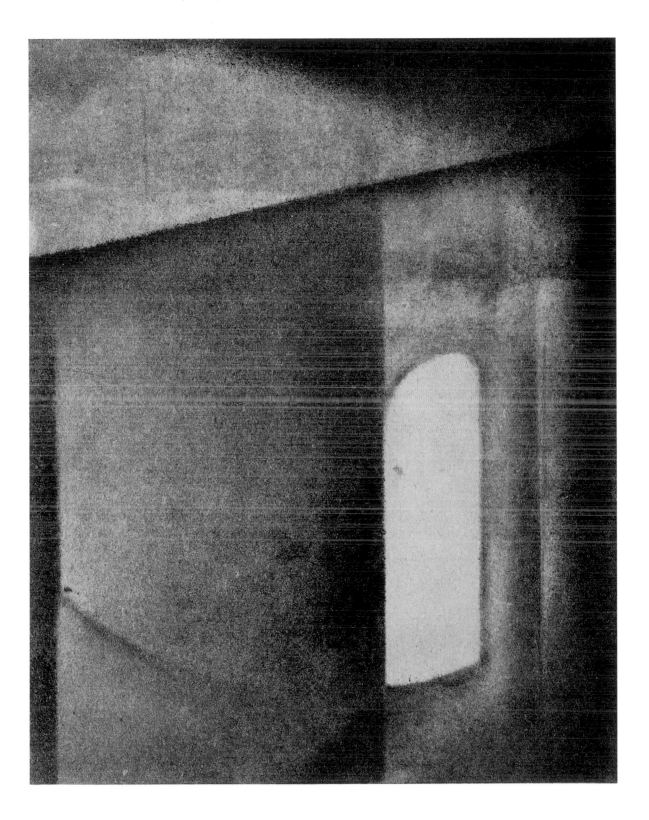

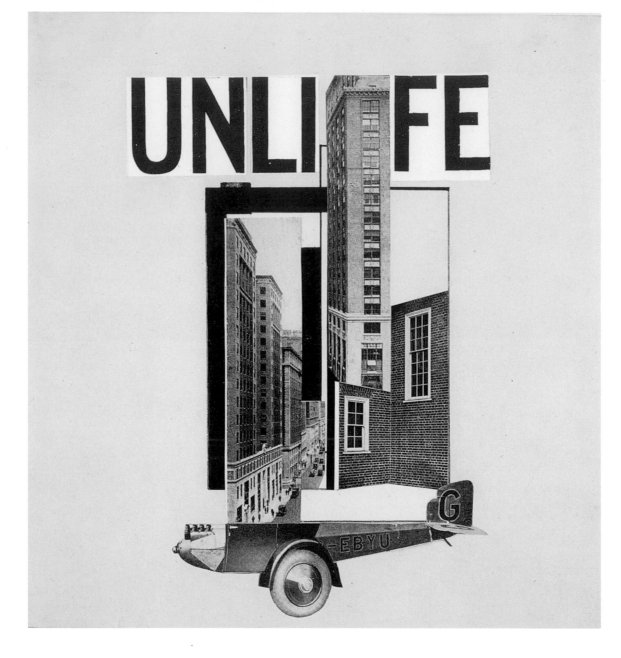

51/ **UNLIFE**, 1926, collage on paper (collection of Jaroslav Anděl, New York)

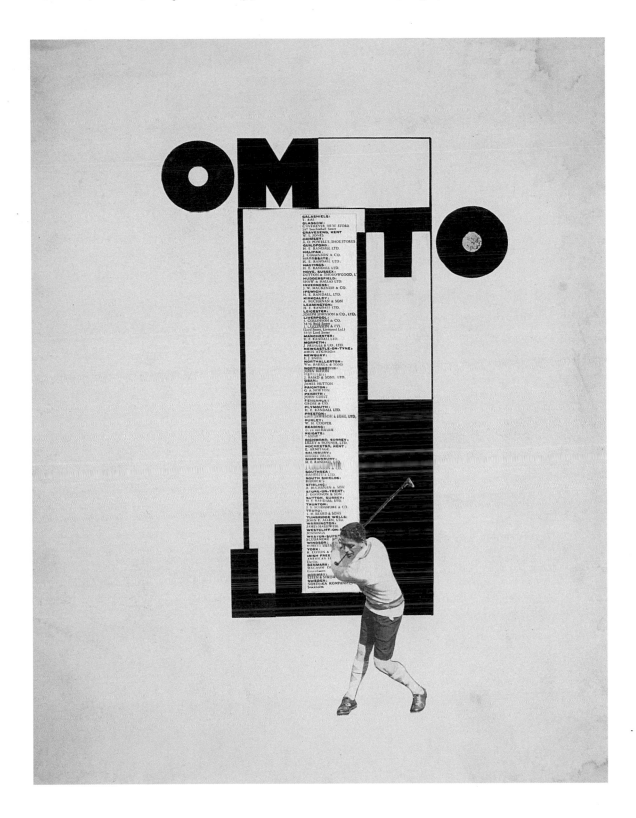

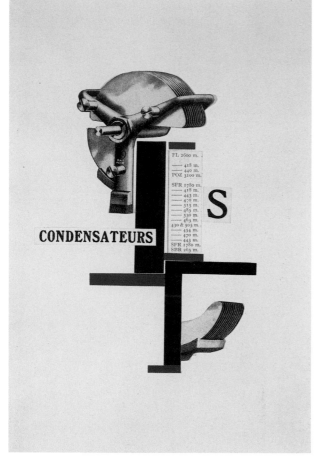

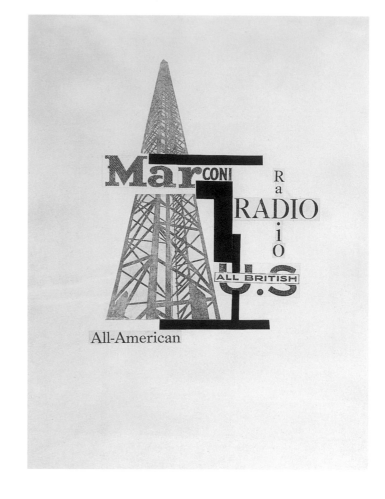

54/ **Radio Marconi**, 1926, collage on paper
(The Museum of Decorative Arts, Prague)

53/ **Condensateurs**, 1926, collage on paper
(The Museum of Decorative Arts, Prague)

55/ **Poster**, 1927–35 (collection of Gary Richwald, Los Angeles)

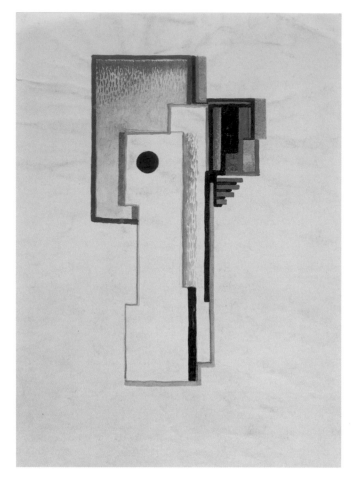

57/ **Untitled**, circa 1926, watercolor on cardboard
(artist's estate)

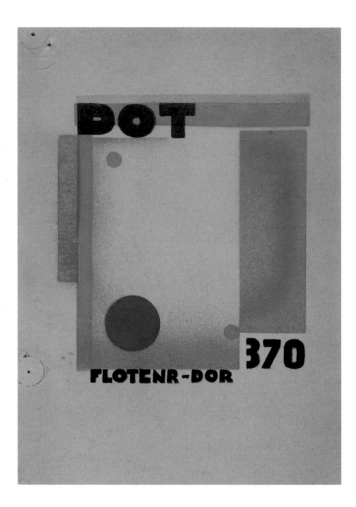

56/ **Untitled**, circa 1926, watercolor on cardboard
(artist's estate)

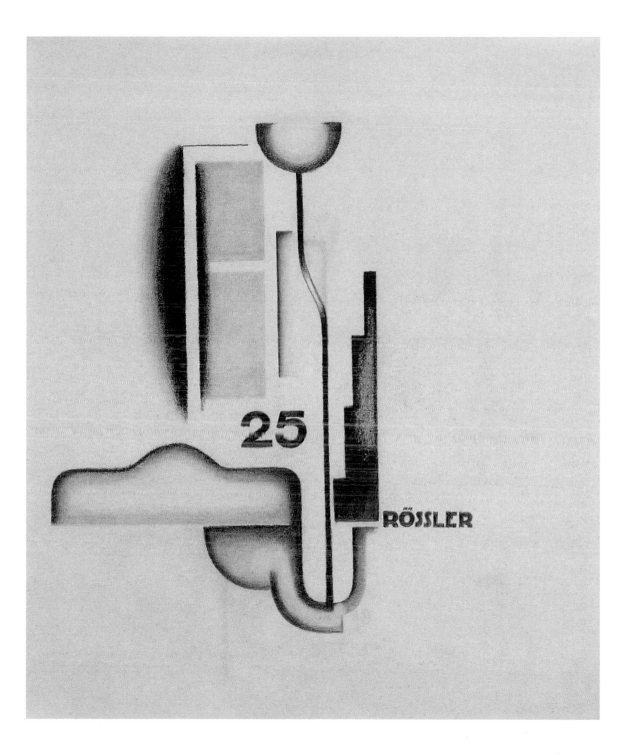

58/ **Untitled**, 1926, pencil on paper (The Museum of Decorative Arts, Prague)

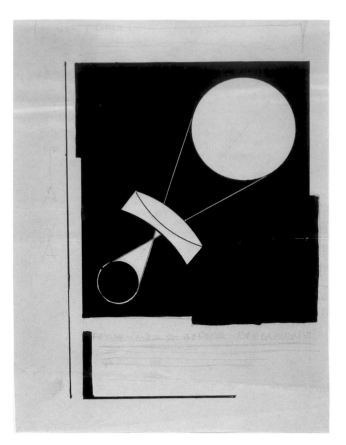

59/ **Untitled**, circa 1926, pencil and ink on paper
(artist's estate)

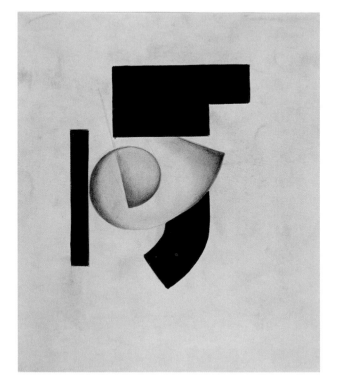

60/ **Untitled**, circa 1926, pencil and ink on paper
(artist's estate)

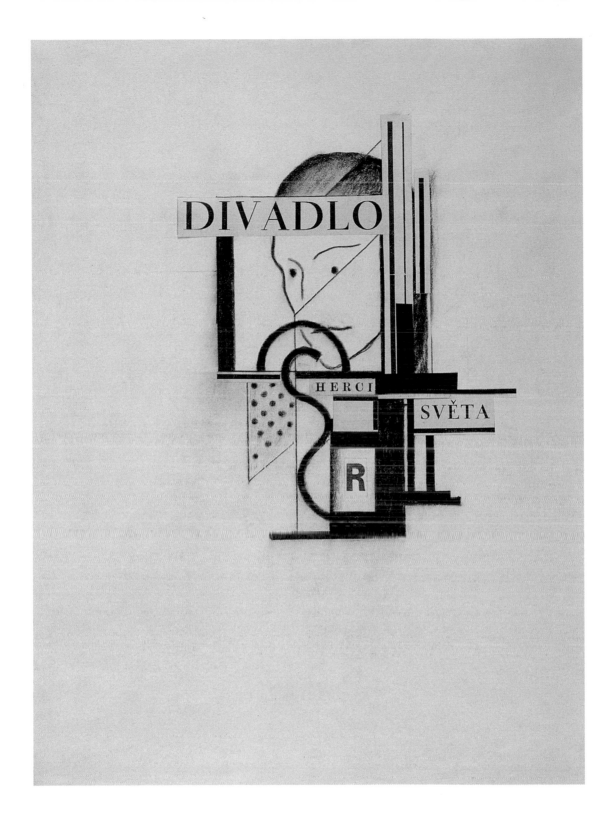

61/ **Untitled**, 1926, collage, charcoal drawing, paper (The Museum of Decorative Arts, Prague)

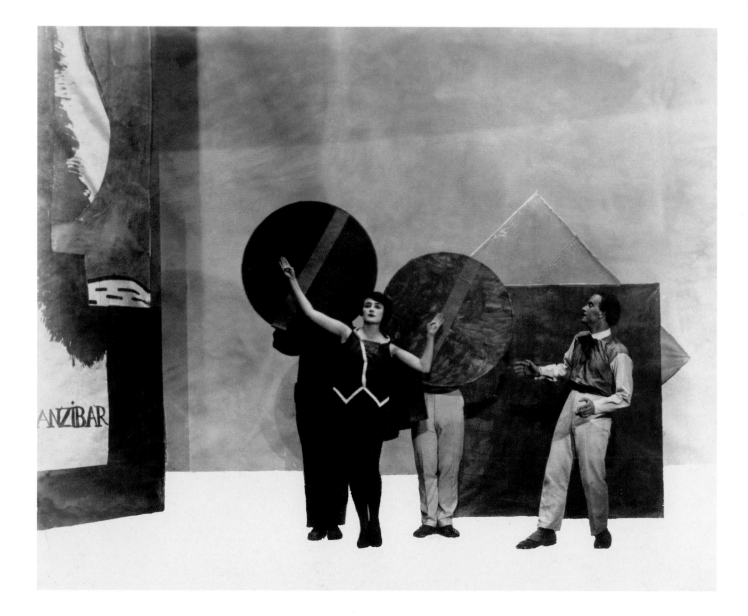

62/ **Theater photograph**, (Liberated Theater, G. Apollinaire: Les Mamelles de Tirésias), 1926, gelatin silver print
(collection of Anna Fárová, Prague)

63/ **Theater photograph**, (Liberated Theater), 1926, gelatin silver print
(collection of Anna Fárová, Prague)

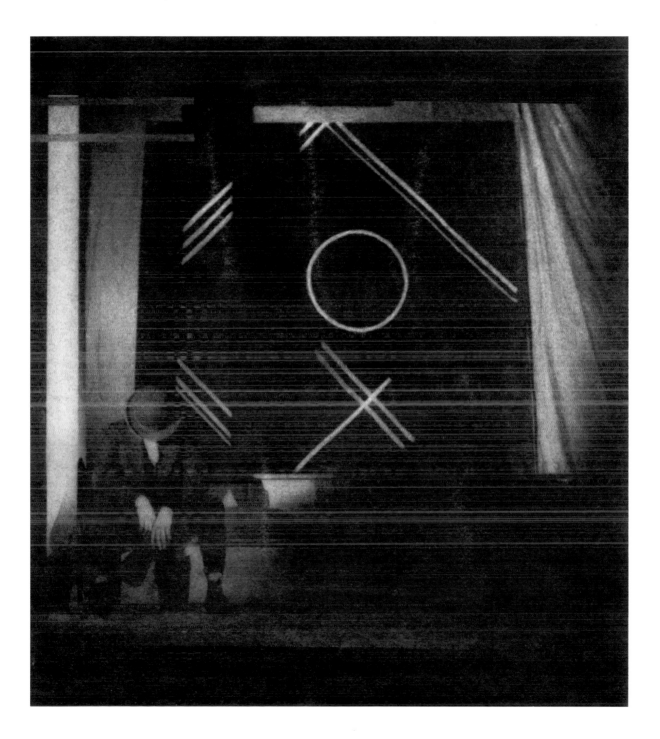

64/ **Untitled**, 1926, gelatin silver print (The Museum of Decorative Arts, Prague)

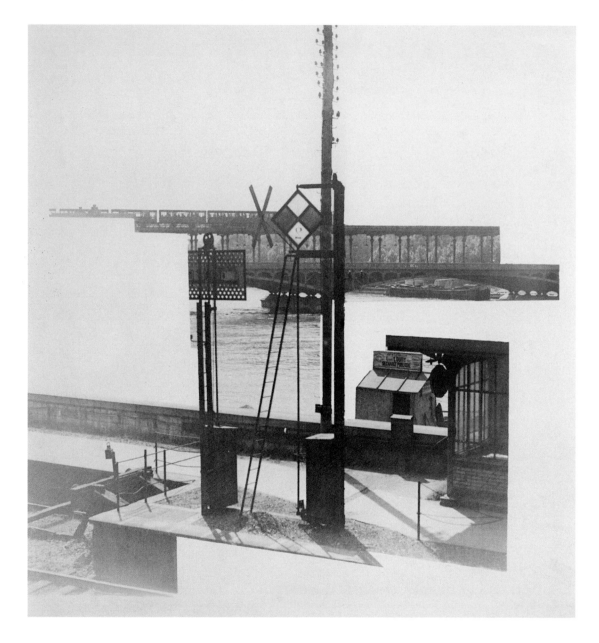

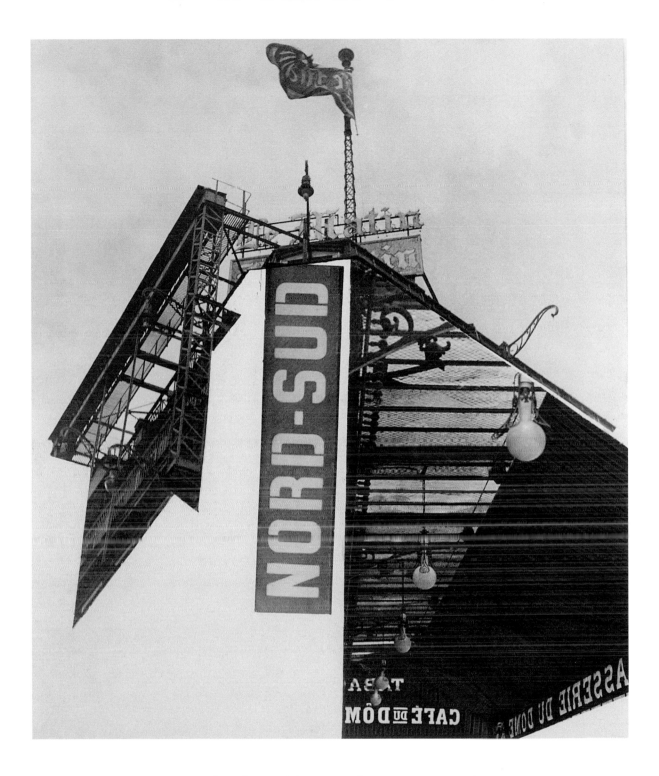

65/ **Paris**, (NORD – SUD), 1926, gelatin silver print (The Museum of Decorative Arts, Prague)

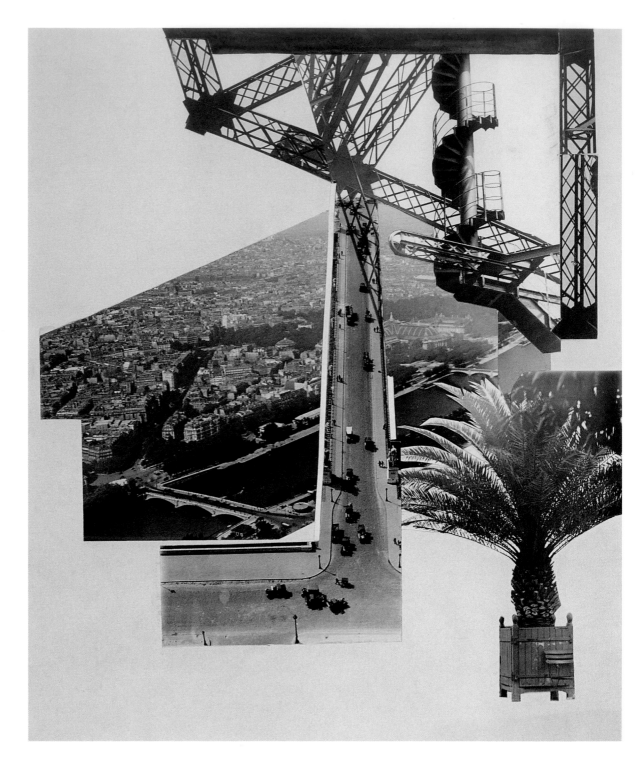

66/ **Untitled**, 1926, collage on paper (The Museum of Decorative Arts, Prague)

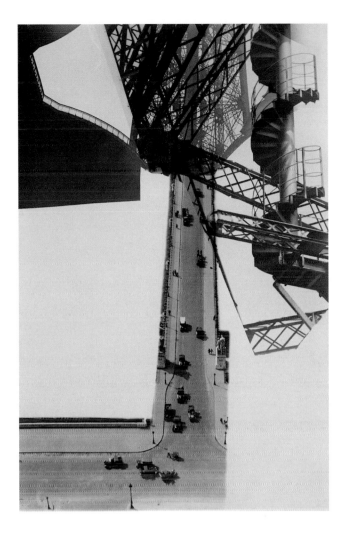

67/ **Untitled**, 1926,
gelatin silver print
(The Museum of Decorative Arts in Prague)

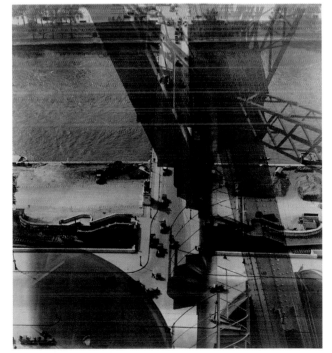

68/ **Untitled**, 1926,
gelatin silver print
(The Museum of Decorative Arts in Prague)

69/ **Eiffel Tower**, 1929, gelatin silver print (Robert Koch Gallery, San Francisco)

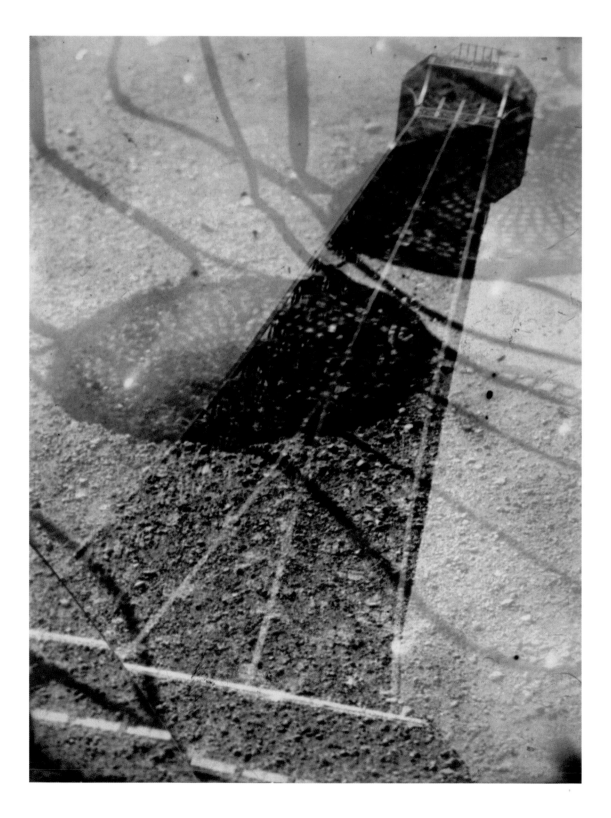

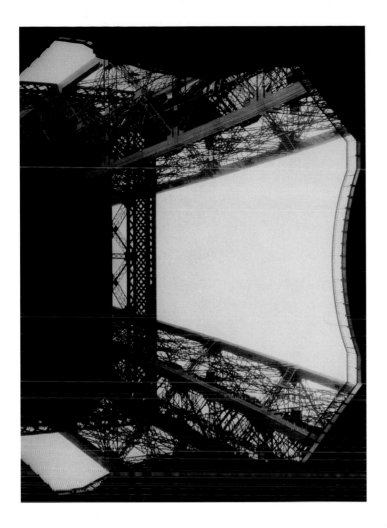

70/ **Untitled**, 1926,
gelatin silver print
(The Museum of Decorative Arts, Prague)

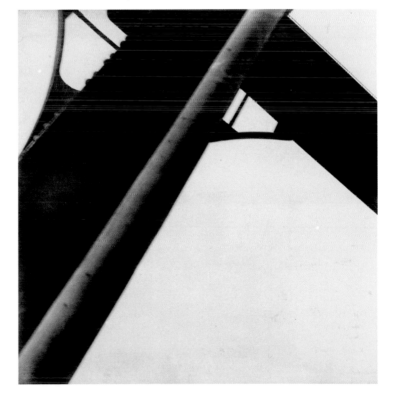

71/ **Untitled**, 1926,
gelatin silver print
(Prakapas Gallery, Bronxville, New York)

72/ **Self – Portrait**, 1929, gelatin silver print (The Museum of Decorative Arts, Prague)

73/ **Paris I**, 1930, gelatin silver print (private collection, Prague)

74/ **Self – Portrait II**
1930, gelatin silver print
(The Museum of Decorative Arts,
Prague)

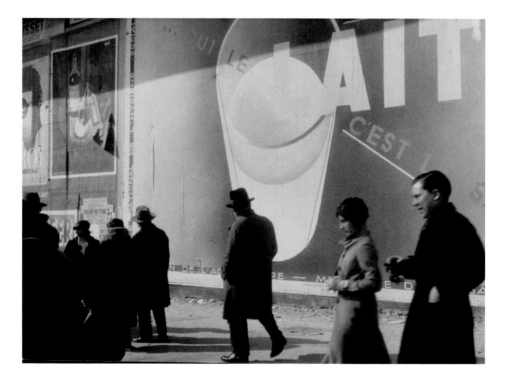

75/ **Paris**, 1931, gelatin silver print (private collection, Prague)

76/ **Paris**, 1931, gelatin silver print (collection of Anna Fárová, Prague)

77/ **Railway Tracks**, 1930, gelatin silver print (The Museum of Decorative Arts, Prague)

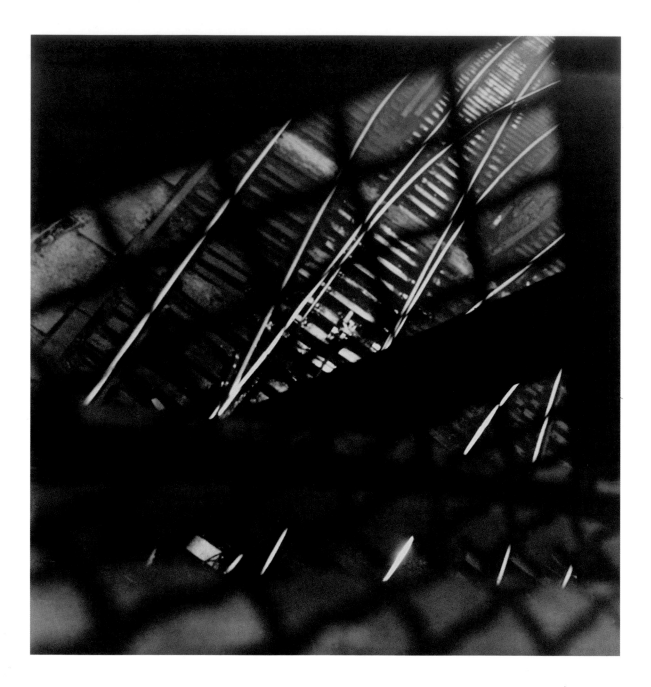

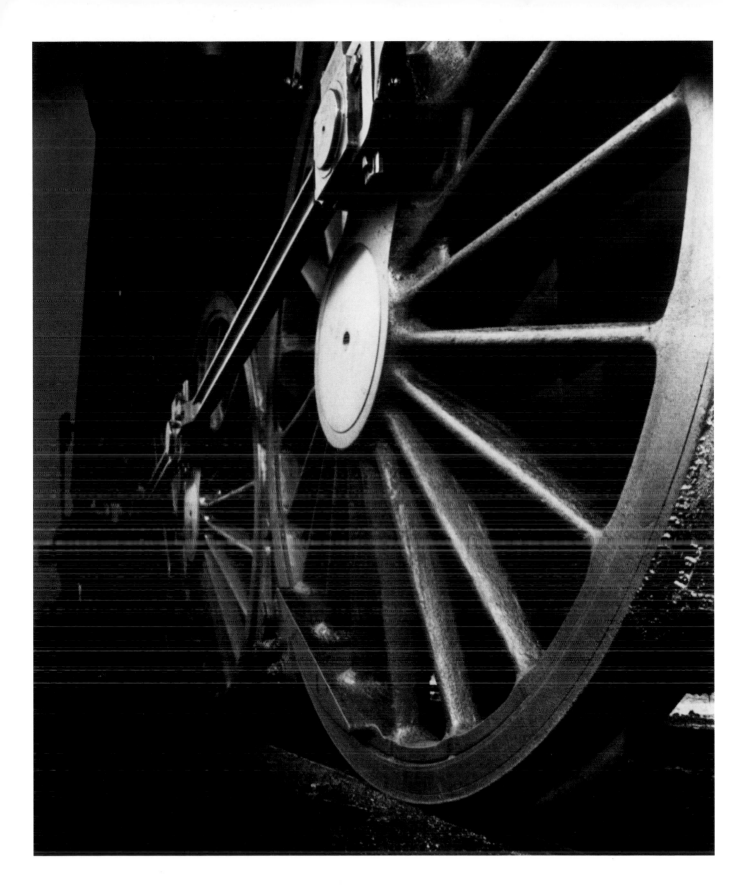

78/ **Untitled**, 1932, gelatin silver print (The Museum of Fine Arts, Houston – collection of Manfred Heiting)

79/ **Photocomposition**, circa 1931, gelatin silver print (The Museum of Fine Arts, Houston – collection of Manfred Heiting)

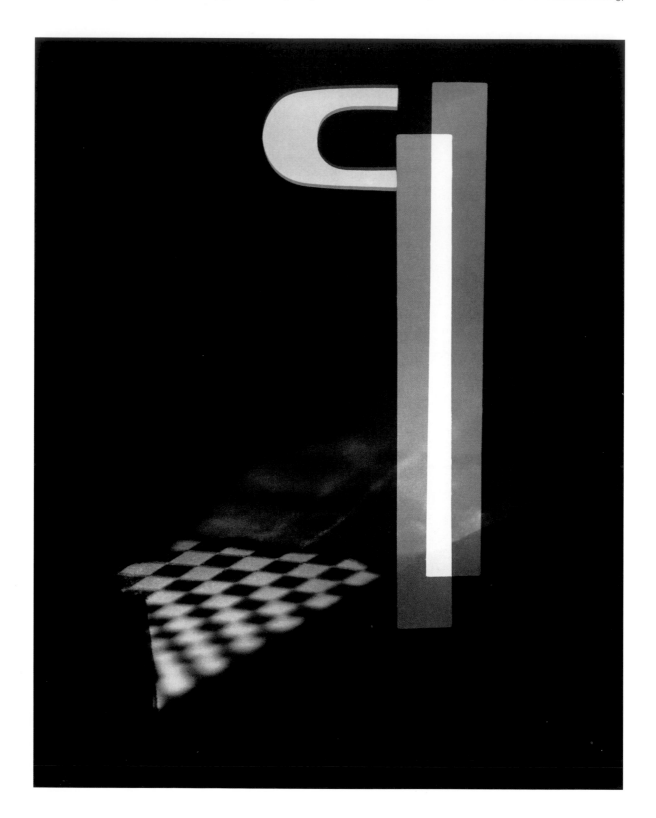

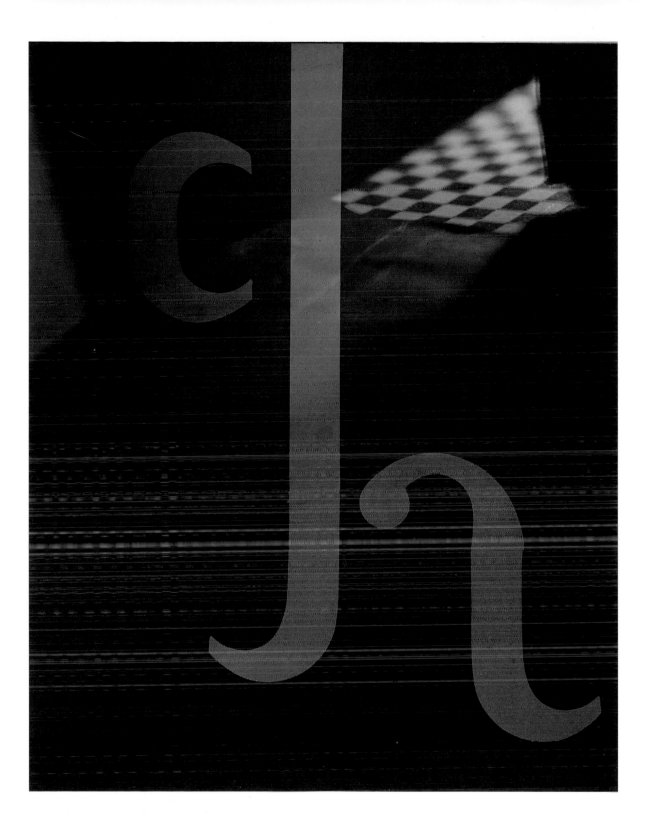

80/ **Untitled**, circa 1931, gelatin silver print (Howard Greenberg Gallery, New York)

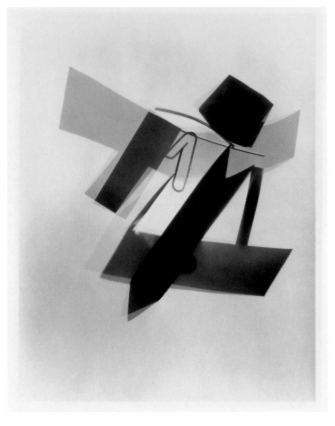

81/ **Photogram**, 1929
(Robert Koch Gallery, San Francisco)

82/ **Photogram**, 1929
(Robert Koch Gallery, San Francisco)

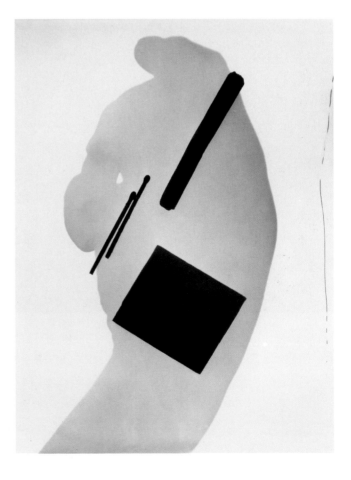

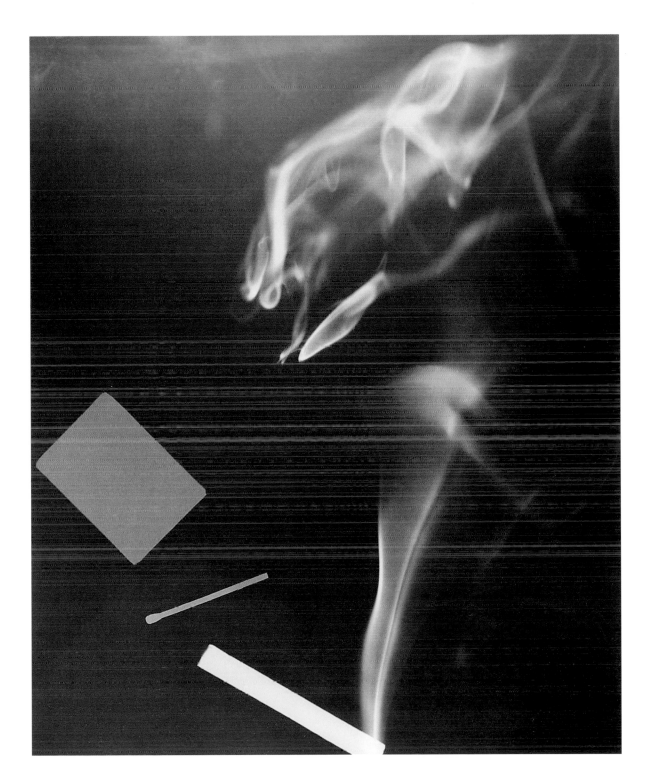

83/ **Smoke**, 1929, photogram (The Museum of Decorative Arts, Prague)

84/ **Untitled**, 1931, photogram and gelatin silver print (artist's estate)

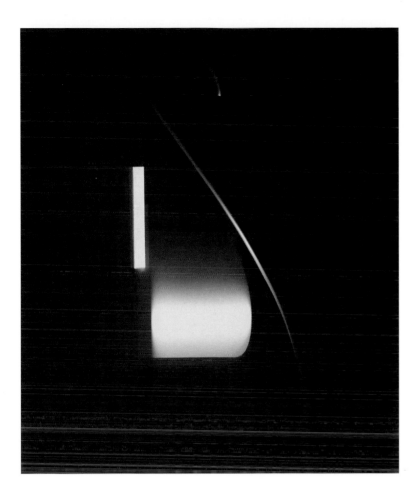

85/ **Untitled**, 1926, photogram
(The Museum of Decorative Arts, Prague)

86/ **Photogram**, 1926
(J. Paul Getty Museum, Los Angeles)

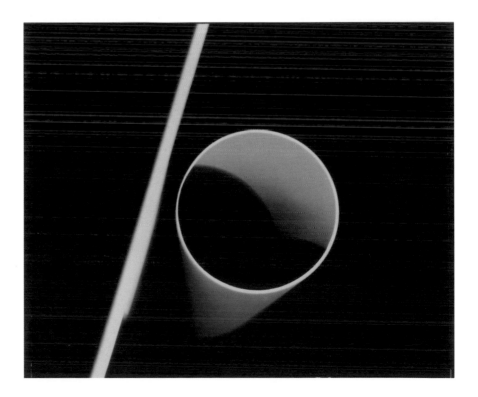

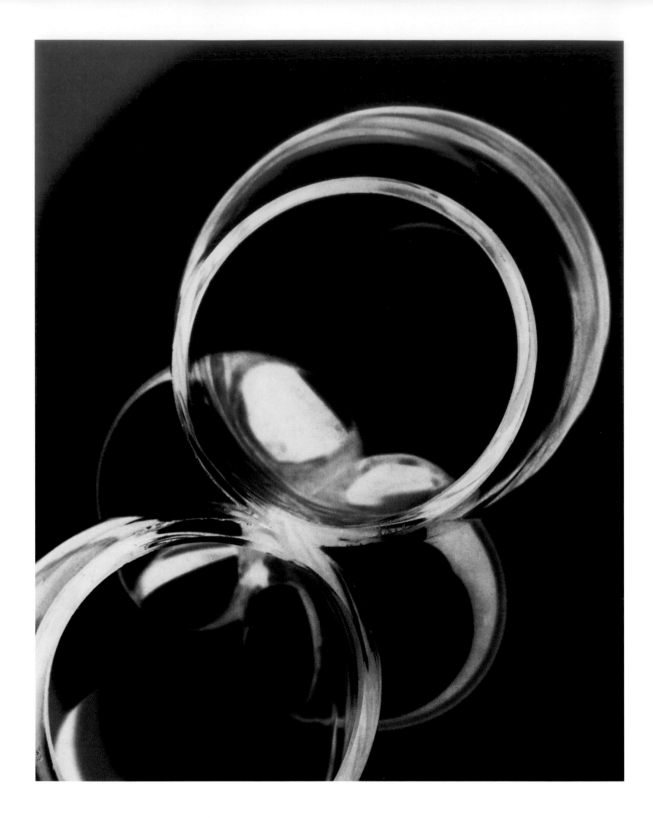

87/ **Circles**, 1926, gelatin silver print (The Museum of Fine Arts, Houston – collection of Manfred Heiting)

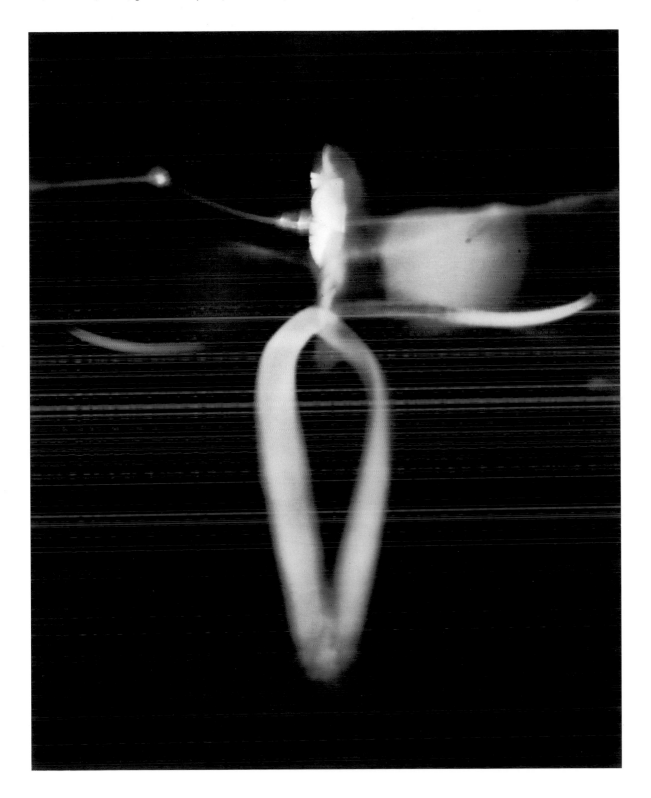

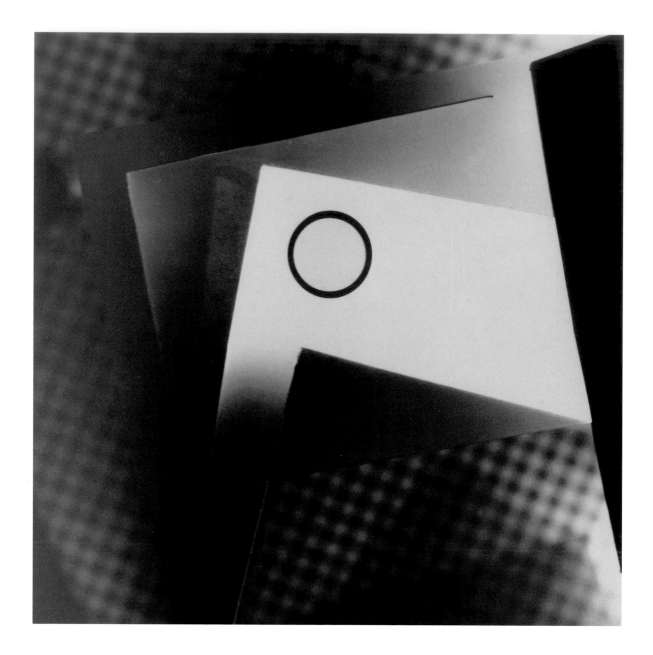

89/ **Abstract Composition**, circa 1931, gelatin silver print (J. Paul Getty Museum, Los Angeles)

90/ **Untitled**, 1931, gelatin silver print (The Museum of Decorative Arts, Prague)

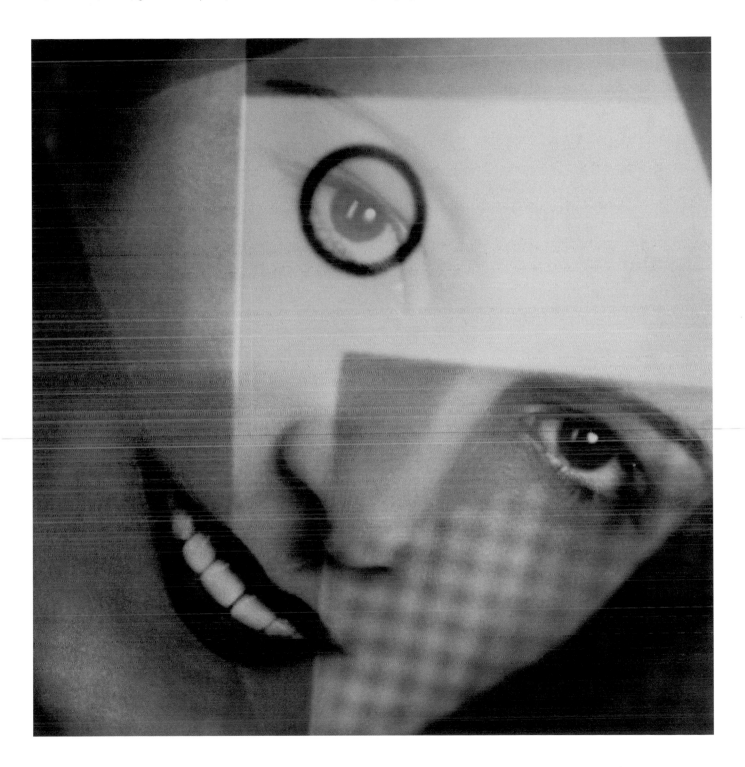

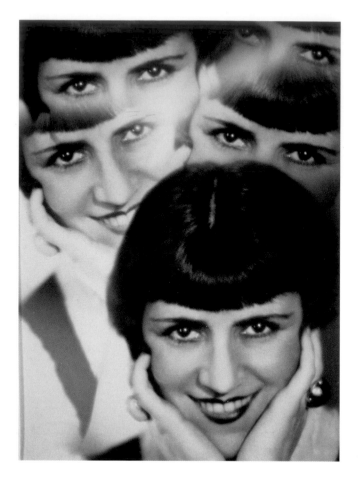

92/ **Untitled**, 1931, gelatin silver print
(collection of Rosa and Aaron Esman, New York)

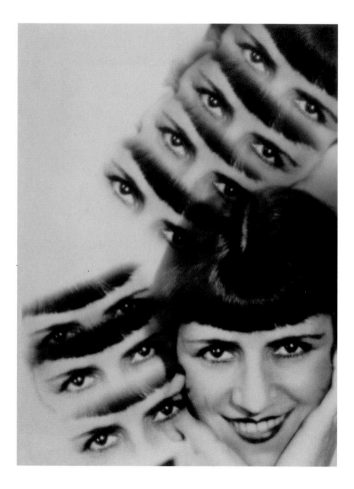

91/ **Untitled**, 1931, gelatin silver print
(J. Paul Getty Museum, Los Angeles)

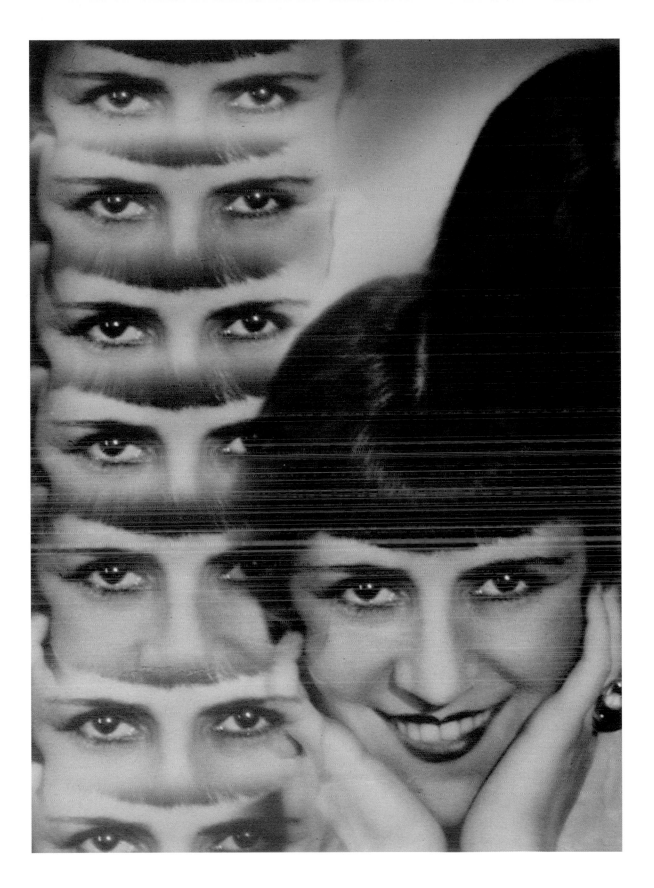

93/ **Untitled**, 1931, gelatin silver print (Vintage Works, Ltd., Chalfont)

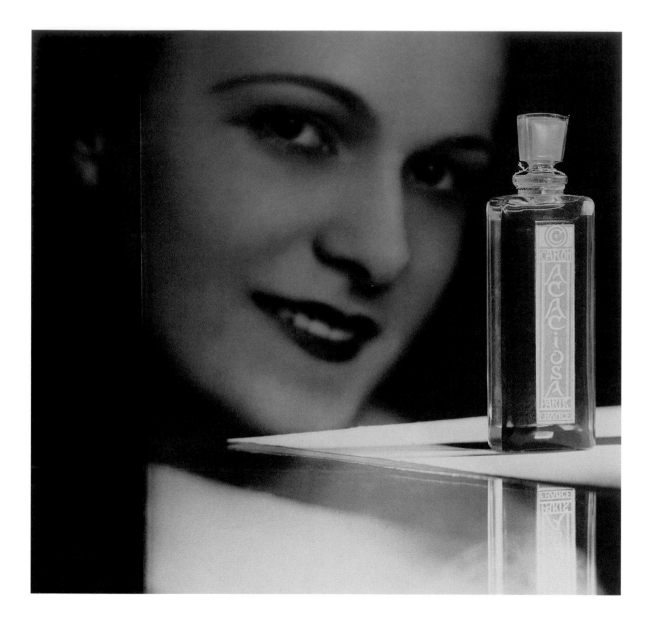

94/ **Advertising photograph**, 1930, gelatin silver print (The Museum of Decorative Arts, Prague)

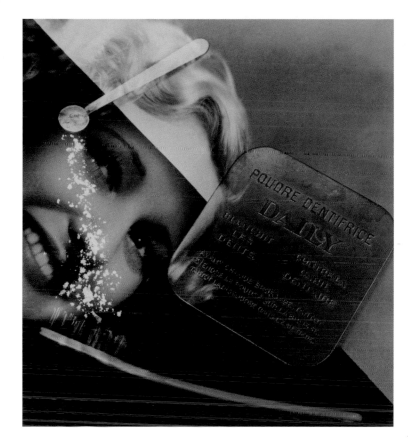

95/ **Advertising photograph**, 1928–31,
gelatin silver print
(J. Paul Getty Museum, Los Angeles)

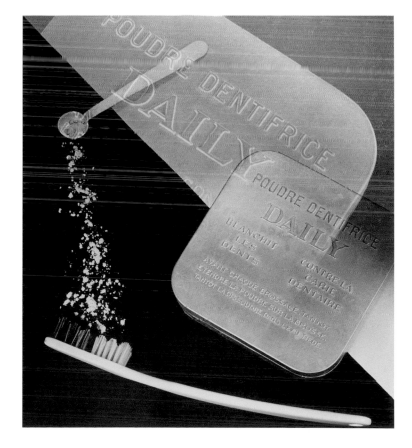

96/ **Advertising photograph**, 1928–31,
gelatin silver print
(The Museum of Decorative Arts, Prague)

97/ **Untitled**, 1932, gelatin silver print (The Museum of Fine Arts, Houston – collection of Manfred Heiting)

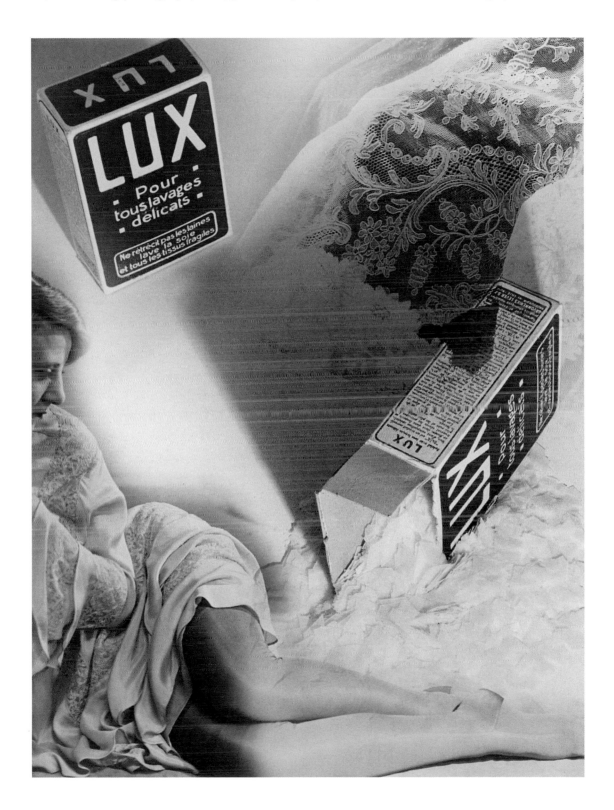

99/ **Advertising photograph**, 1930, gelatin silver print (The Museum of Decorative Arts, Prague)

100/ **Advertising photograph**, 1932, gelatin silver print (The Museum of Decorative Arts in Prague)

102/ **Advertising photograph**, 1931, gelatin silver print (The Museum of Decorative Arts, Prague)

103/ **Advertising photograph**, 1932,
gelatin silver print
(The Museum of Decorative Arts, Prague)

104/ **Advertising photograph**, 1932,
gelatin silver print
(The Museum of Decorative Arts, Prague)

105/ **Advertising photograph**, 1931, gelatin silver print (The Museum of Decorative Arts, Prague)

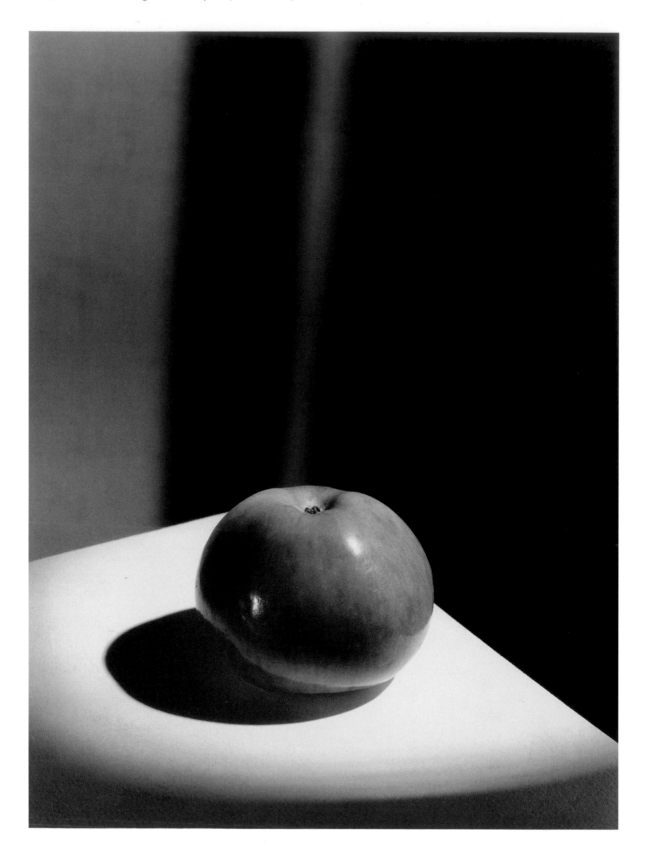

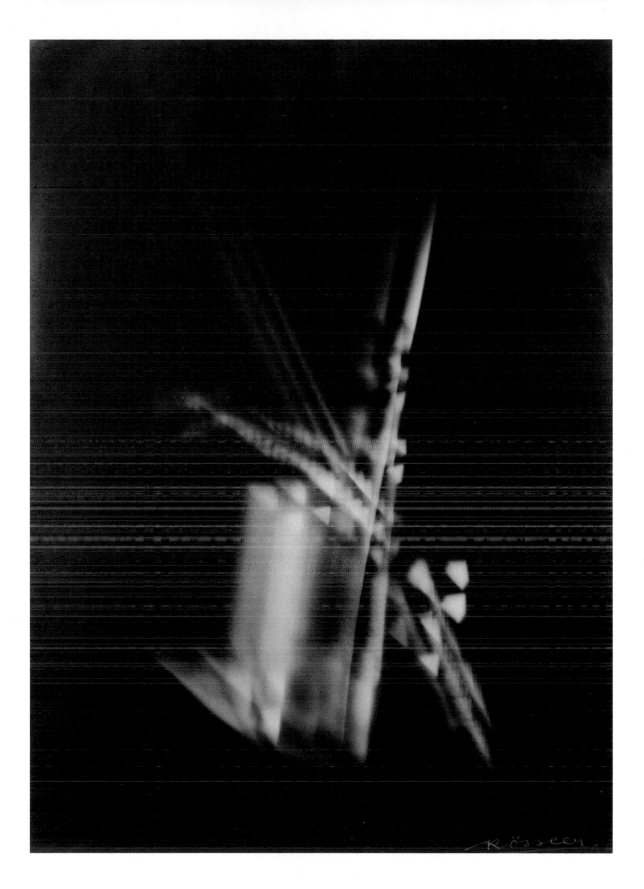

107/ **Optical Study**, 1947, gelatin silver print (The Museum of Decorative Arts, Prague)

108/ **Wagram**, (portrait of daughter Sylva), 1947, gelatin silver print (artist's estate)

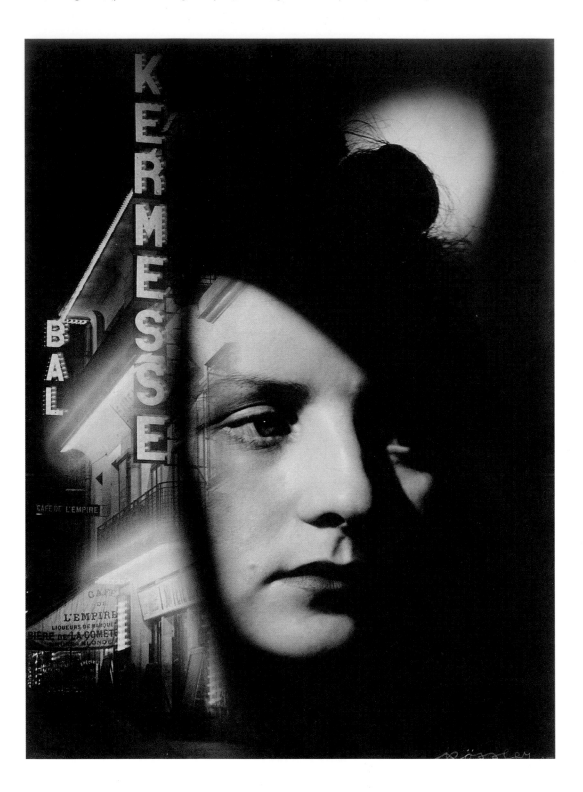

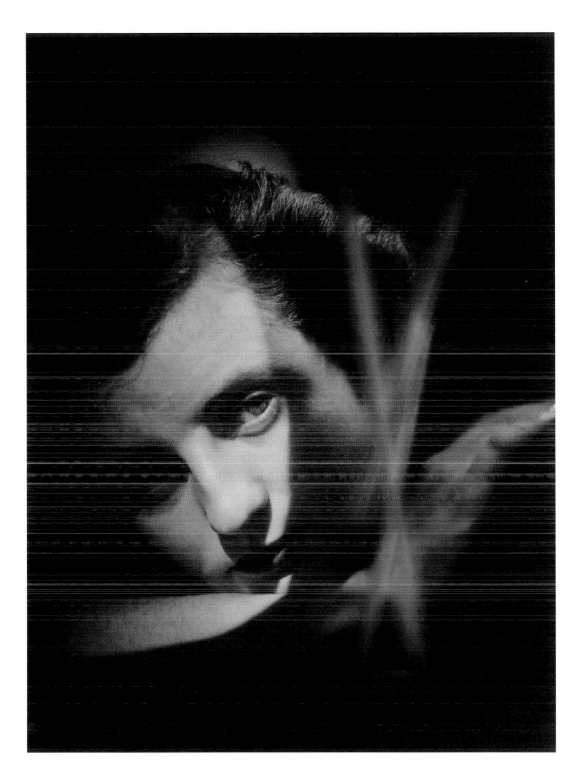

109/ **Sylva**, 1947, gelatin silver print (artist's estate)

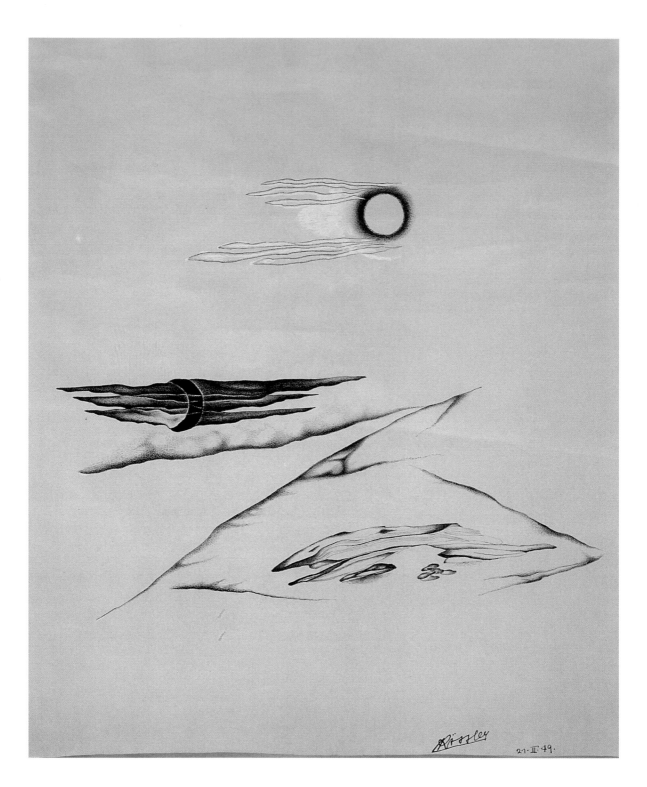

110/ **Untitled**, 1949, ink drawing on paper (private collection, Prague)

111/ **Untitled**, 1949
   ink on paper (artist's estate)

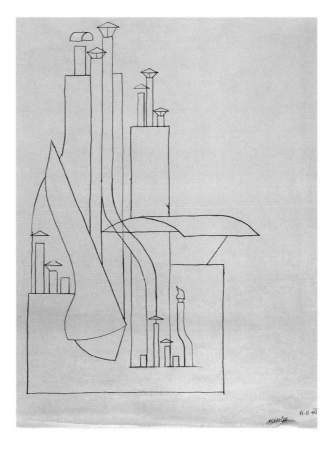

112/ **Untitled**, 1949
   ink on paper (artist's estate)

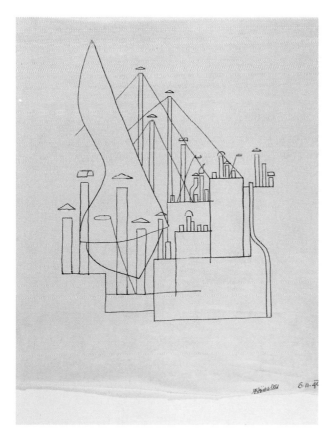

113/ **Untitled**, 1959, gelatin silver print (The Museum of Decorative Arts, Prague)

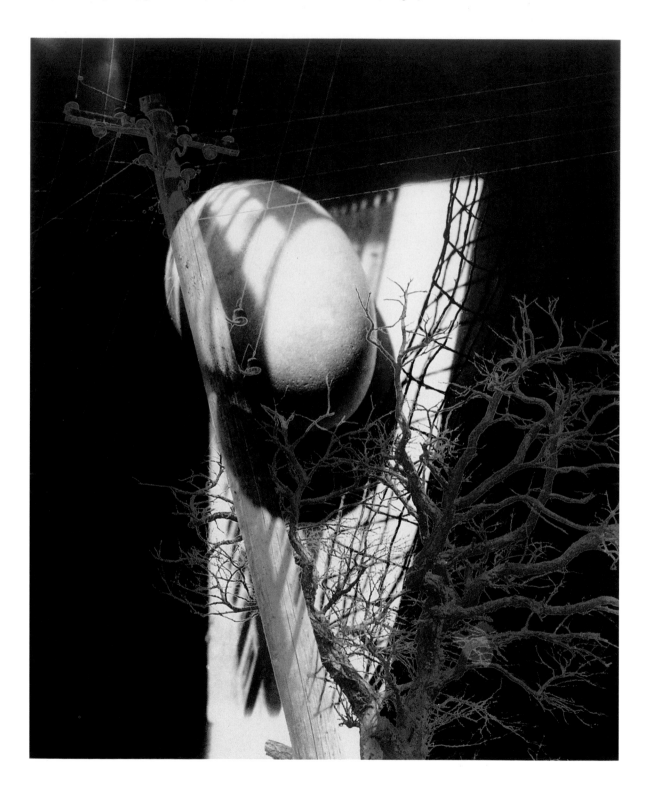

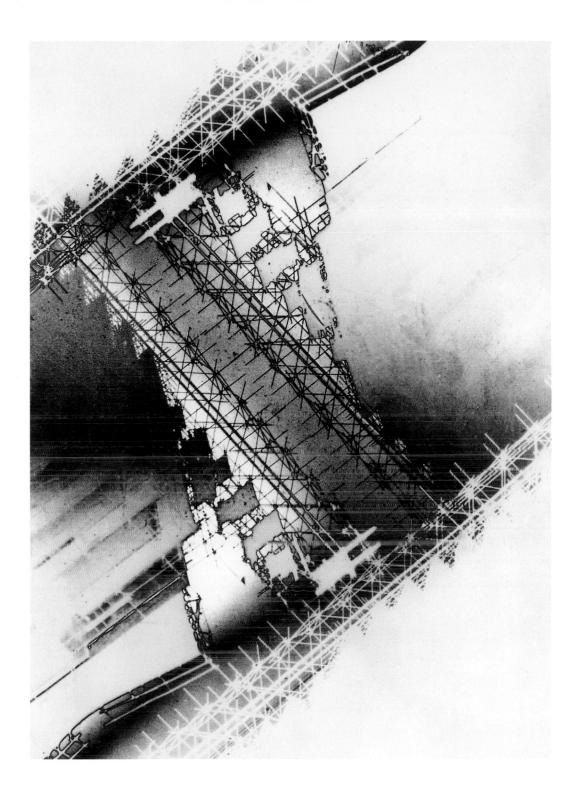

114/ **Scaffolding**, 1964, gelatin silver print (artist's estate)

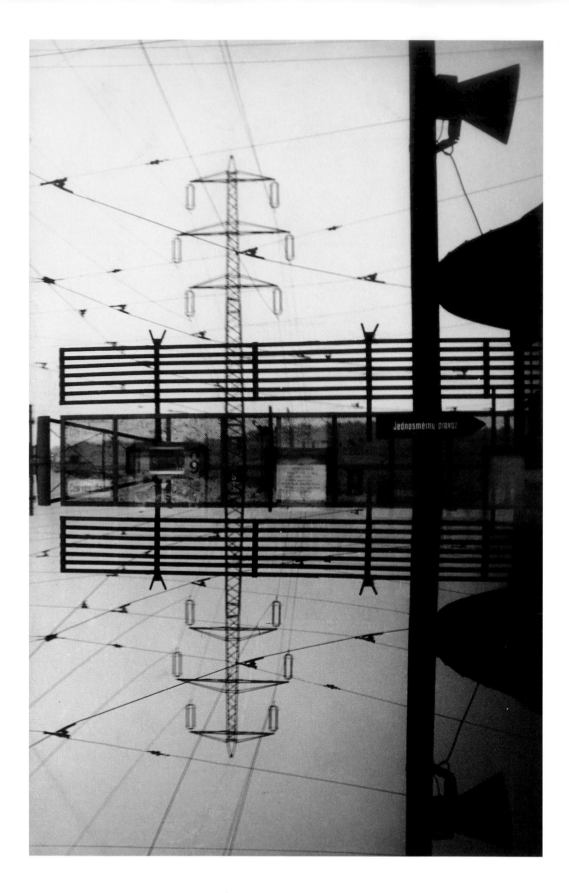

115/ **One–Way Street**, 1957–60, gelatin silver print (artist's estate)

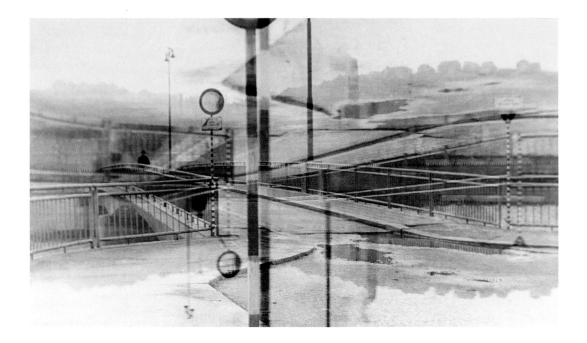

116/ **Untitled**, 1957, gelatin silver print (The Museum of Decorative Arts, Prague)

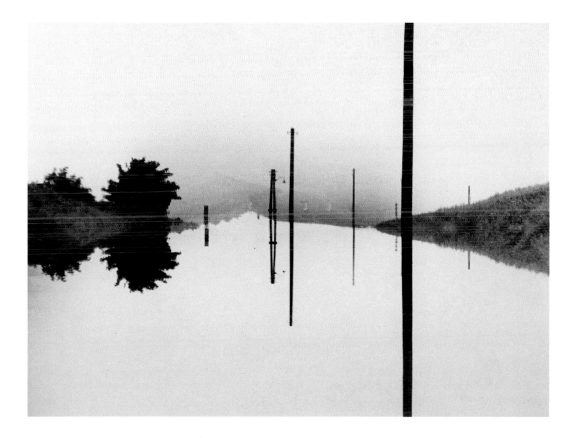

117/ **Landscape**, 1963, gelatin silver print (The Museum of Decorative Arts, Prague)

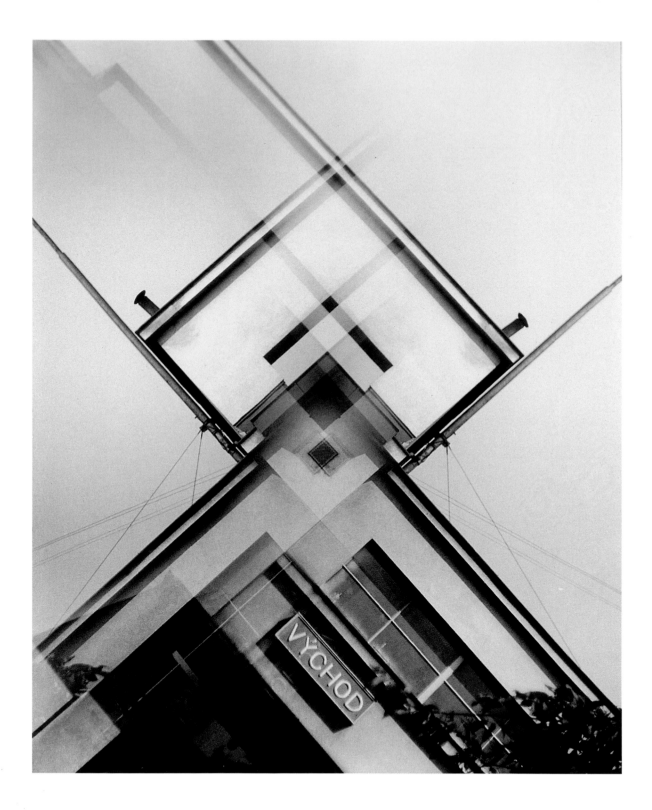

118/ **Composition – Exit**, 1963, gelatin silver print (The Museum of Decorative Arts, Prague)

119/ **Untitled**, 1963, gelatin silver print
(The Museum of Decorative Arts, Prague)

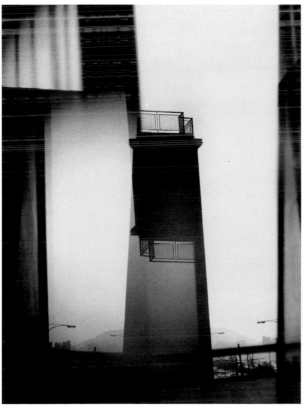

120/ **View from a Window**, 1964, gelatin silver print
(artist's estate)

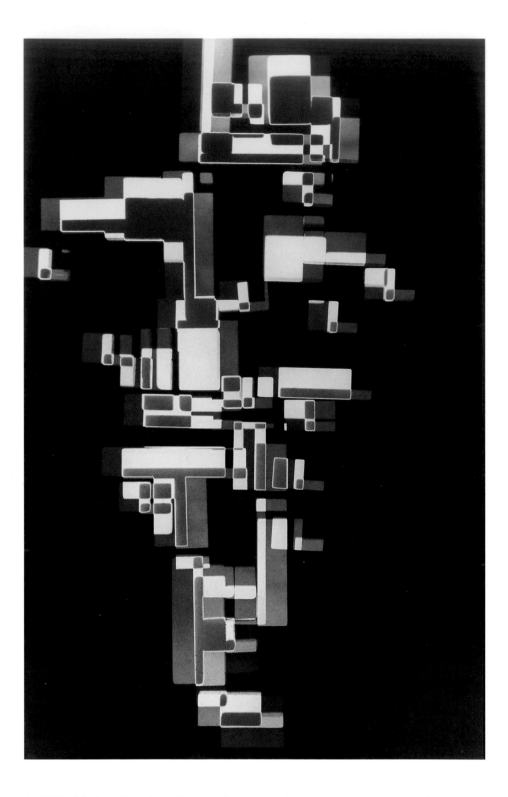

121/ **Untitled**, 1965, gelatin silver print (artist's estate)

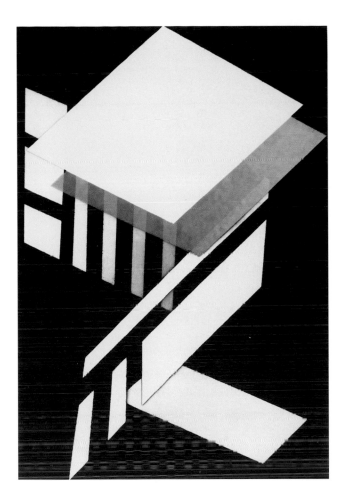

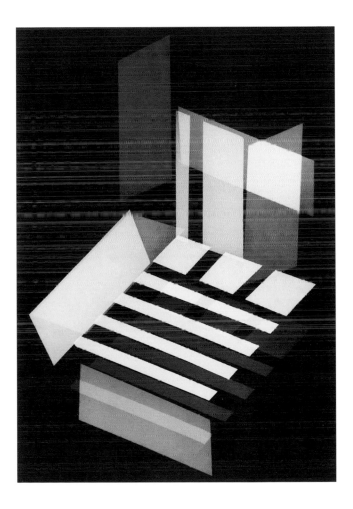

123/ **Variation C**, 1966, gelatin silver print
(The Museum of Decorative Arts, Prague)

122/ **Variation A**, 1966, gelatin silver print
(The Museum of Decorative Arts, Prague)

124/ **Franz Kafka**, 1967, gelatin silver print (artist's estate)

125/ **Garden of Life**, 1964, gelatin silver print (The Museum of Decorative Arts, Prague)

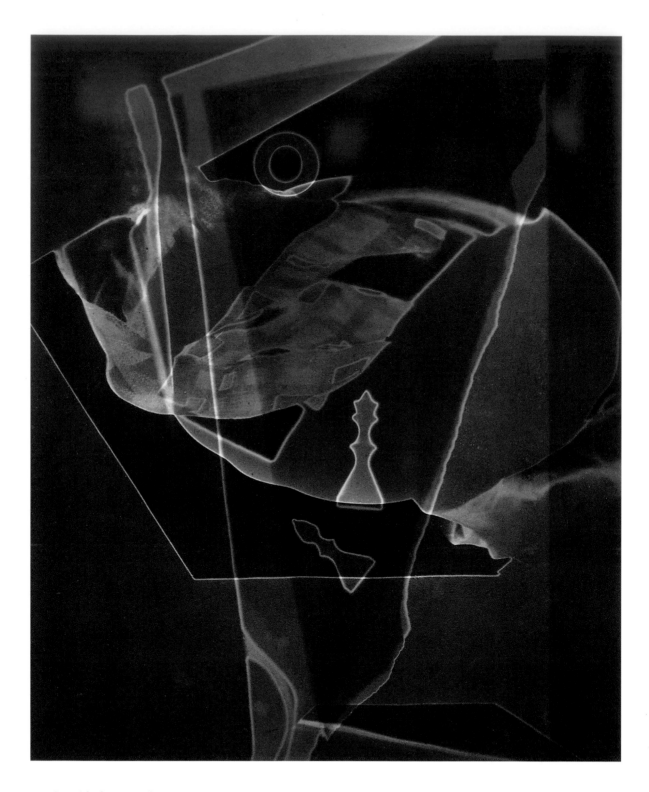

126/ **Untitled**, 1978, photogram (artist's estate)

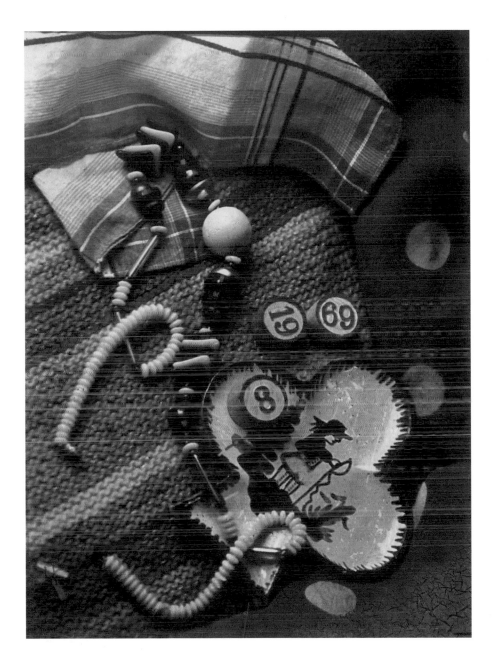

127/ **Untitled**, circa 1936–37,
color photograph, carbo system (artist's estate)

128/ **Untitled**, circa 1936–37,
color photograph, carbo system (artist's estate)

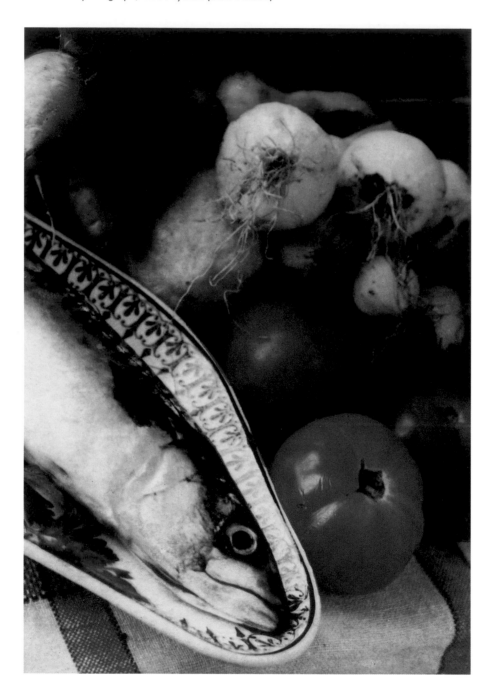

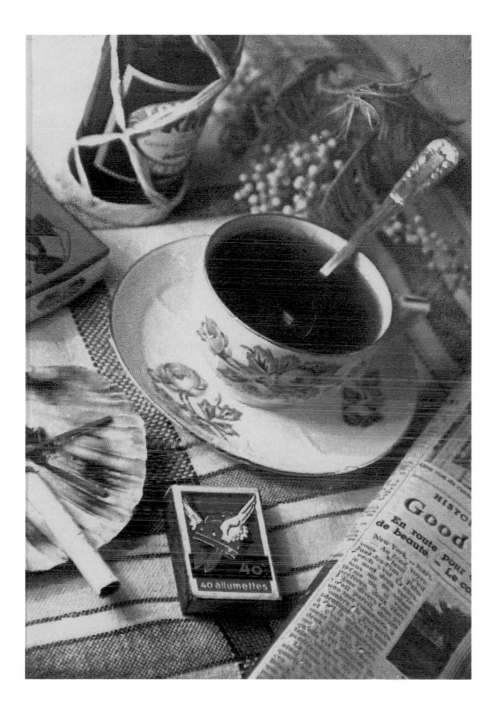

129/ **Untitled**, circa 1930–33,
color photograph, carbo system (artist's estate)

130/ **Grave of Rabbi Jehuda Löw ben Becalel**, circa 1974,
colored transparent sheet (artist's estate)

131/ **Untitled**, 1967–77,
colored transparent sheet (artist's estate)

132/ **Head**, 1967–77, colored transparent sheet (artist's estate)

133/ **Untitled**, 1967–77,
   colored transparent sheet (artist's estate)

134/ **Untitled**, 1967–77,
    coloued transparent sheet (artist's estate)

# Jaroslav Rössler – Life in Dates

VLADIMÍR BIRGUS

**1902**
Born at 8 am, on Sunday, 25 May, at Smilov, near Německý Brod (today Havlíčkův Brod), the first son of Eduard and Adéla Rössler.

**1908**
Began to attend the Czech school in Německý Brod.

**1912**
Entered first grade of gymnasium (secondary school) in Německý Brod.

**1914–17**
Owing to his lack of success as a pupil, transferred to a council school and then to a commercial academy in Kolín, but did not complete that school either.

**1917**
In September, began an apprenticeship in the Drtikol a spol. (Drtikol & Co.) photography studio, Prague. František Drtikol at the time was serving in the Austro-Hungarian army, and did not return to his studio until autumn of the following year.

**1917–18**
Began to take an interest in radio.

**1919**
While still an apprentice at Drtikol's, made *Opus I*, a photograph with Constructivist elements.

**1920**
On 1 September completed his apprenticeship and became Drtikol's assistant, mainly printing and retouching.

**1921**
In August, quit Drtikol's studio; in the autumn, left for Belgrade, where he worked for a while in the Savić photography studio; returned to Drtikol's studio in spring of the following year.

**1922**
Sat as a model for several nudes by his older colleague in Drtikol's studio, Gertruda Fischerová.

**1923**
Got his first 9 x 9 cm camera; began to photograph simple objects on backgrounds composed of paper and cardboard cut-outs as well as abstractive compositions using hazy light. Made a number of drawings and several paintings, moving gradually away from Symbolism to a style influenced by Futurism and Cubism. At the invitation of Karel Teige, became a member of Devětsil, but did not take part in the "*Modern Art Bazaar*" (Bazar moderního umění) exhibition held in Prague that autumn.

**1924**
First exhibited his work in public at the "*19th Paris Photo Salon*" of the French Photographic Society.

**1925**
Made collages titled *Photographs* (Fotografie), combining shots of minimalist motifs with pasted-on black strips. In late December, left for Paris with Gertruda Fischerová. His references from František Drtikol are dated 30 December 1925.

**1926**
In February, began work in the photo studio of Gaston and Lucien Manuel in Paris, where he soon befriended Rudolf Schneider-Rohan and Lucien Lorelle. Took photographs of the Eiffel Tower and other Parisian motifs, made photomontages, collages, and pencil drawings, and also wrote several short screenplays for avant-garde films, which, however, were never made. Karel Teige included his work in the third Devětsil exhibition, at the Rudolfinum, Prague, in May. At the Rote Fahne exhibition in Berlin, exhibited photograms and photographs.
On 16 June, quit the Manuels' studio and returned to Czechoslovakia shortly afterward.
On 24 July, married Gertruda Fischerová in Prague.
On 7 September, their daughter Sylva was born.
Began work with the Osvobozené divadlo [Liberated Theater], where he photographed mainly the productions of Jindřich Honzl, and also worked sporadically with the illustrated weekly *Pestrý týden*.

**1927**
Offered Metro-Goldwyn-Mayer Studios, Hollywood, an apparatus that used mirrors to enable the filming of several motifs at once, but they declined it. Toward the end of the year, at the invitation of Lucien Lorelle, left again for Paris with his wife and daughter.
On 12 December, began work in the Studio Lorelle, where he concentrated mainly on modern advertising photography.

**1928–35**
Concentrated also on his own artwork; made experimental photographs influenced by abstract art, the New Objectivity, and Constructivism, as well as photographing portraits, street scenes, and the horse races.

**1930**
In May, exhibited his work in the "*Výstava nové fotografie*" [New Photography Exhibition] in the Aventinská mansarda (the gallery of the Aventinum publishing house) in Prague, which was organized by Alexandr Hackenschmied and his friends. The first group exhibition of Czech avant-garde photographers in Prague, it also showed work of, among others, Jaromír Funke, Eugen Wiškovský, Jiří Lehovec, Ladislav Emil Berka, and Josef Sudek.

**1932**
On 1 September, began work at the Studio Piaz, Paris, working as a photographer and retoucher until 30 November 1934.

**1934–35**
Worked in the re-established independent studio of Lucien Lorelle, where he began to use the color material of the Carbro process.

**1935**
On 18 July, was arrested while taking photographs of a demonstration of civil servants in the streets of Paris; was questioned and then deported. Suffered a nervous breakdown. In unexplained circumstances, tried to take his life; hospitalized in Strasbourg. His family did not find him until several weeks later. After returning to Prague, lived with his wife and daughter in his mother's house in the Vokovice district.

**1936**
Opened a small photo studio in Poděbradova street (renamed Koněvova, after WW II), in the Prague district of Žižkov; he and his family lived in the same building. Devoted himself mainly to ordinary commissions – portraits, developing film, enlarging. Only sporadically occupied with work done strictly for himself.

**1945**
Began to develop an interest in Jewish religion and history.

**1948**
His daughter Sylva, while a student at the Middle School of Graphic Design, Prague, apprenticed in her father's studio and passed her final exams in photography.

**1949**
While sick, made a number of line drawings of imaginary landscapes, corners of Paris, and *Old Testament* motifs.
On 1 March, acquired a Czechoslovak license to operate a ham radio.

**1951**
Rössler's photo studio incorporated into the Fotografia "people's" co-op.

**1956**
His daughter Sylva married Jaroslav Vít.

**1957**
On 18 June, his granddaughter Michaela was born.
A new period in Rössler's private work began, in which he experimented with various special techniques and projections; in his imaginative photographs of static motifs he often used a prism to multiply the images to be photographed, as well as photomontage.

**1959**
On 31 March, a second granddaughter, Šárka, was born.

**1961**
The first issue of the Prague quarterly *Revue Fotografie*, published four of Rössler's photographs with a short article by J. Schmidt.

**1964**
On 16 April, after a heart attack, left the Fotografia "people's" co-op and took a partial invalidity pension, receiving the minimum amount.
The Artistic Board of the Funke Gallery of the Brno House of Art turned down a proposal for a Rössler exhibition.

**1966**
From May to June, his work was included in the "*Surrealismus a fotografie*" [Surrealism and Photography] exhibition held in the House of Art in Brno, organized by Adolf Kroupa, Vilém Reichmann, Petr Tausk, and Václav Zykmund.

**1967**
Began to make color photographs using gels of different colors.

**1968**
From 12 to 27 April, the first solo exhibition of Rössler's work, organized by Jana Boková, was mounted in the Small Exhibition Hall of the Československý spisovatel publishing house on Národní třída, Prague.

**1969**
Rössler made sketches for three monumental photographs for Oděva, a clothing manufacturer, but the Trade Union Committee of the Union of Czechoslovak Fine Artists did not approve them, and the photographs were never made. Antonín Dufek negotiated the purchase of a set of Rössler's works for the Moravian Gallery, Brno.

**1971**
Anna Fárová acquired a large set of Rössler's photographs and drawings for the Museum of Decorative Arts, Prague; it eventually became the largest collection of originals of his early works.

**1972**
A biographical sketch of Rössler written by Anna Fárová, together with seven photographs, was published in the *Revue Fotografie* no. 2.

**1973**
In the "*Osobnosti české fotografie I*" [Great Czech Photographers, Pt. I] exhibition, which opened in the Fine Art Gallery, Roudnice nad Labem, Anna Fárová included works by Rössler. The exhibition was mounted again the following year in both the Museum of Decorative Arts in Prague and the Brno House of Art.
For the Bibliothèque nationale de France, Jean-Claude Lemagny acquired 45 prints of Rössler's works (mainly later ones).

**1974**
After almost forty years, Rössler visited Paris and met up with former colleagues.

**1975**
On 5 December, an exhibition of Rössler's work, organized by Anna Fárová and accompanied by a small catalogue, opened in the Funke Gallery of the House of Art in Brno.

**1976**
On 26 June, Gertruda Rösslerová died.

**1979**
In *Revue Fotografie* no. 2 (1979), Petr Tausk published the largest biographical sketch of Rössler ever to appear in a magazine, together with nineteen photographs.
Peter Weiermair included Rössler's works in the "*Photographie als Kunst 1879–1979 / Kunst als Photographie 1949–1979*" [Photography as Art 1879-1979/Art as Photography 1949-1979] exhibition, which opened in the Tyrolian Museum, the Ferdinandeum, Innsbruck. A large, two-part catalogue was published to accompany the exhibition.

**1980**
In September, L. Fritz Gruber and Renata Gruber included several of Rössler's photographs in an exhibition titled "*Das imaginäre Photo-Museum*" [The Imaginary Photo Museum], mounted as part of the Photokina in the Josef-Haubrich-Kunsthalle, Cologne. To accompany the exhibition, DuMont, Cologne, published a large book of the same name a year later.

**1981**
From 26 June to 23 August, Rössler's photographs were included in the "*Česká fotografie 1918–1938 ze sbírek Moravské galerie v Brně*" [Czech Photography, 1918–38, from the Collections of the Moravian Gallery, Brno] exhibition, organized by Antonín Dufek. The exhibition, for which a catalogue also was published, moved on to Prague and, in a smaller version, Essen, Frankfurt on Main, Vienna, and Łódž.
The Galerie Rudolf Kicken, Cologne, showed Rössler's photographs in the "*Meisterwerke der Photographie – Photographic Masterpieces*" exhibition.

**1982**
The Galerie Rudolf Kicken, Cologne, published a portfolio of ten contemporary prints of Rössler's photographs from 1923–30, in a print run of fifty.
A biographical sketch of Rössler, written by Petr Tausk, was included in *Contemporary Photographers*, an encyclopedia of photography published in London.

**1983**
From 8 July to 4 September, the "*Photographs tchèques 1920–1950*" exhibition was held in the Centre George Pompidou, Paris, including 17 of Rössler's photographs. The articles in the catalogue were written by Alain Sayag, Antonín Dufek, and Zdeněk Kirschner.

**1984**
The J. Paul Getty Museum, Malibu (today in Los Angeles), bought a collection of Czech photographs from the German collector and gallery-owner Wilhelm Schürmann, including several dozen of Rössler's photographs, photograms, collages, and drawings from the 1920s and 1930s. After the collection in the Museum of Decorative Arts, Prague, this is the best collection of Rössler's photographs.
At the Film and Television Faculty of the Academy of Performing Arts (FAMU), Prague, Martin Stein wrote a dissertation titled "Jaroslav Rössler."

**1985**
From 17 May to 15 June, The Photographers' Gallery, London, mounted the "Czechoslovak Photography" exhibition, which, in addition to the work of 27 contemporary Czechoslovak photographers, included works by Jaromír Funke and Jaroslav Rössler. The exhibition and catalogue were organized by Sue Davies, Antonín Dufek, and Jiří Hlušička. It then moved on to Bristol.
Rössler's photographs were also included in the "Ursprung und Gegenwart tschechoslowakischer Fotografie" [The Origin and Present of Czechoslovak Photography] exhibition, organized by Anna Fárová for the Fotografie Forum gallery in Frankfurt.
A biographical sketch of Rössler was published in Daniela Mrázková's Příběh fotografie [The Story of Photography], Mladá fronta, Prague. Martin Stein and Zdeněk Kirschner made a proposal to Panorama publishers, Prague, for a book about Rössler, but nothing came of it.

**1986**
A large exhibition titled "Devětsil – česká výtvarná avantgarda dvacátých let" [Devětsil: Czech Avant-garde Art of the 1920s], organized by František Šmejkal for the House of Art in Brno, the City Gallery Prague, and the Museum of Modern Art, Oxford, included works by Rössler.

**1987**
Revue Fotografie no. 3 (1987) carried excerpts of Martin Stein's dissertation on Jaroslav Rössler.

**1988**
In October–December, twelve of Rössler's photographs and photograms were shown at the "Linie, barva, tvar v českém výtvarném umění třicátých let" [Line, Color, and Form in Czech Art of the 1930s] exhibition in the City Gallery Prague, organized by Hana Rousová with Antonín Dufek.

**1989**
Rössler's works were included in the "Czech Modernism 1900–1945" exhibition in the Museum of Fine Arts, Houston (the main curator was Jaroslav Anděl), the "Tschechische Kunst der 20er und 30er Jarhre: Avantgarde und Tradition" exhibition, Darmstadt (main curator: Jiří Kotalík), and a number of exhibitions to mark the 150th anniversary of the invention of photography, including "On the Art of Fixing a Shadow" (National Gallery of Art, Washington, the Art Institute of Chicago, and the Los Angeles County Museum of Art), "What Is Photography: 150 Years of Photography" (Mánes Gallery, Prague), "Cesty československé fotografie" [The Paths of Czechoslovak Photography] (City Gallery Prague), and "Sto padesát fotografií ze sbírky Moravské galerie v Brně" [150 Photographs from the Collections of the Moravian Gallery, Brno]. As their logo for an exhibition, the Art Institute of Chicago used his 1931 photomontage with the eye. Rössler was also represented in two small Prague exhibitions of the work of Drtikol and his pupils.

**1990**
On 5 January, Rössler died in Prague.
On 12 January, his funeral was held in the Olšanský Cemetery; the eulogy was given by Zdeněk Kirschner.

Rössler's works were shown in several important exhibitions, including "Fotogramme und die Kunst des 20. Jahrhunderts" (Kunsthaus, Zurich), "Les Avant-gardes Tchéques" (Rencontres Internationales de la Photographie, Arles) and the "Aventinská mansarda – Otakar Štorch-Marien a výtvarné umění" [The Aventinum Garret: Otakar Štorch-Marien and the Fine Arts] (the City Gallery Prague).

**1991**
The Prague House of Photography mounted an exhibition of Rössler's photographs (the curator was Suzanne Pastor), and published a portfolio of ten photographs printed from Rössler's negatives. His works were included in the "Kunstruktion und Poesie – Tschechische Fotografie 1920–1945" exhibition (Kaiser Wilhelm Museum, Krefeld) and "Tchécoslovaque Photographie" (L'Aubette, Strasbourg).

**1993**
A number of Rössler's photographs and collages were shown at the "El arte del la Vanguardia en Checoslovaquia 1918 1938 / The Art of the Avant-garde in Czechoslovakia, 1918–1938" exhibition in the IVAM Centre, Valencia (main curator: Jaroslav Anděl). A smaller version of the exhibition was held under the title "Umění pro všechny smysly" [Art for all the Senses] in the Waldstein Riding School, Prague. Large catalogues were published for both exhibitions.

**1994**
Rössler's work was included in the "Europa, Europa: Das Jahrhundert der Avantgarde in Mittel- und Osteuropa" exhibition, Bonn (curator of the photographic section: Antonín Dufek).

**1996**
The third issue of the English-language journal Imago, published in Bratislava, Slovakia, ran a five-page biographical sketch of Rössler by Vladimír Birgus.

**1997**
Rössler's photographs were part of the "Prague 1900–1938" exhibition in the Musée des Beaux-Arts, Dijon (main curators: Jaroslav Anděl and Emmanuel Starcky).

**1998**
At the "Modern Beauty: Czech Photographic Avant-Garde, 1918–48," exhibition, which opened in the Museu Nacional d'Art de Catalunya, Barcelona, and later in Paris, Lausanne, Prague, and Munich (the main curators were Vladimír Birgus and Pierre Bonhomme, and, in the expanded Prague version, also Jan Mlčoch and Karel Srp), Rössler was presented as one of the key artists of more than two dozen photographs, photograms, and photomontages. To accompany the exhibition, large books were published in Czech (Prague: KANT, 1999), German (Stuttgart: Arnoldsche, 1999), and English (Cambridge and London: The MIT Press, 2002).

**1999**
In its first issue, the British-American History of Photography published an article by Vladimír Birgus, "Jaroslav Rössler and the Czech Avant-garde." Rössler's work was shown at the "Les abstractions et la photographie: Collections de Centre Georges Pompidou" exhibition (curator: Alain Sayag) at the Actes Sud – Rencontres Internationales de la Photographie, Arles.

**2000**
Rössler's works were shown at the "Czech Avant-garde Photography of the 1920s and 30s, from the Collections of the Museum of Decorative Arts, Prague" exhibition, Berlin (curators: Vladimír Birgus and Jan Mlčoch), "Czech Avant-garde Photography, 1918–38" exhibition, Budapest (curators: Birgus and Mlčoch), "Abstrakte Fotografie,"

Bielefeld (curators: Thomas Kellein and Angela Lampe),
and "Laterna Magica," Salzburg (curator: Margit Zuckriegl).
In December the Czech Center of Photography in Prague mounted
a small Rössler exhibition, concentrating on his work from the 1950s
and 1960s (curator: Jiří Jaskmanický).

2001
On 15 March, the first extensive Rössler retrospective "Jaroslav Rössler
– fotografie, koláže, kresby" [Jaroslav Rössler: Photographs, Collages,
and Drawings] opened in the Museum of Decorative Arts, Prague,
organized by Vladimír Birgus, Jan Mlčoch, and Karel Srp. Comprising
158 exhibits, the exhibition was remounted as part of the "Foto España
2001" exhibition, Madrid, in June and July. KANT, Prague, published
a catalogue to accompany the exhibition, with articles by Birgus and
Mlčoch.
TORST, Prague, published the first book solely about Rössler, a bilingual
Czech-English edition, written by Birgus. The Prague House of Photo-
graphy published Jaroslav Rössler: Portfolio 2001, consisting of twelve
new prints from original negatives together with an article by Josef
Moucha, and the Czech Center of Photography published Jaroslav
Rössler, a limited edition with seven prints and an article by Moucha.
The eighth issue of the arts journal Ateliér was devoted mostly to Rössler.
Together with the work of Drtikol, Funke, and Wiškovský, Rössler's work
was shown in the exhibition "Maestri della fotografia dell'avanguardia
ceca negli anni Venti e Trenta/Masters of Czech Avant-garde Photo-
graphy of the 1920s and 1930s" in the CRAF, Lestans, Italy, organized
in collaboration with the Prague House of Photography (curators:
Vladimír Birgus and Margit Zuckriegl).

2002
In May, the Czech Center of Photography, Prague, mounted
a small exhibition to mark the 100th anniversary of Rössler's birth,
organized by Jiří Jaskmanický and Jaroslav Vít.
On 5 December, as part of the "Bohemia Magica – Une saison tchèque
en France," the Centre Atlantique de la Photographie, Brest, mounted
a smaller version of the "Jaroslav Rössler: Dessins – Photographies –
Collages" exhibition.

2003
KANT, Prague, published the large monograph Jaroslav Rössler
– fotografie, koláže, kresby, compiled by Vladimír Birgus
and Jan Mlčoch, with articles by Birgus, Mlčoch, Robert Silverio,
Karel Srp, and Matthew S. Witkovsky.
The first part of the Jaroslav Rössler exhibition was opened in the Josef
Sudek Studio, Prague, showing early abstract photographs in new prints
made from the original negatives. The curator was Josef Moucha.

# Exhibitions

## Individual exhibitions

1968 Malá výstavní síň Československého spisovatele, Prague
1975 Kabinet fotografie Jaromíra Funka, Dům pánů z Kunštátu, Brno
1991 Pražský dům fotografie/Prague House of Photography, Prague
2000 České centrum fotografie/Czech Center of Photography, Prague
2001 Uměleckoprůmyslové museum, Prague
2001 Ministerio de Educatión, Cultura y Deporte – Salla Millares, Madrid
2002 Ceské centrum fotografie/Czech Center of Photography, Prague
2002 Galerie du Quartz, Centre Atlantique de la Photographie, Brest
2003 Ateliér Josefa Sudka, Prague
2003 Rupertinum—Das Museum der Moderne, Salzburg
2004 Fotografie Forum International, Frankfurt

## Group Exhibitions (selection)

1924 *19th Exhibition of Société Francaise de Photographie*, Paris
1926 *Rote Fahne*, Berlin
1926 *3. výstava Devětsilu*, Rudolfinum, Prague
1930 *Výstava nové fotografie*, Aventinská mansarda, Prague
1966 *Surrealismus a fotografie*, Dům umění města Brna, Brno (Prague, Bratislava)
1969 *Současná československá fotografie*, Moravská galerie, Brno
1977 *Česká medzivojnová fotografia zo zbierok MG v Brne*, Komorná galéria fotografie MDKO, Bratislava
1979 *Tschechoslowakische Fotografie 1918–1978*, Fotoforum, Kassel (Caracas)
1979 *Člověk a čas*, Staroměstská radnice, Galerie hlavního města Prahy, Prague
1979 *Photographie als Kunst 1879–1979 / Kunst als Photographie 1949–1979*, Tiroler Landesmuseum Ferdinandeum, Innsbruck (Linz, Graz, Vienna)
1980 *Das imaginäre Photo-Museum*, Josef-Haubrich-Kunsthalle, Photokina, Cologne
1981 *Česká fotografie 1918–1938 ze sbírek Moravské galerie v Brně*, Moravská galerie, Brno (Prague)
1981 *Meisterwerke der Photographie – Eine persönliche Auswahl/ Photographic Masterpieces – A Personal Selection*, Galerie Rudolf Kicken, Cologne
1981 *Germany: The New Vision*, Fraenkel Gallery, San Francisco
1982 *Masterpieces of Czech Photography from the Twenties and Thirties*, Rudolf Kicken Galerie, Cologne
1982 *Lichtbildnisse: Das Porträt in der Fotografie*, Rheinisches Landesmuseum, Bonn
1983 *Photographes tchéques 1920–1950*, Centre Georges Pompidou – Musée national d'art moderne, Paris
1983 *Tschechoslowakische Fotografen 1900–1940*, Leipzig
1983 *Z historie divadelní fotografie*, Malá výstavní síň, Liberec
1984 *Tschechische Fotografie 1918–1938*, Museum Folkwang, Essen (Frankfurt am Main, Vienna)
1984 *Aspects of Czechoslovak Photography*, Thackerey and Robertson Gallery, San Francisco
1985 *Czeska fotografia 1918–1938*, Muzeum Sztuki, Lódź
1985 *Czechoslovakian Photography: 27 Contemporary Czechoslovakian Photographers – Jaromír Funke & Jaroslav Rössler*, The Photographers' Gallery, London (Bristol)
1985 *Ursprung und Gegenwart tschechoslowakischer Fotografie*, Fotografie Forum Frankfurt, Frankfurt am Main
1986 *Devětsil. Česká výtvarná avantgarda dvacátých let*, Dům umění města Brna, Brno (Prague)
1986 *Fotografie, plakát, typografie ze sbírek Uměleckoprůmyslového muzea*, Výstavní síň Emauzy, Prague

1988 *Linie, barva, tvar v českém výtvarném umění třicátých let*, Dům U Kamenného zvonu, Galerie hlavního města Prahy, Prague (Pardubice, Hluboká nad Vltavou)
1989 *Czech Modernism 1900–1945*, The Museum of Fine Arts, Houston (New York, Akron)
1989 *Tschechische Kunst der 20er + 30er Jahre. Avantgarde und Tradition*, Mathildenhöhe, Darmstadt
1989 *Cesty československé fotografie*, Dům U Kamenného zvonu, Galerie hlavního města Prahy, Prague
1989 *Sto padesát fotografií ze sbírky Moravské galerie v Brně*, Moravská galerie, Brno (Hodonín)
1989 *Co je fotografie—150 let fotografie / What Is Photography –150 Years of Photography*, Mánes, Prague
1989 *Z ateliéru Františka Drtikola (žáci)*, Malá galerie Melantrichu, Prague
1989 *Drtikol, Scottová, Rössler*, Památník národního písemnictví, Prague
1989 *On the Art of Fixing a Shadow: One Hundred and Fifty Years of Photography*. National Gallery of Art, Washington (Chicago, Los Angeles)
1990 *Devětsil—Czech Avant-garde Art, Architecture and Design of the 1920s and 30s*, Museum of Modern Art, Oxford
1990 *Anwesenheit bei Abwesenheit. Fotogramme und die Kunst des 20. Jahrhunderts*, Schweizerische Stiftung für die Photographie, Kunsthaus, Zurich
1990 *Photographie Progressive en Tchécoslovaquie 1920–1990*, Galerie Robert Doisneau, Centre Culturel André Malraux, Vandeuvre-les-Nancy (Mülheim a.d. Ruhr, Krefeld, Mulhouse, Rennes)
1990 *Les Avant-garde Tchéques*, Palais de l' Archeveché, Recontres Internationales de la Photographie, Arles
1990 *Aventinská mansarda. Otakar Štorch-Marien a výtvarné umění*, Galerie hlavního města Prahy, Prague
1990 *Surrealist Spirit in Czech Photography*, Robert Koch Gallery, San Francisco
1991 *Konstruktion und Poesie. Tschechische Fotografie 1920–1945*, Keiser Wilhelm Museum, Krefeld
1991 *Tchécoslovaque Photographie*, L'Aubette, Strasbourg
1991 *František Drtikol and Czech Avant-Garde*, Howard Greenberg Gallery, New York
1992 *Czechoslovak Photography 1915–1960*, Jacques Baruch Gallery, Chicago
1992 *Photographien aus der Tschechoslowakei der 30er und 40er Jahre*, Galerie Carla Stützer, Cologne
1992 *Proto-Modern Photography*, Museum of Fine Arts—Museum of New Mexico, Santa Fe (Rochester)
1993 *El arte de la Vanguardia en Checoslovaquia 1918–1938/ The Art of the Avant-Garde in Czechoslovakia 1918–1938*, IVAM Centre Julio Gonzales, Valencia
1993 *Umění pro všechny smysly. Meziválečná avantgarda v Československu*, Valdštejnská jízdárna, Národní galerie, Prague
1993 *Czech and Slovak Photography from Between the Wars to the Present*, Fitchburg Art Museum, Fitchburg (Boston, Middlebury, Seattle, Monaco)
1994 *Europa, Europa. Das Jahrhundert der Avantgarde in Mittel- und Osteuropa*, Kunst- und Ausstellungshalle der Bundesrepublik Deutschland, Bonn
1997 *Prague 1900–1938. Capitale secréte des avant-gardes*, Musée des Beaux-Arts, Dijon
1997 *Seen & Unseen*, Galerie Rudolf Kicken, Cologne
1998 *Bellesa moderna. Les avantguardes fotográfiques txeques 1918–1948*, Museu Nacional d'Art de Catalunya, Barcelona (Paris, Lausanne)
1999 *Les abstraktions et la photographie. Collection du Centre Georges Pompidou, Musée national d'Art moderne et du Fonds National d'Art Contemporain*, Rencontres Internationales de la Photographie, Arles

1999 *Moderní krása. Česká fotografická avantgarda 1918–1948/
Modern Beauty. Czech Photographic Avant-Garde 1918–1948.*
Dům U Kamenného zvonu, Galerie hlavního města Prahy, Prague

1999 *Modern Beauty. Tschechische Avantgarde-Fotografie
1918–1948*, Die Neue Sammlung—Staatliches Museum für an-
gewandte Kunst, Munich

2000 *Tschechische Avantgarde-Fotografie der zwanziger und dreißiger
Jahre aus der Sammlung des Kunstgewerbemuseums in Prag*,
Tschechisches Zentrum, Berlin

2000 *Ozvěny kubismu*, Dům U černé matky Boží, České muzeum
výtvarných umění, Prague

2000 *Csek Avantgárd Fotográfia 1918–1939*, Magyar Fotográfusok
Háza, Budapest

2000 *Abstrakte Fotografie*, Kunsthalle, Bielefeld

2000 *Laterna Magica. Einblicke in eine Tschechische Fotografie
der Zwischenkriegszeit*, Rupertinum, Salzburg
(Mönchengladbach)

2002–2003 *Central European Avant-Gardes: Exchange and
Transformation 1910–1930.* Los Angeles County Museum of Art,
Los Angeles—Haus der Kunst, Munich—Martin-Gropius-Bau,
Berlin

2003 *Das Auge und der Apparat. Aus den Sammlungen der Albertina.*
Albertina, Vienna—Fotomuseum im Münchner Stadtmuseum,
Munich

## Permanent Expositions

Uměleckoprůmyslové muzeum, Prague
Národní galerie—Veletržní palác, Prague
Moravská galerie, Brno

## Public Collections (selection)

Uměleckoprůmyslové museum, Prague
Moravská galerie, Brno
Pražský dům fotografie/Prague House of Photography, Prague
Musée national d'art moderne, Centre Georges Pompidou, Paris
Bibliothéque National, Paris
Société Francaise de Photographie, Paris
Museum Folkwang, Essen
Albertina, Vienna
IVAM Centre Julio Gonzales, Valencia
J. Paul Getty Museum, Los Angeles
The Art Institute of Chicago, Chicago
The Museum of Modern Art, New York
The Museum of Fine Arts, Houston
San Francisco Museum of Modern Art, San Francisco
The Corcoran Gallery of Art, Washington, D.C

# Literature about Jaroslav Rössler

## Monographs
Birgus, Vladimír. *Jaroslav Rössler*. Prague: TORST, 2001.
Birgus, Vladimír, and Jan Mlčoch, eds. *Jaroslav Rössler: Fotografie, koláže, kresby*. Prague: KANT, 2003.

## Portfolios
*Jaroslav Rössler, 10 Photographien 1923–1930*. Cologne: Galerie Rudolf Kicken, 1982.
*Jaroslav Rössler, Portfolio*. 10 photographs/10 fotografií. Prague: Pražský dům fotografie / Prague House of Photography, 1991.
*Jaroslav Rössler, Portfolio 2001*. 12 Photographs/12 fotografií. Text Josef Moucha. Prague: Pražský dům fotografie / Prague House of Photography, 2001.

## Bibliofilie
*Jaroslav Rössler, Bibliofili*. 7 Photographs / 7 fotografií. Text Josef Moucha. Prague: České centrum fotografie / Czech Center of Photography, 2001.

## Dissertation
Stein, Martin. "Jaroslav Rössler." Prague: Department of Photography, Film and Television Faculty, Academy of Performing Arts, 1984.

## Catalogues of Exhibitions
Birgus, Vladimír, and Jan Mlčoch. *Jaroslav Rössler. Fotografie, koláže, kresby / Photographs, Collages, Drawings*. Prague: KANT and Uměleckoprůmyslové museum, 2001.
Birgus, Vladimír, and Jan Mlčoch. *Jaroslav Rössler. Photographies, Collages/Photographs, Collages*. Brest: Galerie du Quartz, Centre Atlantique de la Photographie, 2002.
Dufek, Antonín, ed. *Czechoslovakian Photography. Jaromír Funke and Jaroslav Rössler*. London: The Photographers' Gallery, 1985.
Fárová, Anna. *Jaroslav Rössler*. Brno: Dům umění města Brna, 1975.

## Essays and Articles
A. K. "Jaroslav Rössler." *Revue Fotografie*, no. 3 (1976): 78.
Birgus, Vladimír. "The Avant-Garde Photographer Jaroslav Rössler." *Imago*, no. 3 (1996): 11–15.
Birgus, Vladimír. "Jaroslav Rössler and the Czech Avant-Garde." *History of Photography*, no. 1 (1999): 82–87.
Birgus, Vladimír. "Jaroslav Rössler–zacatky tvorby." *Ateliér*, no. 8 (2001): 2–3.
Birgus, Vladimír. "Jaroslav Rössler (1902–1990)." In *Photography and Research in Austria. Vienna, the Door to the European East. European Society for the History of Photography Symposium 2001 Vienna*. Passau: Dietmar Klinger Verlag, 2002, pp. 119–133.
Birgus, Vladimír. "Jaroslav Rössler. Der vergessene Pionier der Avant-garde." *Photonews*, no. 5 (2001): 10–11.
Birgus, Vladimír. "Nedoceněný Jaroslav Rössler." *Fotografie*, no. 5 (1991): 13–14.
Burian, Petr. "Znovuobjevený významný představitel české fotografické avantgardy Jaroslav Rössler." *Haló noviny*, 27. 3. 2001.
-dt- "Z prací Jaroslava Rösslera." *Revue Fotografie*, no. 1 (1961): 40–41.
Dufek, Antonín. "Fotografická sbírka Moravské galerie – Jaroslav Rössler." *Československá fotografie*, no. 11 (1978): 508–509.
Fárová, Anna. "Jaroslav Rössler." *POST*, no. 3 (1991): 8–9.
Fárová, Anna. "Výtvarný, reklamní i divadelní fotograf a grafik Jaroslav Rössler." *Revue Fotografie*, no. 2 (1972): 34–37.
Fárová, Anna. "Ze sbírek fotografií UPM v Praze–Jaroslav Rössler." *Československá fotografie*, no. 5 (1972): 212–213.
"Fotografie Jaroslava Rösslera." *Svoboda*, 15. 3. 2001.
Frajerová, Blanka. "Fotograf Jaroslav Rössler se konečně dočkal výstavy." *České slovo*, 9. 4. 2001.
Chuchma, Josef. "Méně slov, prosím, fotografuji." *Reflex*, no. 24 (2003): 21.
Kirschner, Zdeněk. "Jaroslav Rössler po sto letech." *Fotografie Magazín*, no. 9 (2002): 10–11.
Kopáč, Radim. "Znovuobjevený Jaroslav Rössler." *Literární noviny*, no. 5 (2001).
Kuneš, Aleš. "Fotograf neprávem opomíjený. V Praze se dnes otevírá jedinečná výstava experimentátora Jaroslava Rösslera." *Lidové noviny*, 14. 3. 2001.
Kuneš, Aleš. "Jaroslav Rössler's Exhibition and Monograph." *Imago*, no. 12 (2001): 62–63.
Kuneš, Aleš. "Pocta experimentátoru Rösslerovi." *Lidové noviny*, 5. 1. 2001.
Laufrová, Berta. "Retrospektiva Jaroslava Rösslera–fotografie, koláže, kresby." *Listy Prahy 1*, no. 5 (2001): 7.
(mgd) = Váňová, Magdalena. "Abstrakce v Rösslerově díle." *Hospodářské noviny*, 12. 12. 2000
(mgd) = Váňová, Magdalena. "Rössler se dostává na výsluní. Avantgardní fotograf světového jména se dočkal své první retrospektivy." *Hospodářské noviny*, 15. 3. 2001.
Mlčoch, Jan. "Jaroslav Rössler–fotograf reklamy." *Ateliér*, no. 8 (2001): 16.
Moucha, Josef. "Absolutní fotograf Jaroslav Rössler." *Týden*, no. 12 (2001): 76–77.
Moucha, Josef. "Dým liany světelné, přezíraná abstrakce." *Ateliér*, no. 8 (2001): 1, 6.
Moucha, Josef. "Legenda Jaroslav Rössler." *Dotyk*, no. 2 (1999): 42–43.
Moucha, Josef. "Umělec zaslouží docenění." *Mladá fronta Dnes*, 3. 3. 2001.
Moucha, Josef. "Zážeh abstraktní fotogenie." *Art & Antiques*, no. 6 (2003): 89–90.
Moucha, Josef. "Zjevení Jaroslava Rösslera." *Host do domu*, no. 10 (2000).
Mužíková, Monika. "Průkopník Rössler." *Prague Dnes (Mladá fronta Dnes)*, 3. 3. 2001.
Podešul, Václav. "Jaroslav Rössler má konečně monografii." *Noviny Slezské univerzity*, November 2001, p. 15.
Podestát, Václav. "Mistr abstrakce Jaroslav Rössler se dočkal monografie." *Ateliér*, no. 19 (2001): 2.
Pospěch, Tomáš. "Avantgardista Rössler se v nové knize konečně stává klasikem." *Právo*, 5. 6. 2003.
Silverio, Robert. "Poválečná tvorba Jaroslava Rösslera." *Ateliér*, no. 8 (2001): 7.
Sougez, Marie-Loup. "Jaroslav Rössler." *Mundo*, 13. 6. 2001.
Srp, Karel. "Zóny vizuality. Jaroslav Rössler, kresba, foto, radio." *Umění*, 2000, no. 6 (2000): 423–434.
Stein, Martin. "Jaroslav Rössler." *Revue Fotografie*, no. 3 (1987): 26–33.
Tausk, Petr. "Nad fotografickým dílem Jaroslava Rösslera." *Revue Fotografie*, no. 2 (2001): 49–73.
Valoch, Jiří. "Fascinující odkaz." *Ateliér*, no. 8 (2001): 1.
Váňová, Magdalena. "Plachý fotograf se dočkal monografie. Publikaci o Jaroslavu Rösslerovi připravili pro nakladatelství KANT renomovaní kunsthistorici." *Hospodářské noviny*, 28. 5. 2003
Vitvar, Jan H. "Fotograf Rössler mez mýtů i skrupulí." *Mladá fronta Dnes*, 25. 6. 2001.
Vitvar, Jan H. "Introvert, který si uměl stát za svým. Jaroslav Rössler je definitivně klasikem, má velkou výstavu a brzy mu vyjde monografie." *Mladá fronta Dnes*, 14. 3. 2001.
Vitvar, Jan H. "Příprava na Rösslera a Medkovou." *Mladá fronta Dnes*, 3. 1. 2001.
Vitvar, Jan H. "Velká, leč rozpačitá monografie." *Mladá fronta Dnes*, 2. 6. 2003.
Volf, Petr. "Jaroslav Rössler–Reklamní fotografie." *Reflex*, no. 25 (2003): 58.

## Further Literature

### Books

Auer, Michéle, and Michel Auer. *Encyclopédie internationale des photographes de 1839 a nos jours / Photographers Encyclopaedia International 1839 to the Present.* Hermance/Genéve: Editions Camera Obscura, 1985.

Birgus, Vladimír Birgus, ed. *Czech Photographic Avant-Garde 1918–1948.* Cambridge: The MIT Press, 2002.

Birgus, Vladimír, ed. *Česká fotografická avantgarda 1918–1948.* Prague: KANT, 1999.

Birgus, Vladimír, and Scheufler Pavel. *Fotografie v českých zemích 1839–1999.* Prague: Grada, 1999.

Birgus, Vladimír. "Fotografie." in: *Informatorium 2.* Prague: Mladá fronta, 1984.

Birgus, Vladimír Birgus, ed. *Tschechische Avantgarde-Fotografie 1918–1948.* Stuttgart: Arnoldsche, 1999.

*Contemporary Photographers.* Detroit: St. James Press, 1995.

*Dějiny českého výtvarného umění IV.* Prague: Academia, 1998.

Dufek, Antonín. *Černobílá fotografie.* Prague: Odeon, 1987.

*Encyklopedie českých a slovenských fotografů.* Prague: ASCO, 1993.

Fárová, Anna. *Současná fotografie v Československu.* Prague: Obelisk, 1972.

Frizot, Michel, ed. *A New History of Photography.* Cologne: Könemann, 1998.

Gruber, Renate, and L. Fritz. *Das imaginäre Photo-Museum.* Cologne: DuMont, 1981.

Honnef, Klaus, ed. *Lichtbildnisse, Das Porträt in der Fotografie.* Cologne: DuMont, 1982.

Horová, Anděla, ed. *Nová encyklopedie českého výtvarného umění.* Prague: Academia, 1995.

Jäger, Gottfried, ed. *Die Kunst der Abstrakten Fotografie / The Art of Abstract Photography.* Stuttgart: Arnoldsche, 2002.

Kellein, Thomas, and Angela Lampe. *Abstrakte Fotografie.* Ostfildern-Ruit: Hatje Cantz, 2000.

Lemagny, Jean-Claude, and André Rouillé. *Histoire de la Photographie.* Paris: Bordas, 1986.

Lionel-Marie, Annick, and Alain Sayag. *Collection de photographies du Musée National d'Art Moderne 1905–1948.* Paris: Centre Georges Pompidou, 1996.

Mrázková, Daniela. *Příběh fotografie.* Prague: Mladá fronta, 1985.

Mrázková, Daniela, and Vladimír Remeš. *Cesty československé fotografie.* Prague: Mladá fronta, 1989.

Mrázková, Daniela, and Vladimír Remeš. *Tschechoslowakische Fotografen.* Leipzig: VEB Fotokinoverlag, 1983.

Neusüss, Floris M. *Das Fotogramm in der Kunst des 20. Jahrhunderts.* Cologne: DuMont, 1990.

Primus, Zdenek. *Art is Abstraction. Czech Visual Culture of the Sixties.* Prague: KANT, 2003.

Primus, Zdenek. *Tschechische Avantgarde 1922–1940. Reflexe europäischer Kunst und Fotografie in der Buchgestaltung.* Münster: Vier-Türme-Verlag, 1990.

Tausk, Petr. *Die Geschichte der Fotografie im 20. Jahrhundert.* Cologne: DuMont, 1977.

Tausk, Petr. *Photography in the 20th Century.* London: Focus, 1980.

Tausk, Petr. *Přehled vývoje československé fotografie od roku 1918 až po naše dny.* Prague: SPN, 1986.

### Catalogues of Exhibitions

Anděl, Jaroslav, ed. *El arte de la Vanguardia en Checoslovaquia 1918–1938 / The Art of the Avant-garde in Czechoslovakia 1918–1938.* Valencia: IVAM Centre Julio Gonzales, 1993.

Anděl, Jaroslav, and Anne Tucker, eds. *Czech Modernism 1900–1945.* Houston: The Museum of Fine Arts, 1989.

Anděl, Jaroslav, and Emmanuel Starcky, eds. *Prague 1900–1938. Capitale secrète des avant-gardes.* Dijon: Musée des Beaux-Arts, 1997.

Anděl, Jaroslav, ed. *Umění pro všechny smysly. Meziválečná avantgarda v Československu.* Prague: Národní galerie, 1993.

Birgus, Vladimír, and Pierre Bonhomme. *Beauté Moderne Les avantgardes photographiques tchéques 1918–1948.* Paris: Mission du Patrimoine photographique and Prague: KANT, 1998.

Birgus, Vladimír, and Jan Mlčoch. *Csek Avantgárd Fotográfia 1918–1938.* Budapest: Magyar Fotográfusok Háza, 2000.

Birgus, Vladimír, and Margit Zuckriegl. *Maestri della fotografia dell'avanguardia ceca negli anni Venti e Trenta / Masters of the Czech Avant-garde Photography of the 1920s and the 1930s.* Milano: Silvana Editoriale, 2001.

Birgus, Vladimír, and Pierre Bonhomme. *Moderní krása. Česká fotografická avantgarda 1918–1948 / Modern Beauty. Czech Photographic Avant-garde 1918–1948.* Prague: Galerie hlavního města Prahy and KANT, 1999.

Bydžovská, Lenka, and Karel Srp, eds. *Aventinská mansarda. Otakar Štorch-Marien a výtvarné umění.* Prague: Galerie hlavního města Prahy, 1990.

Dufek, Antonín, ed. *Czechoslovakian Photography. Jaromír Funke and Jaroslav Rössler.* London: The Photographers' Gallery, 1985.

Dufek, Antonín, Antonín Dufek and Urszula Czartoryska. *Czeska fotografia 1918–1938.* Lódź: Muzeum Sztuki, 1985.

Dufek, Antonín, Antonín Dufek (ed.). *Česká fotografie 1918–1938 ze sbírek Moravské galerie v Brně.* Brno: Moravská galerie, 1981.

Dufek, Antonín, and Zdeněk Kirschner – Kateřina Klaricová – Alain Sayag. *Photographes tchéques.* Paris: Centre Georges Pompidou – Musée national d'art moderne, 1983.

Dufek, Antonín, and Ute Eskildsen. *Tschechische Fotografie 1918–1938.* Essen: Museum Folkwang, 1984.

*Europa, Europa. Das Jahrhundert der Avantgarde in Mittel- und Osteuropa.* Bonn: Kunst- und Ausstellungshalle der Bundesrepublik Deutschland, 1994.

Fárová, Anna. *Osobnosti české fotografie I.* Roudnice nad Labem: Galerie výtvarného umění, 1973.

Fárová, Anna. *Osobnosti české fotografie I.* Prague: Uměleckoprůmyslové museum, 1974.

Fárová, Anna. *Ursprung und Gegenwart tschechoslowakischer Fotografie.* Frankurt am Main: Album, 1985, 3.

Forbes, Murray, Antonín Dufek, Václav Macek, and Vladimír Birgus. *Czech and Slovak Photography from Between the Wars to the Present.* Boston: The Navigator Foundation, 1993.

Greenough, Sarah, ed. *On the Art of Fixing a Shadow. One Hundred and Fifty Years of Photography.* Washington: National Gallery of Art and Chicago: The Art Institute of Chicago, 1989.

Gruber, L. Fritz, and Suzanne E Pastor. *Meisterwerke der Photographie – Eine persönliche Auswahl / Photographic Masterpieces – A Personal Selection.* Katalog 6. Cologne: Galerie Rudolf Kicken, 1981.

Chocholová, Blanka. *Z ateliéru Františka Drtikola (žáci).* Prague: Malá galerie Melantrich, 1989.

Jírů, Václav. *Člověk a čas.* Prague: Galerie hlavního města Prahy, 1979.

Klaricová, Kateřina. *Z historie divadelní fotografie.* Liberec: Malá výstavní síň, 1983.

Krimmel Bernd, and Jiří Kotalík. *Tschechische Kunst der 20er + 30er Jahre. Avantgarde und Tradition.* Darmstadt: Mathildenhöhe, 1989.

Mrázková, Daniela, ed. *Co je fotografie – 150 let fotografie / What Is Photography – 150 Years of Photography.* Prague: Videopress, 1990.

Newhall, Beaumont, and Steve Yates. *Proto-Modern Photography.* Santa Fe: Museum of Fine Art – Museum of New Mexico and Rochester: International Museum of Photography at George Eastman House, 1992.

Philippot, Claude, and Zdenek Primus. *Photographie Progressive en Tchécoslovaquie 1920–1990.* Vandeuvre-les-Nancy: Galerie Robert Doisneau, Centre Culturel André Malraux, 1990.

Rousová, Hana, ed. *Linie, barva, tvar v českém výtvarném umění třicátých let*. Prague: Galerie hlavního města Prahy, 1988.

*Rudolf Kicken Galerie 1976–1986*. Cologne: Rudolf Kicken Galerie, 1986.

*Seen & Unseen*. Cologne: Rudolf Kicken Galerie, 1997.

Šmejkal, František, ed. *Devětsil. Česká výtvarná avantgarda dvacátých let*. Brno and Prague: Dům umění města Brna and Galerie hlavního města Prahy, 1986.

Šmejkal, František, ed. *Devětsil – Czech Avant-garde Art, Architecture and Design of the 1920s and 30s*. Oxford: Museum of Modern Art, 1990.

*Vive les modernités!* Arles: Actes Sud – Rencontres Internationales de la Photographie, 1999.

Weiermair, Peter. *Photographie als Kunst 1879–1979 / Kunst als Photographie 1949–1979*. Innsbruck: Allerheiligenpress, 1979.

Zuckriegl, Margit, ed. *Laterna Magica. Einblicke in eine Tschechische Fotografie der Zwischenkriegszeit*. Salzburg: Rupertinum, 2000.

Zykmund, Václav. *Surrealismus a fotografie*. Brno: Dům umění města Brna, 1966.

**Essays and Articles**

Anděl, Jaroslav. "Construction et 'poetisme' dans la photographie tcheque." *Photographies*, no. 7 (1985): 21–25.

Birgus, Vladimír, and Jan Mlčoch. "Cseh avantgárd fotográfia 1918–1939." *Fotóművészet*, no. 1–2 (2001): 67–81.

Birgus, Vladimír. "Česká fotografická avantgarda v mezinárodním kontextu." *Film a doba*, no. 2 (2000): 69–76.

Birgus, Vladimír. "Modern Beauty–Czech Avant-Garde Photography 1918–1948." *Imago*, no. 6 (1998): 58–60.

Birgus, Vladimír. "The New Objectivity and Constructivism in Czech Inter War Photography." *Imago*, no. 9 (2000): 8–20.

Birgus, Vladimír. "Tschechische Fotografie der Avantgarde 1918–1948." *Stifter Jahrbuch*, Neue Folge 11 (1997): 70–80.

Boček, Jaroslav. "Vychutnejte krásu české moderní fotografie." *Právo*, 5. 3. 1999.

Czartoryska, Urszula, and Antonín Dufek. "Miedzywojenna fotografia czeska." *Fotografia*, no. 1 (1982): 13–19.

Dattenberger, Simone. "Hemdkragenspitzen. Neue Sammlung, Tschechische Avantgarde Fotografie." *Münchner Merkur*, 9. 6. 1999.

D'Hooghe, Alain. "La Tchécoslovaquie révélée. Les avant-gardes tchéques a Paris." *Le Matin*, 6. 8. 1998.

Dufek, Antonín. "Fotografie v Čechách a na Slovensku 1919–1945." *Revue Fotografie*, no. 3 (1989): 2–9.

Dufek, Antonín. "Z historie české fotografie (od r. 1918 do r. 1930)." *Revue Fotografie*, no. 5 (1985): 36–43.

Elwall, Robert. "Local traditions: Czech Photographic Avant-Garde 1918–1948." *Architects' Journal*, no. 24 (2002): 48.

Fontaine, François. "Poemes d'images venus de l'Est. Les photomontages tchéques célebrent le monde moderne." *Journal des Arts*, 19. 6. 1998.

Gautran, Jean-Claude. "Beaute Moderne. Les avant-gardes photographiques tchéques." *Le Photographe*, no. 7–8 (1998): 10–11.

Ginart, Belén. "El MNAC ofrece la primera gran exhibición de fotográfia checa de vanguardia." *Pais*, 8. 4. 1998.

Horak, Jean Christopher. "The Czech Avant-Garde." *Afterimage*, summer 1984.

Horak, Jean Christopher. "Le photographie tcheque entre les deux guerres." *Photographies*, no. 7 (1985): 100–102.

Chuchma, Josef. "Čas opožděných premiér. Edice FotoTorst má za sebou prvních šest svazků." *Respekt*, no. 27 (2001): 21.

Chuchma, Josef. "Nakolik je ta krása moderní?" *Literární noviny*, no. 21 (1999): 12.

Kanyar, Helena. "Licht-Schatten-Spiele, Tschechische Fotoavantgarde 1918–46." *Basler Zeitung*, 12. 12. 1998.

Kuneš, Aleš. "Moderní krása. Česká fotografická avantgarda 1918–1948." *Týdeník Rozhlas*, no. 14 (1999).

Kuneš, Aleš. "Po Paříži se česká avantgardní fotografie představí v Praze." *Lidové noviny*, 2. 3. 1999.

Lebhart, Walter. "Poesie und Technik–böhmische Moderne." *Der Landbote*, 19. 11. 1998.

Lechowicz, Lech. "Fotografia v kregu czeskiej awangardy miedzywojennej." Lódź: *Acta universitas lodzensis*, Folia scientiae artium et litterarium, 1990, pp. 125–146.

Meyer, Claus Heinrich. "Kraftwerk der Bilder. Eine Ausstellung tschechischer Avantgarde-Photographie in der Münchner Neuen Sammlung." *Süddeutsche Zeitung*, 15. 7. 1999.

Mrázková, Daniela. "Fotografické dědictví–vývojové proudy v české meziválečné fotografii." *Československá fotografie*, no. 6 (1978): 260–269.

Podestát, Václav. "Česká fotografická avantgarda." *Plzeňský deník*, 11. 5. 1999.

Pokorný, Marek. "Do Prahy doputoval pokus o anatomii české avantgardní fotografie." *Mladá fronta Dnes*, 3. 3. 1999.

Pospěch, Tomáš. "Česká fotografická avantgarda 1918–1948." *Ateliér*, no. 8, (2000): 7.

Pospěch, Tomáš. "Tschechische Avantgarde-Fotografie 1918–1948." *Camera Austria International*, no. 74 (2001): 97.

Požárek, Marcela. "Kostbare spielräume des Vissuellen. Ein Klassiker der Fotografie im Prager Kunstegewerbemuseum." *Prager Zeitung*, 21. 3. 2001.

Rail, Evan. "Handbooks Offer Enriching Tours." *Prague Post*, no. 1 (2003): 12.

Rother, Hans-Jürgen. "Als die süßen Jahre bitter wurden. Tschechische Fotografie zwischen Avantgarde und Realismus, Eine Doppelaustellung in Berlin." *Frankfurter Allgemeine Zeitung*, 23. 6. 2000.

Silverio, Robert. "Velký návrat radikálů vizuality. K expozici Česká fotografická avantgarda 1918–1948." *Lidové noviny*, 1. 4. 1999.

Spiegel, Olga. "El MNAC presenta la efervescencia creativa de las vanmguardias fotográficas checas." *La Vanguardia*, 8. 4. 1998.

Srp, Karel. "Optická slova–obrazové básně a poetismus 1922–26." *Ateliér*, no. 5 (1999): 9.

Suk, Jan. "I tady na stole leží růže. Jindřich Štyrský, Jaroslav Rössler, Zdeněk Tmej." *Nové knihy*, no. 34/35 (2001): 32–33.

Szegö, György. "Made in Europe: Cseh avantgárd fotográfia 1918–1938." *Művészét*, no. 3 (2001): 28–29.

Tausk, Petr. "The Roots of Modern Photography in Czechoslovakia." *History of Photography*, no. 3 (1979): 253–271.

Teige, Karel. "Cesty československé fotografie." *Blok*, no. 6 (1948): 77–86.

Teige, Karel. "Výstava S. M. K. Devětsil." *Stavba*, no. 1 (1926–27): 16.

Thomas, Robert M. "O české fotografii na XIX. pařížském salonu fotografickém." *Rozhledy fotografa amatéra*, no. 11 (1924): 157.

"Tschechische Avantgarde-Fotografie." *Profi Foto*, no. 5 (2001): 6.

Uberquoi, Marie-Claire. "El MNAC acoge una exposición sobre la fotografía checa de vanguardia." *Mundo*, 8. 4. 1998.

Zuckriegl, Margrit. "Im Auge des Taifun. Einblicke in eine tschechische Fotografie der Nachkriegszeit." *Parnass*, no. 4 (2000): 119–120.

# Index

Ambrosi, Vilém 26
Anděl, Jaroslav 21, 26, 41, 42
Apollinaire, Guillaume 20
Archipenko, Alexandr 16
Atgèt, Eugene 43
Baraduc, Hippolyt 13
Bayard, Hippolyt 44
Bayer, Herbert 15, 26
Benc, Stanislav 38
Benson, Timothy O. 23
Benjamin, Walter 43
Biebl, Konstantin 16, 33
Bílek, Alois 12
Binge, Ilse 41
Binko, Josef 8
Birgus, Vladimír 23, 24, 28, 31
Bleyová, Oľga 38
Bloch, Miloš 28
Boccioni, Umberto 12
Boudník, Vladimír 38, 39
Bourke-White, Margaret 18
Braque, Georges 11
Braný, Antonín 23
Braun, Matyáš Bernard 8
Bruguiére, Francis Joseph 13, 14, 24
Buľka, Vladimír Jindřich 8, 23
Bulhak, Jan 10
Carrá, Carlo 12
Cartier-Bresson, Henri 21
Chevalier, Maurice 18
Chochol, Josef 8
Coburn, Alvin Langdon 8, 10, 11, 12, 13, 18, 23, 24
Cocteau, Jean 18
Cohn, Alfred 14
Comeriner, Erich 18
Čapek, Josef 8, 12, 31
Černík, Artuš 18
Čiurlionis, Mikalojus Konstantinas 13
Daguerre, Louis Jacques Mandé 44
Darget, Louis 10
Davis, Keith F. 13
Delluce, Louis 32
Demanins, Ferruccio A. 29
Doležal, Stanislav 23
Dostal, Karel 12
Dostoevsky, Fyodor Mikhaylovich 31
Drtikol, František 7, 8, 9, 10, 11, 12, 15, 17, 19, 20, 23, 25, 26, 28, 30, 31, 32, 36, 40, 42, 43, 44
Dubreuil, Pierre 10, 14, 24
Dufek, Antonín 11, 16, 22, 23, 24, 28, 31, 35, 36, 39, 44
Enyeart, James 24
Fábera, Jarda 11, 28
Fárová, Anna 23, 28, 36
Feuerstein, Bedřich 16
Filla, Emil 8
Fischerová, Gertruda 9, 10, 15, 17, 19, 23, 25
Frizot, Michel 23

Foltýn, František 12
Fragner, Jaroslav 16
Frejka, Jiří 20
Friedrich, Caspar David 34
Funke, Jaromír 14, 15, 17, 21, 22, 23, 24, 27, 28, 32, 36, 44
Gernsheim, Alison 24
Gernsheim, Helmut 24
Getty, J. Paul 7, 20, 22, 26, 44
Gočár, Josef 8,
Goll, Ivan 17, 20, 44
Grasset, Bernard 26
Gribovský, Antonín 38
Gruber, L. Fritz 23
Gruber, Renate 23
Gutfreund, Otto 8, 11
Hackenschmied, Alexandr 19, 21, 27
Hájek, Karel 27
Halas, František 16
Hamanová, Růžena 35
Hambourg, Maria Morris 24
Hartshorn, Willis 28
Haupt, Karl Hermann 18
Hausenblas, Josef 18, 32
Häuslerová, Emy 29, 35
Heiting, Manfred 23
Henri, Florence 18
Heythum, Antonín 16, 17
Hight, Eleanor M. 44
Hirschfeld-Mack, Ludwig 14
Hoffmeister, Adolf 16, 17, 20
Hofman, Vlastislav 11, 12, 31
Höch, Hannah 43
Honzik, Karel 16
Honzl, Jindřich 16, 17, 19, 20, 22, 24
Horne, Bernard S. 14
Howe, Graham 24
Istler, Josef 36
Jäger, Gottfried 12, 23, 24
Janák, Pavel 8
Jesenská, Milena 19, 20
Kuľka, Franz 19
Kandinsky, Wassily 13
Keetmann, Peter 37
Kellein, Thomas 23, 24
Kertész, André 17, 21, 42, 45
Kicken, Rudolf 23, 26, 37
Kirschner, Zdeněk 35
Klaricová, Kateřina 23
Klucis, Gustav 15
Kmentová, Eva 36
Koch, Jindřich 38
Koch, Robert 21, 23, 27
Kollar, Francois /Kolár, František/ 27, 28
Komrs, Ludvík 8
Koppitz, Rudolf 20
Kramář, Vincenc 11
Krátký, Čestmír 38, 39
Krauss, Rolf H. 13, 24
Krejcar, Jaromír 16, 18, 29
Krull, Germaine 18
Krupka, Jaroslav 17
Kubišta, Bohumil 8, 12
Kupferová, Ervina 10
Kupka, František 12, 13
Kytka, Rupert 38
Lampe, Angela 24

Lionel-Marie, Annick 23, 24, 28
Lissitzky, El 15, 16, 33, 43, 44
Lodder, Christina 39, 42
Lorelle, Lucien 18, 20, 22, 24, 25, 26, 27
Mach, Ernst 13
Man Ray 14, 15, 16, 17, 21, 28, 32, 33, 41, 43, 45
Mancová, Margita 38
Manuel, Gaston a Lucien 18, 19, 23, 25, 27
Marey, Etienne-Jules 13
Marinetti, Filippo Tommaso 11, 12, 29, 31
Markalous, Bohumil 32
Markalous, Evžen 17, 32, 34
Markham, Jacqueline 24
Martin, Ira 13
Mattis, Michael 11
Mayerová, Milča 32
Medek, Mikuláš 38, 39
Medková, Emila 38, 39
Mellor, David 45
Mileaf, Janine 42
Mináčová, Zuzana 38
Mißelbeck, Reinhold 24
Mlčoch, Jan 23, 24, 25, 26
Moholy-Nagy, László 14, 15, 16, 18, 21, 25, 33, 41, 43, 45
Molderings, Herbert 41, 45
Mondrian, Piet 40
Moucha, Josef 23
Mrázková, Daniela 24
Mrkvička, Otakar 16
Nedoma, Petr 23
Newhall, Nancy 24
Nezval, Vítězslav 16, 18, 29, 32, 43
Null, Milos 8
Novak, Alex 20
Nožička, Alois 36
Obrtel, Vít 16
Ore, Tarraco (Kulhánek) 11, 30, 31
Outerbridge, Paul 11, 14, 21, 24
Paspa, Karel 27
Petrák, Jaroslav 8
Piaf, Edith 15
Picasso, Pablo 11
Ponc, Miroslav 16
Popper, Grete 27
Pound, Ezra 14
Prakapasová, Dorotky 122
Prakapas, Eugene J. 19
Prampolini, Enrico 12, 31
Procházka, Antonín 8, 12, 19
Přeček, Ivo 38
Quedenfeldt, Erwin 13, 24
Reichmann, Vilém 38, 39
Remeš, Vladimír 24
Renger-Patzsch, Albert 21
Rodchenko, Alexandr 15, 16, 18, 21, 24, 41, 43, 44
Roegiers, Patrick 28
Rossmann, Zdeněk 27, 28
Rössler, Eduard 8
Rössler, Zdeněk 8
Rösslerová, Adéla, née Nollová 8
Rösslerová, Gertuda 21, 22, 23

Russolo, Luigi 12
Růžička, Drahomír Josef 10
Santholzer, Vilém 29, 30, 35
Sayag, Alain 23, 24, 28
Seeley, George H. 14
Seifert, Jaroslav 16, 18, 25, 29, 43
Severini, Gino 12
Schad, Christian 14
Scheeler, Charles 18
Schneieder-Rohan, Rudolf 18, 20, 25, 27, 28
Schürmann, Wilhelm 37
Srp, Karel 35, 39
Stacho, Ľubomír 28
Stein, Martin 7, 8, 9, 16, 19, 22, 23, 24, 28, 33
Steinert, Otto 38
Stieglitz, Alfred 8, 10, 45
Stockar, Rudolf 31
Strand, Paul 8, 13, 14, 16, 42
Sudek, Josef 17, 22, 27, 28, 36, 37, 42
Sutnar, Ladislav 27, 28
Štělc, Otto 8
Šíma, Josef 16, 17, 21, 33, 34, 43
Škarda, Augustin 9
Škoch, Jiří 38
Šmejkal, František. 24, 35
Šourek 8
Špála, Václav 31
Špillar, Karel 8
Šplíchal, Jan 38
Šťastný, Bohumil 27
Štech, V.V. 27
Štyrský, Jindřich 12, 16, 17, 36, 43
Tabard, Maurice 17, 41
Tatlin, Vladimír 41
Tausk, Petr 23, 24
Teige, Karel 10, 14, 15, 16, 17, 18, 19, 21, 22, 24, 25, 26, 28, 29, 31, 32, 33, 34, 35, 36, 43
Thomas, M. Robert 17
Thun-Hohenstein 8
Toyen, 12, 16, 17, 26, 43
Tucker, Anne Wilkes 23
Václavek, Bedřich 16, 30, 35
Vančura, Vladislav 16, 18, 20
Vít, Jaroslav 7, 22, 23
Vítová, Sylva 7, 22, 24
Voskovec, Jiří 16, 17, 18, 20, 32, 35
Vyšata, Adolf 8
Walther, Thomas 23
Watkinson, Margaret 14
Weaver, Mike 24
Weiermair, Peter 24
Werich, Jan 20
Weston, Edward 42
White, Hudson Clarence 10
Wilfred, Thomas 141
Yapp, Nick 35
Zielke, Willy 21
Zoubek, Olbram 36
Zych, Alois 8

Editors:

VLADIMÍR BIRGUS is Head of the Institute of Creative Photography at Silesian University, Opava,
and a Professor of History of Photography at the Department of Photography, Academy of Performing Arts (FAMU), Prague.
He is the author and co-author of numerous books including *Czech Photography of the 1990s, Photography in Czech Lands 1839–1999, Photographer František Drtikol*, and *Czech Photographic Avant-Garde 1918–1948*.

JAN MLČOCH is the Curator of the Photography Collection of the Museum of Decorative Arts, Prague,
and a teacher at the Academy of Arts, Architecture and Design in Prague.
His publications include *František Drtikol: Photographs 1901–1914* and *The Nude in Czech Photography*.

Other Contributors:

ROBERT SILVERIO is Lecturer at the Center for Audio-Visiual Studies,
the Academy of Performing Arts (FAMU), Prague. He has written on Karel Cudlín.

KAREL SRP is the Curator of the City Gallery Prague. He has published widely on Czech art of the 20th Century,
particularly Toyen, Jindřich Štyrský, Karel Teige, Jan Zrzavý, Emila Medková, and Devětsil.

MATTHEW S. WITKOVSKY is Assistant Curator of Photography, National Gallery of Art, Washington, D.C.
His publications on Czech modernism include facsimile translations of Abeceda (Alphabet) (1926) and *Photography Sees the Surface* (1935).